American
Portraiture
in the
Grand
Manner:
1720–1920

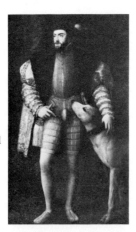

1

Titian
(Tiziano Vecelli)
1477–1576

*Charles V with Hound*
1533

75½ x 44 in.

Courtesy of the
Prado Museum, Madrid

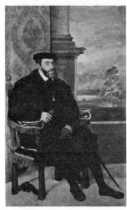

2

Titian
(Tiziano Vecelli)
1477–1576

*Charles V*
1548

81 x 48 in.

Alte Pinakothek,
Munich

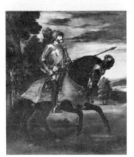

3

Titian
(Tiziano Vecelli)
1477–1576

*Charles V on Horseback*
1548

131 x 110 in.

Courtesy of the
Prado Museum, Madrid

sixteenth century, a group of conventions and attitudes surrounding the portraiture of important persons had been thoroughly cultivated and accepted.

The Baroque period of the early seventeenth century saw portraiture acquire new dramatic force, as masters such as Rubens and Van Dyck developed allegories, settings, poses, and viewpoints that served to make their subjects more imposing. From this time forward, a heightened, more formal style was expected for official portraiture, as well as for private portraits of important persons. During the third quarter of the eighteenth century, Sir Joshua Reynolds (1723–1792) carried these expectations further, developing and codifying the concept of portraiture in the Grand Manner. It was a self-conscious portraiture that reflected Western art historical traditions, particularly those of the Italian High Renaissance and the Seicento. From such classic works the educated portraitist took the most elevated manner, varied poses, and classical conceits, in effect joining portraiture with the richer, more active, and colorful realm of history painting. The term "portraiture in the Grand Manner" had a precise meaning for Reynolds and his period, although it is used more loosely today and in the present exhibition simply to signify elevated, heightened, formal portraiture. Later, portraitists of the Romantic period cultivated the formal qualities of color and lighting to increase the impact of their dramatic official portraits. To this end formal experimentation continued through the nineteenth century. In each of these eras, special efforts were made to raise official portraiture to a level of superhuman majesty.

Painting in this country during the colonial period was an extension of European and primarily English painting, and shared their fundamental view of portraiture as personal and official propaganda. A factor that may have made this inclination less pronounced was the relatively small number of established fortunes and therefore large houses in the colonies. This dictated the size of portraits, and thus bust portraits, with their limited scope for amplified presentation, were the usual format. The large number of these portraits with lifeless black backgrounds unfortunately lend colonial painting an image of simplicity. By contrast, a three-quarter-length portrait of the standard large size at this time—fifty inches high and forty inches wide—almost always incorporates some element that heightens the presentation. With few exceptions, these larger portraits were all private commissions, painted to hang in private houses.

One of the richest sources for grand manner imagery is the full-length, life-size portrait, a format that seemed to call for an expanded presentation. The full-length portrait, whether of a standing, seated, or equestrian subject, appears to have been reserved briefly in the Renaissance for royal or at least noble patrons, and it retained at least some sense of the court, even when in general use. Certain specific attributes, such as coronation robes and armor, continued to be restricted to nobility and military leaders, but most others, including the colossal column, palatial backgrounds, and imaginary parks, were used at will, even if highly inappropriate to the sitter's actual social position. A need for the most impressive image possible was felt at all levels of society, and court practices set the model.

Most of the full-length portraits painted during the colonial period were done for private houses. Full-length children's portraits were not unusual, since they could be painted on a fifty-by-forty-inch canvas. Full-size, full-length portraits of adults were rare, presumably because of cost and size considerations.[2] This format, however, was not considered inappropriate for private use, as several examples indicate. The commissioning of these portraits sometimes coincided with the building of mansions, at a time when cost and size were no longer problems and an impressive image of the owner would have been desirable. Apparently, the first full-size, full-length portrait painted in the American colonies is the remarkable portrait of

*Ariantje Coeymans* of about 1718 (fig. 4). The subject had inherited a large fortune and built a stately manor house on the Hudson, for which the portrait was presumably ordered. The mansarded palace in the background was taken from a print after Kneller's portrait of *Lady Bucknell* (fig. 5), but may symbolically refer to the new mansion, the owner's pride and joy. A view of Browne Hall near Salem, Massachusetts, likewise appears in the full-length portrait of *Mrs. William Browne* (fig. 6) painted in 1738 by John Smibert and probably intended to hang, with Smibert's portrait of her husband, in the large central salon of the house. Other examples are the brilliant pair of Copley portraits of Mr. and Mrs. Jeremiah Lee (cat. nos. 14 and 15), elaborate full-length works that were painted to hang in the Lee home in Marblehead, Massachusetts, the most lavish private colonial residence of its day.

It is to full-length portraits that one must also look for information about official portraiture in the colonies, even though so few official portraits remain in their original locations that it is difficult to distinguish a group of them. Most of the full-length adult portraits actually painted in the colonies were painted for private houses, but numerous full-length state portraits were imported from England and the form seems to have been strongly associated with public use. All primary houses of colonial government probably had portraits of the king and queen, and it is likely that many of these were full-length. Unfortunately, nearly all were destroyed in the iconoclastic fury of the Revolution, so that it is difficult to obtain much information about them. Certainly full-length royal portraits would have influenced the choice of a full-length format for portraits of colonial officials meant to hang in the same room. A letter of 1730 refers to Smibert's full-length portrait of Governor Jonathan Belcher of Massachusetts: ''His Picture is a Drawing at full-length to answer the King and Queen's...''[3] The empty places left by the removal of royal portraits during the Revolution may also have been a factor in the frequent use of the full-length format

4

Attributed to
Nehemiah Partridge
1683–c. 1729/37

*Ariantje Coeymans*
c. 1718

79¾ x 47¾ in.

Collection Albany Institute of History and Art, New York, Bequest of Gertrude Watson

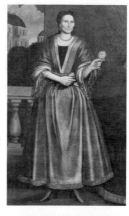

5

Mezzotint of
*Lady Bucknell*
c. 1715–25
after Sir Godfrey Kneller's painting

13½ x 10 in.

Courtesy, The Henry Francis du Pont Winterthur Museum, Winterthur, Delaware

6

John Smibert
1688–1751

*Mrs. William Browne*
1738

92½ x 57 in.

The Johns Hopkins University, Baltimore

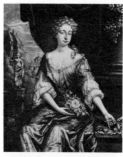

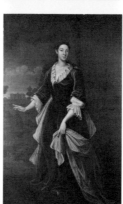

immediately afterward. It is recorded that in one case the frame of the king's damaged portrait was used for Charles Willson Peale's heroic portrait of Washington at Princeton University.[4]

It is not entirely clear whose portraits were hung in governmental buildings. William Shirley replaced Jonathan Belcher as governor of Massachusetts in 1741, and Smibert's notebook records a fifty-by-forty-inch portrait in 1742, although it is not definitely known that it was intended to be placed in the statehouse. Records of Faneuil Hall, which served as an official meeting place after 1742, reveal that official portraits were exhibited there. In 1765 Boston citizens voted for portraits of General Conway and Colonel Barré, and Governor Shirley was given a conspicuous place.[5]

Massachusetts' ''Town House,'' now known as the Old State House, erected in 1713, had state portraits prominently displayed in its governmental chambers. In 1739 the building contained at least five royal portraits, and arrangements were being made to obtain full-length portraits of King William and Queen Mary. By 1763 records mention portraits of George II and George III, full-length portraits of Charles II and James II, and a portrait of himself that Governor Prownall had presented. These lists probably do not include the set of portraits given by Governor Shirley in 1746 and destroyed in a fire in 1748.[6] An inventory of the Council Chamber of the Governor's Mansion in New York at the time of a fire in 1773 indicated that a number of portraits hung there. Likenesses of King William III and Queen Anne, George I, George II and Queen Caroline, and George III and Queen Charlotte were featured in the Council Chamber; and in the dining room were portraits of Mary, Queen of Scots, the Marquess of Granby, and a Mr. Reid.[7] In Pennsylvania, Thomas Penn, governor and proprietor of that colony, ordered as gifts for the statehouse life-size portraits of all British monarchs since Queen Anne; because of the Revolution, however, they were not delivered.[8] The stately ballroom in the Governor's Palace in Williamsburg,

Virginia, was furnished in magnificent style by the governor in 1768 and was hung with full-length state portraits of George III and Queen Charlotte. Over the judge's seat, opposite the entrance to the main hall of the second statehouse in Annapolis, Maryland, hung a full-length portrait of Queen Anne presenting the city with its charter.[9] At the time of the Revolution, Governor Robert Eden of Maryland had in his mansion a "large elegant" portrait of himself and one of Charles I, as well as a portrait of Lord Baltimore. Presumably it was either the full-length portrait of Frederick Calvert, Sixth Lord Baltimore, said to have been presented by the subject to the colony in 1766, or else the magnificent state portrait of *Charles Calvert, Fifth Lord Baltimore* (fig. 7), that the Maryland proprietor brought with him in 1732 when he visited the colony to assert his authority.[10] The painting portrays Calvert in the full panoply of the provincial ruler. It hung with a portrait of Queen Anne in the ballroom of the armory where council meetings were held. Charles Willson Peale later said that it was this painting that inspired him to be an artist.[11] (He used its pose in his portrait of William Stone in 1774 and later acquired the Calvert portrait for himself.) Peale in 1774 donated a copy of his portrait of *William Pitt* (cat. no. 18) to help adorn the new Maryland statehouse then under construction. Records of uses of state portraiture are sketchy, but these instances suggest that there was a considerable quantity of these paintings, and that they must have had a significant effect in reinforcing the taste for formal private and official portraits.

In addition to the placing of governors' portraits in the seats of government, there were several other established uses of official portraiture in the colonies. Though not necessarily full-length, these portraits generally were carried out in this format when their subjects were particularly important. They were commissioned by governing bodies, organizations, or by public subscription, either as a token of gratitude to the subject, or as a kind of *exemplum virtutis* to hold up to the community. The latter was a tradition with roots in antiquity. The first portrait known to have

been commissioned by a community to honor heroes was a bronze sculpture by Antenor of the tyrannicides Harmodius and Aristigon, erected in the marketplace of Athens about 530 B.C. It is well to bear in mind that before the Revolution New York had life-size public sculptures of George III and William Pitt, Charleston had another William Pitt, and Williamsburg a marble Lord Botetourt.

One of the earliest recorded public portrait commissions honored Peter Faneuil, a benefactor of Boston. Faneuil had contributed the funds necessary for the erection of a public market there, with a second story to be used for public meetings. At the first meeting held in the new structure, on September 13, 1742, it was resolved to name the building in honor of its donor, and to commission a full-length portrait of him, to be hung in the meeting hall. Smibert, who also had served as architect of the hall, painted the portrait during the following March.[12]

Colleges also owned portraits of some of their benefactors. It is likely that the anonymous portrayal of *William Stoughton* (fig. 8) was originally owned by Harvard College before its gift was recorded in 1810. Governor Belcher, instrumental in the founding of the College of New Jersey (now Princeton University), gave the college his full-length portrait by Smibert in 1755. The most notable of these benefactor portraits are the full-length likenesses by Copley at Harvard, his *Thomas Hancock* of 1764–66, his *Thomas Hollis* of 1766, and his *Nicholas Boylston* of 1773; the *Hollis* replaced a portrait by Joseph Highmore that had been destroyed by fire in 1764.

One of the most important public portrait commissions was arranged by a group of citizens in Virginia who called themselves the Gentlemen of Westmoreland County. In 1768 they took up a collection to commission Benjamin West to paint a portrait of Charles Pratt, Lord Camden, who had been influential in the House of Lords' repeal of the Stamp Act. Possibly because he realized the potential political significance of the commission, Camden was reluctant

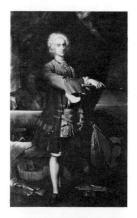

7

Attributed to
Herman van der Mijn

*Charles Calvert,
Fifth Lord Baltimore*
c. 1730

96 x 50 in.

The Peale Museum,
Baltimore

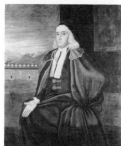

8

Anonymous artist

*Portrait of
William Stoughton*
c. 1700

50¼ x 42 in.

Courtesy of Harvard
University Portrait Collection, Given by Joan
Cooper to Harvard
College in 1810

to sit for the portrait. This led Edmund Jenings, representing the gentlemen in London, to commission Charles Willson Peale to paint a heroic portrait of William Pitt, the man chiefly responsible for the repeal of the Stamp Act by the House of Commons. The extraordinary portrait that resulted (cat. no. 18) fulfilled its political objectives through the use of a range of republican symbols.

Portraits had also been commissioned by citizens to honor the heroes of the campaign against Louisbourg, on Cape Breton Island in Nova Scotia, which resulted in the capture of the fortress and the province from the French in 1745, the most important military action taken to that date by colonial forces in concert with the British. In July, August, and September 1746, soon after the victors' return, Smibert painted full-length portraits of three of the expedition's principal figures, Sir William Pepperrell, *Sir Peter Warren* (cat. no. 5), and Governor William Shirley, as well as a three-quarter-length portrait of Sir Richard Spry. Shortly afterward, Feke painted a full-length portrait of General Samuel Waldo. The portrait of Governor Shirley was reproduced as a three-quarter-length mezzotint by Peter Pelham in 1747. The inscription indicates that Smibert's portrait had been painted "at the request of several Merchants and Gentlemen in Boston, as a *Memorial* of the Grateful Acknowledgements to his Excellency for his Signal Services...." Since the three related full-length portraits of the military leaders were painted soon after one another, it might be reasonable to assume that they were commissioned for some festival or commemorative purpose. The accounts of Sir Peter Warren, however, indicate that he paid Smibert sums corresponding to the cost of two of the portraits.[13] The pair were apparently private commissions intended as a gift to Pepperrell. Nevertheless, a mezzotint of Pepperrell's portrait was produced for sale to an admiring public.

It is clear that by the outbreak of the Revolution certain standard subjects of official portraiture had been established. State portraits were most regularly painted of heads of government, public benefactors, political leaders, and military heroes. Such portraits were commissioned by private citizens even when a particular government itself could not pay for them and even when there was no suitable public location for the completed portraits, so important was their symbolic function. With the establishment of independent governing bodies during the Revolution and with the construction of large government buildings during the Federal period, physical settings were provided for the development of these traditions. Governments of cities such as New York and Charleston, South Carolina, challenged artists with ambitious commissions; the chambers and hallways of new civic structures soon became galleries of magnificent state portraits. Through the third quarter of the nineteenth century, the most important, most impressive, and most innovative portraits in this country tended to be the result of public commissions. Private portraits of the period could be nearly as grand, however, and by the end of the nineteenth century it was again private houses that contained the most impressive new portraits.

∎

Documents reveal the presence of portraitists in Boston and New York in the late seventeenth century. The earliest date on a surviving portrait is 1664, more than a generation after the founding of the first permanent colonies. The early New England portraits look back to the late Jacobean styles surviving in the rural English communities from which the colonists came. In spite of their relative simplicity, they are nevertheless governed by the formal conventions that had shaped what has been called the "Elizabethan icon," the flat, anti-illusionistic image of power and prestige.[14] The forms of these portraits are close to the surface of the painting, their costumes arranged decoratively.

Despite the rudimentary nature of these early efforts, many contain some of the devices of formal portraiture. Curtains fill upper corners in the pair of Freake family portraits (1674) in Worcester, Massachusetts; a distant landscape and a vase of flowers adorn the portrait of *Elizabeth Paddy Wensley* (c. 1670–80) in Plymouth, Massachusetts;

the self-portrait of *Thomas Smith* (c. 1690) in Worcester contains as much external apparatus as it does portrait, its corners crowded with a curtain, skull, and vanitas poem, as well as a view of a harbor where a naval battle rages; and the anonymous painting of *William Stoughton* (fig. 8) at Harvard shows him seated before a distant view of Stoughton Hall, his gift to the college, as *Matthew Vassar* (cat. no. 50) was to be portrayed by Charles Loring Elliott more than 150 years later. Even in the seventeenth century, American sitters wanted portraits that presented them at their most impressive, situating them in the suggestion of a grand setting or showing them adorned with attributes of power. This the early colonial artists attempted to do, within the limits of their skills.

By the turn of the century, the colonies had become stable and prosperous enough to be able to attract the better-trained artists who could create the impressive portrait images that were required. A new chapter in American portraiture opens with the portrayal of *Eleanor Darnall* (fig. 9), painted about 1710 by Justus Engelhardt Kuhn, newly arrived in Maryland from Germany. The young girl, dressed in lace, is placed in a grand setting that clearly could not have existed in the American colonies. The balustrade, urn, and mask suggest the terrace of a great European palace, opening onto a vista of extensive formal gardens and a distant castle.

While Kuhn may have drawn this fanciful background from his memory of grand portraits or great estates in Europe, similarly elaborate settings were sometimes used by even the most primitive New York State limners, at least some of whom may be presumed to have been native-born and self-taught. This kind of ambitious presentation seems to have been of interest to painter and patron alike at all levels of sophistication.

The process by which grand portrait conceptions were transmitted to colonial artists was discovered by Waldron Phoenix Belknap, Jr., and discussed, with many illustrations,

9

Justus Engelhardt
Kuhn
?–1717

*Eleanor Darnall
(Mrs. Daniel Carroll)*
c. 1710

53¾ × 44 in.

Maryland Historical
Society, Baltimore,
Bequest of Miss Ellen
C. Daingerfield

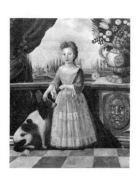

10

Mezzotint of
*Katherine Queen Dowager*
altered, c. 1705
from an original pub-
lished by Alexander
Browne, c. 1690–95,
after a painting by
Sir Peter Lely

13¼ × 9⅞ in.

Henry E. Huntington
Library and Art Gallery,
San Marino, California

11

James McArdell
1728–1765

Mezzotint of
*Lady Caroline Russell*
c. 1759
after a painting by
Sir Joshua Reynolds

14³⁄₁₆ × 9¹⁵⁄₁₆ in.

Print Collection, Art,
Prints and Photo-
graphs Division, The
New York Public Li-
brary, Astor, Lenox,
and Tilden
Foundations

in his *American Colonial Painting.*[15]
In seventeenth- and eighteenth-century
Europe and America a considerable
number of prints were published after
portraits of distinguished figures. The
same process occurred within the colonies,
as is attested by Peter Pelham's numerous
prints, notably his mezzotints of Smibert's
portraits of the heroes of the siege of
Louisbourg. Mezzotints such as these were
taken from the most ambitious portraits
of the period and represented a catalogue
of the conventions of formal portraiture.
How certain poses were chosen as prototypes
for colonial portraits is not entirely clear.
It may have been that the patron owned
mezzotints and imagined his own portrait
in a similar mode, or that the artists may
have had a group of prints to submit to the
patron for his selection. The latter possibil-
ity would seem more likely, since poses
and backgrounds often repeat themselves
in the work of a given artist.

The occasional
use of mezzotint sources was a universal
practice among artists of the period, as is
demonstrated in the genealogy of a
portrait conception that was transmitted
from Lely to Reynolds to Copley (figs. 10
and 11, and cat. no. 12).[16] Of course,
Copley may have had to rely more fre-
quently on such a source of inspiration,
lacking Reynolds' access to collections of
portraits in England. Nevertheless, even in
Reynolds' case, the prints must also have
served to recommend a specific treatment
to the sitter, since there are few art forms
more governed by conventions than
portraiture, and sitters are normally very
careful about the way they are presented
to the world.

The mezzotints furnished co-
lonial artists with three principal guides.
Recently published prints could supply in-
formation about new fashions and about
more elaborate court dress than might be
found easily in the colonies. The poses of
the figures certainly provided a second
source of guidance. Robert Feke, for instance,
generally used print sources for just his
poses. Finally, the prints could supply op-
tions for backgrounds, often of an elabo-
rate nature.

Examples of the selective use of
elements from a print source are contained
in the family of portraits related to the

mezzotint by Smith after Kneller's portrait
of *Lord Clifford and Lady Jane Boyle* (fig.
12).[17] In the Duyckinck portrait of a boy
of the De Peyster family (fig. 13), the artist
has taken over the costume of Lord Clif-
ford, his pose, the curtain, and the com-
plete background (assuming that this
painting was originally taller). Lady Jane
has been replaced by a dog, and the dog in
the print has been eliminated. A much
less complete use of the information in the
print is found in the anonymous portrait
of *Abraham Van Cortlandt* (fig. 14), in
which the curtain, wall, garden, and pose
are all that remain of the print. In the
portrait of Van Cortlandt's brother, Pierre
(cat. no. 2), the dog and the general com-
position are all that remain, the rest being
freely interpreted.

Thus, it is hard to define
precisely the nature of grand manner
portraiture in the colonies, since the great
tradition was adopted both in its entirety
and in its components; but it is clear
that the influence and flavor of formal
portraiture pervaded colonial painting,
from the Hudson Valley limners to John
Singleton Copley, from the least to the
most skillful and sophisticated. Just as im-
portant is the conclusion that painters and
patrons felt no hesitation about having
themselves painted in the costume, pose,
and setting of royalty. They saw no
difference, no separation between the
tradition of the court painter and the work
of the semitrained itinerant in the
countryside.

Although tendencies toward
portraiture in the grand manner had been
manifest in most early works, the first
truly monumental portraits were produced
about 1720 in the Hudson Valley. Size
and immediacy characterize these first
efforts, such as the portraits of *Ariantje
Coeymans* (fig. 4) and *Pieter Schuyler*
(cat. no. 1). Both figures are unusually
large in relation to their schematic setting
and to the dimensions of the canvas.
Their costumes balloon out, with strongly
shaped contours that bring the figures to
the surface of the canvas. The absolute
frontality and centrality of the figure of
Ariantje Coeymans is startlingly direct,
lending the subject a powerful presence.

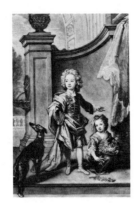

12

John Smith
1652?–1742

Mezzotint of
*Lord Clifford and Lady
Jane Boyle*
c. 1715–25
after a painting by
Sir Godfrey Kneller

16¾ x 10½ in.

Courtesy, The Henry
Francis du Pont
Winterthur Museum,
Winterthur, Delaware

13

Attributed to
Gerardus Duyckinck
1695–1746

*De Peyster Boy with
a Dog*
c. 1730–34

50¼ x 41 in.

Courtesy of the
New-York Historical
Society,
New York City

14

Anonymous artist

*Abraham Van Cortlandt*
1725–30

68½ x 42¾ in.

Sleepy Hollow
Restorations,
Tarrytown, New York

Pieter Schuyler, although his body is turned slightly, is also placed centrally on the canvas, dominating the design. The stern gaze and directing finger are sufficient to suggest the forceful personality and leadership of the New York colony's governor. As an icon of authority, this early effort has not been surpassed.

Formal portraiture in the colonies was carried to its next stage of development through the academic tradition, which was initiated with the arrival of John Smibert in Boston in 1729. Having traveled in Italy and having established a successful portrait practice in London, Smibert brought to the colonies a level of skill and an awareness of styles unapproached there before. At some point during the winter of 1729–30 Mather Byles saw Smibert's recent work and hailed the dawn of true art in the New World. Smibert took Boston by storm and dominated portraiture there for fifteen years.

The degree of sophistication with which Smibert dazzled Mather Byles is seen in the portrait of *Major General Paul Mascarene* (cat. no. 3), which combines an impressively modeled figure with a still life and a presumably topographical landscape suffused with natural light. Its use of ceremonial armor for a military portrait was new to New England portraiture, not to mention the ability to represent the shapes and reflections of the armor. With such works, the means of expressing personal, professional, or official standing in a portrait were significantly expanded.

While noting this fresh influence, it is important to point out that, although Smibert had competed successfully as a portraitist in London, the general level of English portraiture in the late 1720s was unusually poor. Standards that had declined during the dominance of Sir Godfrey Kneller's studio-factory slipped even further during the leaderless period that followed Kneller's death in 1723. More significantly for the development of American portraiture, Smibert had mastered and brought here the tired traditions of formal portraiture that originated in the Restoration period with Sir Peter Lely. Smibert's manner followed in a straight line from the formality and cold reserve of the Restoration.

Smibert's deep roots in the Lely and Van Dyck traditions are seen in his portrait of *Mrs. Nathaniel Cunningham* (cat. no. 4). She is posed seated in a park, a standard convention for portraits of English ladies during the seventeenth century. Like Lely's series of Windsor Beauties, Mrs. Cunningham is seen against outcropping rocks, their ruggedness meant to set off her delicate beauty. In the landscape beyond are suggestions of shadowy glades, where a wood nymph or goddess might dwell. Yet her low dress clearly belongs to the period, unlike the sometimes revealing classical draperies of Lely. Such was the ideal of feminine grace that Smibert portrayed, as indeed did many other portraitists who borrowed from the conventions of the mezzotints. Smibert portrayed men with a reserve amounting almost to sternness. They usually are seen seated or standing in a simple darkened interior; the back wall of the room, parallel to the picture plane, forms a shallow space that is punctured by a window with a distant view of the ocean. The forms of his figures are compact, their gestures undemonstrative, their faces mask-like, decorous, and nearly expressionless. Smibert's characteristic reserve extends even to his heroic portraits of the victors of Louisbourg (cat. no. 5) who stand solidly before a backdrop, their gestures relaxed, their faces unmoved.

Possibly due to Smibert's ill health, a fourth full-length portrait from the series of the heroes of Louisbourg was painted by an American artist of the second generation, Robert Feke. How utterly different from Smibert's generals is Feke's portrait of *Brigadier General Samuel Waldo* (fig. 15), a painting that presages the new style that arose in the second half of the century. It is characterized in all of its aspects by a much greater precision. The features are much more individual and finely drawn, and the expression is alert although still decorously placid. Most importantly, the contours and interior shapes of the figure's costume are organized into a series of strong lines that sweep up toward the

head. The open silhouette of the figure and its narrow base lend it a feeling of lightness and movement. This quality, and the way in which the figure is clearly at home in the ample landscape, are the rococo elements of its style. One could assert that Feke's source for this boldly three-dimensional figure is French, rather than English (fig. 16), reflecting the dynamism and movement that during these years was slowly beginning to leaven the heavier English manner.

This same feeling of concentration of forces around the head is felt in Feke's three-quarter-length portrait of *Judge Richard Saltonstall* of about 1748 (cat. no. 6). The thrust of foreshortening and the scale of the figure in relation to the landscape contribute to the portrait's commanding presence. Added to this is the luster of material, the rich velvets, sparkling gold embroidery, and crisp linen that characterize the subject as a man of style and taste.

Feke's influence on colonial painters was considerable and can be readily discerned in Joseph Badger's monumental portrait of *Captain John Larrabee* (cat. no. 9), which must have been inspired by Feke's *Samuel Waldo*. Although Badger is less well trained, his organization less clear, and his line less elegant than Feke's, his style in this work clearly puts him in the second half of the century. The assertive stance, lively silhouette, placement in a landscape, and increased forcefulness relate it to Feke's *Waldo* rather than Smibert's *Warren*. One senses a quite strong and specific personality here, as well as a departure from the masklike Augustan reserve of the early part of the century.

Feke is referred to in documents as a "mariner," so it is possible that the American-born artist visited London on one or more of his voyages and thus came into contact with contemporary English portraiture. Perhaps he was alert enough to absorb trends in style from French and English prints. In any case, his manner moves in the direction of English painting of the 1740s and 1750s—which increasingly came under stylistic influence from France—toward greater movement,

15
Robert Feke
1707–1752

*Brigadier General Samuel Waldo*
c. 1748

96¾ x 60¼ in.

Bowdoin College Museum of Art, Brunswick, Maine

16

Nicholas Jean Baptiste de Poilly
1712–?

Engraving of
*Prince Charles Edward Stewart*
1746
after a painting by Domenico Dupra

12 x 8¼ in.

Scottish National Portrait Gallery, Edinburgh

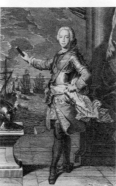

revelation of the subject's personality, and informality.

When considering state portraiture of the Rococo period in England and America, one should be aware of how highly people of that time prized the alert inner life, taste, and delicacy—a blend of qualities the French termed *esprit*. For any gentleman or lady, cultivation and flair in the worlds of society and fashion were highly desirable qualities. Considerable effort was expended in acquiring skills of connoisseurship and conversation. Libraries in newly built English country houses grew steadily, and by the end of the century were the main gathering places for families and their guests. In Rococo portraits the private world of intellect and social grace that the Augustans—the classical English poets of the eighteenth century—had concealed behind a mask of propriety and reserve was now given full expression. The English also developed during this period a taste for explicitly informal portraits, for "conversation pieces," typically showing a family relaxing together in their park, and for portraits of turbaned (wigless), informally dressed gentlemen relaxing in their studies.

With the obvious symbols of rank and power now absent from portraits, the artist sought to heighten his portrayal through suggestions of intellectual alertness and stylishness, achieved through movement and lightness within the forms and ambience. The spare settings, simple forms, and immobility of Augustan portraits gave way to a greater dynamism. Spatial complexity, elaboration, and even ambiguity increased. Poses became freer and less stable. The contours of the figures were more open and broken into short, irregular movements, the interior volumes set in motion by patterns of flickering highlights. The personality of the sitter glimmered through a smile or an arch look. Thus, while many of the obvious symbols and conventions of formality fell into abeyance, the elements of the painter's style were more completely marshaled to convey an image of style and spirit. While portraitists in the colonies adopted many

of these techniques for heightening a less obviously formal image, it should be noted that they and their patrons did not favor the explicitly informal formats of the English painters. With some notable exceptions, conversation pieces were rare before the Revolution. Similarly, the portrait of the gentleman in his study, seen with a musical instrument or hobby, or working at his profession, while sometimes painted by Copley, was nearly as rare. Americans must have prized too highly their recently won social position to want to cultivate the English nonchalance.

These current tendencies were imported to the colonies in their fullest form chiefly by Joseph Blackburn, who worked in America between 1753 and 1763. John Wollaston brought a similar, though simpler, style to the Middle Atlantic colonies in 1749. It was a style shared, to some extent, by Jeremiah Theus in South Carolina and John Hesselius in Maryland. Blackburn's fully developed style is seen in his portrait of the family of *Isaac Winslow* (fig. 17), asymmetrical and informal enough to be called a conversation piece. Every surface seems to shimmer and undulate in a flickering Rococo lightness, in accord with its pastel color. Significantly, the subjects smile and move. Grace and spirit are now highly desirable qualities in a portrait, marks of sophistication. This softening of formal reserve is even seen in Blackburn's rare full-length portraits of *Benning Wentworth* (cat. no. 8) and his father, *John Wentworth*, painted to be hung as state portraits in the room of the Wentworth home in Portsmouth, New Hampshire, known as the council chamber during Benning Wentworth's term as colonial governor. Even though the governor is posed before a column and curtain, he assumes a casual attitude; his clothes are relaxed into rumples, their lines in agitated movement unlike the crisp lines of *Judge Richard Saltonstall*, for example, although the portrait in other ways foreshadowed this change of taste. The colors are again pleasantly soft, and the great man seems to be at his ease. The fullest realization of Blackburn's style comes in his portraits of women, such as that of *Mrs. James Pitts* (cat. no. 7). A vision of lightness and shimmering silks, every surface alive with

17

Joseph Blackburn
active 1752–1774

*Isaac Winslow
and His Family*
1755

54½ x 79½ in.

Courtesy,
Museum of Fine Arts,
Boston, Abraham
Shuman Fund

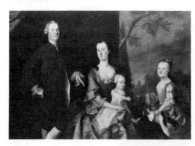

18

John Singleton Copley
1738–1815

*Portrait of
Theodore Atkinson, Jr.*
1757–58

50 x 40 in.

Museum of Art,
Rhode Island School
of Design, Providence,
Jesse H. Metcalf Fund

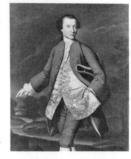

19

John Singleton Copley
1738–1815

*Portrait of
Sarah Prince Gill*
1764

49¾ x 39½ in.

Museum of Art,
Rhode Island School
of Design, Providence,
Jesse H. Metcalf Fund

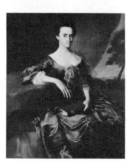

highlights, the figure itself is in motion, as her trailing scarf would seem to indicate. It is instructive to compare this portrait with the print after Kneller from which the pose is taken (see opposite cat. no. 7). Although the notorious prostitute Sally Salisbury is shown in what is for Kneller an unusually active pose, her costume is considerably heavier, her gestures less elegant, and her face less expressive than that of Mrs. Pitts.

A similar approach to indicating personal importance is also felt in the portrait of *Charles Calvert* (cat. no. 10) by the leading Middle Atlantic painter, John Hesselius, of 1761. The tiny general strikes a convincingly dynamic pose and achieves a persuasive scale in relation to his kneeling slave. Its forms broken, its accents crisp, this portrait is an exceptionally active one for the usually quiet style of Hesselius. Its asymmetrical composition, sense of movement, and pastel coloring bespeak the more informal and dynamic world of the Rococo ideal.

The 1750s and 1760s saw the community of colonial artists grow considerably in answer to an expanding demand for portraits in an increasingly prosperous land. Better-trained English artists, such as John Wollaston, flourished in New York and the Middle Atlantic colonies. They painted three-quarter-length portraits of leading citizens posed in imaginary parks and gardens in a crisply accented style of relaxed stateliness. At the same time, a school of provincial painting transmitted this lighter taste into images of immense charm and decorative grace (cat. no. 11). Even these potentially static portraits are sparked by precise accents in their lines and details.

As a developing painter in the 1750s, John Singleton Copley was naturally affected more by the fresh style of Blackburn than by that of any other artist. Considering the artistic context of the colonies, Copley's *Theodore Atkinson, Jr.* of 1757–58 (fig. 18) is an exceptionally dynamic portrait. It combines the figure in motion and a low horizon—both features of Blackburn's style—with the stronger light and shadow that were to characterize nearly all of Copley's American portraits. The effect, derived particularly from the work's low viewpoint, is one

of great monumentality. The late 1750s and early 1760s saw the appearance of other, relatively simple portraits that depended upon purely formal devices to attain their considerable monumentality. The portraits of *Epes Sargent, Thaddeus Burr,* and *Mrs. John Amory* use the device of the leaning, standing figure, frequently employed by the English portraitist Thomas Hudson, to build a pyramidal composition with a very broad base. These and the portrait of *Sarah Jackson* utilize a very low point of view to make their figures additionally imposing. The movement and lightness of the portrait of Theodore Atkinson were not qualities close to Copley's personal vision and did not endure through the course of his development. Rather, his primary direction was toward monumentality, achieved first through elaborate presentation, and later through its very opposite, a severe simplicity.

Copley drew upon many print sources to bring to his portraiture of the 1760s a degree of variety new to the colonies. His subjects assume many different poses and bear unexpected accessories, such as parasols, garlands of flowers, and even a carriage whip. The strikingly beautiful portrait of *Mrs. Daniel Sargent* (cat. no. 12) owes no small part of its success to the novelty of the wall fountain with its sparkling play of fresh water as an image of purity and beauty. Working in as traditional a form as portraiture, Copley naturally sometimes was asked to employ older modes. Such a request must have prescribed the form of the *Portrait of Sarah Prince Gill* (fig. 19). Like Smibert's portrait of Mrs. Cunningham (cat. no. 4), it employs the by then outmoded convention of a woman seated in a park. Copley's range in reviving, adopting, or contriving devices to lend distinction to a portrait was highly exceptional among American colonial artists.

A strong inclination in Copley's portraits of the early 1760s was toward increasingly pretentious settings. His subjects move out onto palatial terraces, where columns, frequently of a colossal order, lend majesty. This tendency climaxes in Copley's first full-length portrait, that of *Nathaniel Sparhawk,* of 1764 (fig. 20).[18]

The device of the leaning figure is here made to appear boldly three-dimensional. Distinguished by its full integration into the palatial architecture, it no longer stands before a backdrop, as in earlier portraits employing grand settings. The thrust of the foreshortened balustrade and the bulk of the column behind him lend Sparhawk a forceful monumentality, new both to colonial painting and to Copley's art. Another new quality in this portrait, the elaborateness of the architecture, was seen again in the full-length portrait of *Thomas Hancock* of 1765. No doubt derived from architectural engravings, these backgrounds reflect aspirations to classical correctness that characterized the leading English portraitists of the day.

Copley's portraits during the latter part of the 1760s can become even richer, while his handling of materials becomes ever more skilled. The portraits of Mr. and Mrs. Jeremiah Lee (cat. nos. 14 and 15) are impressive primarily through their use of color and sumptuous fabrics. These elaborate portraits of 1769 represent the culmination of Copley's efforts to fashion images of wealth and position during the 1760s. He turned away from this approach while in America during a part of the next decade. In most of his portraits of the early 1770s monumentality is achieved through a simplicity that verges on starkness, and through the force of the sitter's personality. The heavy chiaroscuro that lends these figures immediacy and solemn majesty simultaneously renders forms simpler and more static, steals the brilliance of color, and obscures the setting. A cheerless and unflinching realism, far from the Rococo frivolity of Blackburn, characterizes these portraits. Their monumentality depends upon the rejection of all the allurements of his predecessor's animated style. Copley's is a world of stasis rather than of movement. His final American style can also be exceptionally dramatic, however, as in the portrait of *Samuel Adams* (fig. 21), the champion of liberty, thundering his defiance to Governor Hutchinson.

It is instructive to compare Copley's American work with fashionable English portraiture

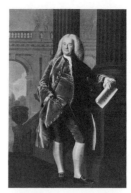

20

John Singleton Copley
1738–1815

*Nathaniel Sparhawk*
1764

90 x 57½ in.

Courtesy,
Museum of Fine Arts,
Boston, on deposit
from the
Rindge Family

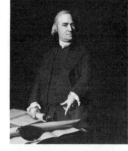

21

John Singleton Copley
1738–1815

*Samuel Adams*
1770–72

50 x 40¼ in.

Courtesy,
Museum of Fine Arts,
Boston, deposited by
the City of Boston

22

John Singleton Copley
1738–1815

*Hugh Montgomerie,
12th Earl of Eglinton*
1780

94½ x 59¾ in.

Los Angeles County
Museum of Art,
Gift of Andrew Norman
Foundation and
Museum Acquisitions
Fund

of the period, as exemplified by Reynolds. Copley's reliance on convention is especially clear in his disregard for dramatic movement, the most important innovation of his generation. Copley's poses are almost uniformly static, and his subjects nearly always wear contemporary clothing and appear as themselves rather than in the classical costumes and allegorical guises characteristic of the most fashionable English portraiture. In other words, he—or his clients—adhered to a middle course of somewhat heightened formal portraiture, neither venturing the grandest nor yet cultivating the most intimate. Once in England, however, Copley embraced the spirit of the most ambitious grand manner with the spectacular results seen in his portrait of *Hugh Montgomerie* (fig. 22).

Much closer to the trend of English portraiture was the remarkable portrait of *William Pitt* (cat. no. 18) painted by the youthful Charles Willson Peale while perfecting his skills in London. The allegorical presentation of Pitt in Roman costume, as a champion of liberty, was entirely appropriate to the purpose of the commission, which was intended to celebrate his defense of American freedom in Parliament. The portrait was commissioned by a group of private citizens but for a public, or political, purpose. It is therefore laden with the elaborate symbolism of its public message. It looks beyond the Revolution to the time when a new nation, with new heroes, would use formal portraiture differently, departing from the primarily private patronage of the colonial period.

MICHAEL QUICK
*Curator of American Art*
*Los Angeles County Museum of Art*

## Footnotes

1.

See Marianna Duncan Jenkins, *The State Portrait, Its Origin and Evolution*, New York, 1947. See also Hubertus Froning, *Die Entstehung und Entwicklung des stehenden Ganzfigurenporträts in der Tafelmalerei des 16. Jahrhunderts: Eine formalgeschichtliche Untersuchung. Inaugural-dissertation zur Erlangung der Doctorwürde der Philosophischen Fakultät der Julius-Maximilians-Universität zu Würzburg*, Krefeld, 1971; Würzburg, 1973.

2.

It would appear from his journal that Smibert painted only eight full-length, life-size portraits while he was the leading portraitist in New England during the period from 1729 to 1746. Feke and Badger each painted but one. Blackburn painted two. Even Copley painted only six while in America. The form was even rarer outside of New England during the colonial period, with the notable exception of the Hudson Valley.

3.

The letter from John Boydell of Boston to the Honourable John Yeamans, dated March 1, 1730, is quoted by Henry Wilder Foote in *John Smibert, Painter*, Cambridge, 1950, p. 201.

4.

See Donald Drew Egbert, *Princeton Portraits*, Princeton, 1947, p. 322.

5.

Abram English Brown, *Faneuil Hall and Faneuil Hall Market*, Boston, 1900.

6.

Thomas Wendell Parker, director of the Bostonian Society, has most graciously shared with me the fruits of his research on portraits that hung in the Old State House.

7.

Richard J. Koke, Curator of Collections, New-York Historical Society, kindly extracted the list of portraits from the inventory in the society's collection.

8.

Information on these portraits intended for Independence Hall was kindly furnished by Charles G. Dornan, Museum Curator, Independence National Historical Park. He provided a copy of his unpublished manuscript, "Furnishing Plan for the Second Floor of Independence Hall (Parts D–F)," Sept. 1971.

9.

Elihu S. Riley, *"The Ancient City": A History of Annapolis, in Maryland, 1649–1887*, Annapolis, 1887, p. 80.

10.

I am grateful to Robert H. McGowan, Curator of Artistic Property, Maryland Commission on Artistic Property, for kindly supplying a copy of the inventory of Governor Eden's possessions prepared in 1781 and now in the Maryland Hall of Records, Annapolis. Mr. McGowan has been most helpful in sharing his extensive knowledge of early portraits in Annapolis.

11.

See Wilbur Harvey Hunter, Jr., "The Portrait of Charles Calvert, Fifth Lord Baltimore (1699–1751)," *Peale Museum Historical Series*, no. 12, Feb. 1957.

12.

When Faneuil Hall was gutted by fire in 1761, Smibert's portrait of Peter Faneuil was badly damaged. It may have served as the basis for the portrait by Henry Sargent, commissioned by the selectmen in 1827, which hangs there now.

13.

The Warren account book is cited by Richard Saunders in *John Smibert (1688–1751): Anglo-American Portrait Painter*, Ph.D. diss., Yale University, 1979, p. 252, n. 49.

14.

See Roy Strong, *The English Icon: Elizabethan and Jacobean Portraiture*, London and New Haven, 1969.

15.

Waldron Phoenix Belknap, Jr., *American Colonial Painting: Materials for a History*, Cambridge, Mass., 1959.

16.

The discovery of the English mezzotint source for Copley's portrait of Mrs. Jerathmael Bowers was the first instance of this kind of influence published in the *Metropolitan Museum of Art Bulletin*, vol. 11, no. 3, Mar. 1916, p. 21. The earlier mezzotint source for Reynolds' portrait was later discovered by Belknap, *American Colonial Painting*, p. 42.

17.

First identified by Belknap, *American Colonial Painting*, p. 43.

18.

Sparhawk's marriage to Elizabeth Pepperrell, daughter of Sir William Pepperrell, brought to his house Smibert's full-length portraits of Sir William Pepperrell and Sir Peter Warren (cat. no. 5). Their presence no doubt inspired Sparhawk to commission his own full-length portrait from Copley. His son, William Pepperrell Sparhawk, later Sir William Pepperrell, grew up with the three grand portraits and in turn commissioned one of Copley's most ambitious portraits (cat. no. 16).

Of all the epochs in American history, the Federal period is one of the most difficult to define in terms of its ethos and hence its span of time. To say that the Federal period began as early as the promulgation of the Declaration of Independence—technically marking the end of the colonial period—is unwarranted in view of the ensuing years that were consumed by the events of the American Revolution. Nor can the Federal period be said to have begun with the cessation of military hostilities in 1781 or the conclusion of the Treaty of Paris in 1783. Except for the portraits by Charles Willson Peale, very little painting of any real quality was done in this country between the departure of Copley in 1774 and the return of Stuart in 1792/93. It would seem best, therefore, to regard the year in which the Constitution was ratified, the Congress of the United States was established, and our first president was elected—1789—as the beginning of the Federal period in this country.

The neoclassicism that had come to dominate the art and life of England during the final quarter of the eighteenth century was to find even more fertile ground in the new American nation. It was an impulse, as much philosophical as archaeological, born out of a desire to rekindle the noblest aspirations of the Roman Republic and to replace much of the value structure that had animated the Rococo world. But this impulse was short-lived, and it soon came to be expressed more in artistic style than in political substance. The center of neoclassicism shifted from England to France, where the trappings and ideals of the French Revolution were supplanted by those of the Napoleonic era. Not only was the line between style and fashion breached, but the distinction between Republican and Imperial Rome became blurred. This change was to find its parallel in America as the Federal period drew to a close, about 1815. After the War of 1812 had ended, the United States felt itself free of any further threats of foreign domination and could begin to focus its attention on the many challenges—not the least of which was its

own course of empire—confronting a now firmly established new nation.

Charles Willson Peale, who had started out in life as a saddlemaker and woodcarver, had his first painting lessons from John Hesselius in the early 1760s and subsequently studied for two years at the end of that decade with Benjamin West in London. By the time Peale was commissioned by the Continental Congress to portray *Conrad Alexandre Gérard* (cat. no. 19) in 1779, he had been painting portraits for nearly fifteen years. Although this full-length likeness most assuredly qualifies as being in the "Grand Manner," as had a few of the artist's earlier endeavors (such as his portrait of *William Stone*, done in 1774), stylistically the *Gérard* belongs to the epoch of the colonial Rococo in American art, standing with perhaps even greater ease among its contemporary counterparts in European portraiture. Congress never paid Peale's bill for the work, possibly because in a time of economic stringency they thought it too high, although more probably because the distinguished subject's diplomatic tour in this country was cut short after fifteen months by an illness that necessitated his return to France just after the portrait had been completed.

Earlier in the same year that Peale painted the *Gérard,* he had executed his first full-length of *George Washington at Princeton* (fig. 1). Here is the supremely self-confident revolutionary commander-in-chief, leaning against one of his trusty cannons, with captured Hessian flags casually strewn at his feet, and a scene of battle vignetted to the rear—the subject's head and the flag of his cause surmounting all. Here is a grand manner uninfluenced either by its colonial Rococo predecessors or by the more recent European full-lengths Peale would have seen in London, although it was not, of course, in the federal neoclassical style that had yet to be born. Instead, in this portrait, it is almost as if the languor, if not quite the haughty superiority, of Van Dyck's military

heroes had been reconstituted in a thoroughly original American idiom.

The preeminent portraitist of federal America was, incontestably, Gilbert Stuart; it is through his eyes more than through any others that we see not only the faces of the nation's most illustrious inhabitants of the period but the veritable face of federal society itself.

Stuart, who was born in rural Rhode Island, received his initial lessons in painting as a teenager from Cosmo Alexander, a Scottish portraitist whom he had met in Newport and had accompanied to Edinburgh for a brief sojourn. The young American's first known portraits were painted in the early 1770s after his return to Newport. Although limited by the brevity of his formal instruction and the provincial ambience in which they were executed, Stuart's portraits are nevertheless more remarkably precocious than they generally are regarded and forecast their maker's brilliant future in the art of face painting. Setting off in 1775 for London, where after two years of floundering he reconciled himself to the tutelage of Benjamin West, Stuart soon perfected his abilities to such an extent that West pronounced him a better portraitist than himself.

The work which brought Stuart his first important notoriety was his full-length likeness of a Scotsman named William Grant, a painting known as *The Skater* (cat. no. 21), done in 1782. A manifesto of sorts, the portrait proclaimed that Stuart could indeed "get below the fifth button"—which he had been criticized for not being able to do—and could, to boot, show his subject doing something more than just standing there. Although *The Skater* has been praised for the accuracy with which Stuart captured the "balance between stability and movement" that characterizes the sport depicted, the poise with which the subject had mastered the art of skating on ice may have been intended, as well, as a metaphor for that aplomb with which the artist had mastered the art of painting full-length portraits. The fact that Stuart estab-

1

Charles Willson Peale
1741–1827

*George Washington
at Princeton*
1779

93 x 58½ in.

Courtesy of
the Pennsylvania
Academy
of the Fine Arts,
Philadelphia

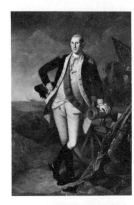

2

Gilbert Stuart
1755–1828

*George Washington*
("Athenaeum"
portrait)
1796

48 x 37 in.

Jointly owned by the
National Portrait Gallery, Smithsonian Institution, Washington,
D.C.; and the Museum
of Fine Arts, Boston

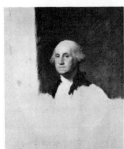

lished his credentials in the Grand Manner so early in his career impels one to consider the nature of his subsequent American clientele—rather than any inability of the artist—for his having practiced it so infrequently thereafter.

Stuart's success as a Neoclassical portraitist, equal in stature to the most renowned British practitioners of that fashionable mode of painting, was vitiated by his profligate life-style. Fleeing his creditors in London, he set up shop in Dublin. When his debts mounted in that city, he decided to return to his native land to pursue his art. He probably reasoned that there he would be the best, and hence the preeminent, portraitist in the new nation. In this expectation his career was to be fulfilled, for there were few competitors of either his quality or up-to-date style to whom clients could turn. Certainly none of his rivals could boast the unique credential he swiftly achieved as the painter of the "Athenaeum" portrait of *George Washington* in 1796, which immediately became recognized as the national icon.

Stuart's "Lansdowne" portrait of Washington (cat. no. 22), was commissioned by Mrs. William Bingham, one of the leading tastemakers of federal society (her husband was a United States senator from Pennsylvania), as a present for her friend the Marquis of Lansdowne. As the Earl of Shelburne, Lansdowne had been one of the few outspoken British supporters of American independence. It was vital, therefore, that the portrait make just the right statement about its subject, and the position he occupied, to the audience for which it was intended. Washington, the rebel general who had wrested American independence from Great Britain, was now the first president of the United States, and it was necessary that he be imbued with a dignity equal to that of George III himself.

Given these circumstances, it was entirely appropriate that the "Lansdowne" portrait should be full length and very much in the grand manner so that its message would be unmistakable. As the nineteenth-century American art historian Charles

Henry Hart pointed out, Stuart may have used as a prototype Pierre Drevet's 1723 engraving after Hyacinthe Rigaud's painting of Bishop Jacob Bossuet. Whatever the case, Washington himself surely never "stood" for the portrait, which has given rise to oft-repeated criticisms of the proportions of his figure in it. Yet, on the basis of contemporary accounts of his subject's appearance, Stuart may have been more accurate than he is given credit for. As one observer wrote, Washington's "head was not large in contrast to every other part of his body, which seemed large and bony at all points. His finger-joints and wrists were so large as to be genuine curiosities."

Stuart used the "Athenaeum" portrait (fig. 2), done from life on April 12, 1796, as the basis for Washington's likeness in the "Lansdowne" portrait. This stern visage perfectly reflects the subject's grim mood at the time, which resulted from criticisms of certain motives of a presidency he considered above politics. One skeptic, Thomas Paine, whose *Common Sense* Washington had admired, wondered in print "whether you have abandoned good principles, or whether you ever had any." The gravity of Washington's expression was, nonetheless, exactly right for a man whom the British were now meant to recognize as a statesman, just as they formerly had been compelled to accept him as a general.

The format of Stuart's *Dr. William Smith* (cat. no. 23), highly unusual for the artist, suggests a grand manner more sixteenth-century Renaissance than seventeenth-century Baroque or eighteenth-century Rococo in origin. The subject was posed in his Oxford Doctor of Divinity robe, with books symbolic of his political, historical, literary, and theological writings, a theodolite indicative of his scientific interests, and a landscape signifying his considerable landholdings. Smith was involved in many aspects of the affairs of Pennsylvania. Especially noteworthy were his services to the College of Philadelphia (later the University of Pennsylvania), of which he was provost, and his part in establishing the school later known as Washington College

(in Chestertown, Maryland). He also founded, in 1757, *The American Magazine and Monthly Chronicle*, which published the works of several young American literary figures. Though Smith opposed the Stamp Act and other British measures, he was against independence, arguing instead for a liberal reconciliation with Great Britain. Dr. Benjamin Rush, writing in his Commonplace Book at the time of Smith's death, observed: "This man's life and Character would fill a Volume." While acknowledging that "He possessed genius, taste, and learning," Rush added that "His person was slovenly, and his manners awkward and often offensive in company. . . . His time and talents were principally devoted to acquiring property . . . and for these he often made sacrifices, it is said, of conscience and reputation." According to Rush, Smith "became towards the close of his life an habitual drunkard. His temper was irritable in the highest degree." Smith, who "was extremely avaricious," Rush noted, "lived, after acquiring an estate of £50,000, in penury and filth." The ultimate obloquy, in Rush's estimation, was that Smith "had three sons and one daughter [but] not a drop of kindred blood attended his funeral."

Because it is all but impossible to read any of these complaints into the dignified image the painter has given us, it is entirely possible that Stuart did not know his subject as Dr. Rush knew him. It is also possible, however, that Stuart dismissed as irrelevant some of those faults Dr. Rush saw fit to record. The artist had one or two of them himself. Then, too, Stuart's father had been born in Scotland, as had Dr. Smith, which conceivably may have helped him to understand his subject better than Dr. Rush did. How like Stuart to have portrayed Dr. Smith, whose cantankerous behavior and antagonistic political opinions had alienated so many Philadelphians (including Benjamin Franklin), as a man who deserved to be remembered far more for his wide accomplishments than for his personal foibles—quite in the manner that not a few sixteenth-century Renaissance

men were preserved for history by the artists who painted them.

John Trumbull had wanted to be an artist from his earliest youth but had been opposed in that aspiration by his father, a man entirely occupied by business and politics, who was to become the governor of his native state of Connecticut. When Trumbull asked to study with Copley, his father, determined that no son of his would engage in what he regarded as a frivolous calling, sent him off instead to Harvard in the expectation that the boy would thereby be influenced to become, more properly, a clergyman or a lawyer. But when the young Trumbull met Copley and saw the painter wearing a suit of "fine maroon cloth with gilt buttons" in his grand house on Beacon Street opposite Boston Common, he realized that he would not completely abrogate the devotion he felt as a dutiful son if he were to pursue the arts. In addition, perhaps in part because Trumbull felt that he could best fulfill his filial obligations by pursuing a branch of art his father would recognize as the most respectable, he planned from the outset of his career to be a history painter. This objective was, of course, to be emphatically reinforced by the focus of so much of his master's, Benjamin West's, work, as well as by Copley's successful accomplishments in this same area, at the same time, in the same city, London, then the capital of world art.

Although Trumbull was destined to become the first native-born painter to record the great historical events associated with the founding of the American republic, no artist at that time, given the limited circumstances of public patronage for such a scheme, could hope to earn a livelihood solely through the painting of vast historical scenes. Trumbull, therefore, was obliged to lower his sights and content himself with portraiture for a significant portion of his life. Of course, in his earlier years, many of the portraits Trumbull took—some of them were just tiny sketches—served a necessary purpose as visual documents of the participants in the historical epics he intended to paint.

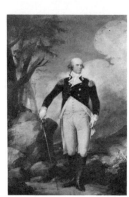

Trumbull's portrait of *George Clinton* (fig. 3)—though it ultimately did provide the subject's likeness for *The Declaration of Independence*—was commissioned by the mayor and Common Council of New York to hang in city hall. It is a splendid image of the New Yorker who was a delegate to the Second Continental Congress, a signer of the Declaration of Independence, a brigadier general in the Continental Army, a seven-term governor of his state (1777–95 and 1801–05), as well as Jefferson's second and Madison's first vice-president. Painted in 1791, the fifty-two-year-old Clinton is shown wearing his general's uniform, with a scene of battle representing one of his not very glorious military exploits in the distance at the lower-right of the canvas. The details of trees and clouds recollect a style of contemporary and earlier landscapes to which the artist had been exposed in British and Continental painting during his half-decade of study with Benjamin West in London, from 1784 to 1789.

The *Clinton* had been commissioned to hang opposite Trumbull's *George Washington*—the chief of the state of New York facing the chief of the federal state. In the telescoped time between then and now, we hardly question the fact that Washington is shown in military uniform. Yet in 1790, the year his portrait was executed, he was president of the United States and wore civilian dress. Admittedly, Trumbull, who had first seen and portrayed his subject as a general, almost certainly preferred to do so again—a preference that his clients probably shared with him. Military costume is, after all, more glamorous than civilian dress, especially in the case of a subject whose most noteworthy achievements to date had been on the battlefield. This being so, Clinton, as pendant, surely was more fittingly shown in his brigadier general's uniform than in any suit he wore as governor of New York.

Although Clinton's stern visage may have been calculated to suggest his bearing as a military man, the greater part of his career had been spent in political life, a career in which individuals have been known to pose for the proverbial statue in the park with an equal degree of seriousness. As far as Clinton is concerned, however, it is worth pointing out that he was the dour "Cato" whose letters in the *New York Journal* in 1797 vigorously opposed the federal Constitution. Therefore, to some degree, however small, there may have been yet another reason for Washington to be portrayed as revolutionary general, rather than as president of the United States.

The question of clothes aside, the absolutely riveting gaze with which Trumbull has imbued Clinton imparts real distinction to his likeness. Here is a man who, sword in hand or not, is thoroughly capable of command on the battlefields of both war and politics. Indeed, he seems quite ready to stand up in either arena to his commander-in-chief.

The numerous full-length likenesses by Ralph Earl, executed in Connecticut during the 1790s, are essentially a provincial expression of Federal period portraiture in the grand manner. Nothing certain is known about Earl's early artistic training, or with whom he may have studied, before he established himself as a professional painter in New Haven just prior to the Revolution. He departed for London in 1778 not for the reason one ordinarily assumes for an American artist of his time—to improve his ability—but because he had been expelled from Connecticut for spying for the British.

In England, Earl is said to have studied with West, but opinions differ as to when this might have been; and Earl's work shows little or nothing of West's tutelage. Indeed, West, who preferred to steer clear of politics, might not have offered his usual welcome to a prospective student who had petitioned the Lord Commissioners of the Treasury for loyalist compensation. In any event, Earl's English work displays certain influences of various British artists (especially Reynolds and Romney), but it was not profoundly transformed by any of them. Earl, who perhaps already regarded himself as a practicing professional, and who is known to have worked in Norfolk, may have preferred to paint in the provinces rather than face the

competition in London, although he did finally take up residence there and had portraits admitted to the Royal Academy exhibitions of 1783 and 1784.

Following Earl's return to this country in 1785, the evidences of his English experience receded almost in proportion to the years that separated him from it. Instead, his paintings responded to the ethos of the more provincial world to which he had returned, echoing in their own way Earl's profound lifelong admiration for Copley's American work.

If Ralph Earl's artistic achievement as a federal portraitist in the grand manner is not in the same class as that of Gilbert Stuart or John Trumbull, it nevertheless is not without considerable charm, as well as the power to evoke that unadorned directness in the American character that the more academic point of view tends to idealize out of existence. It is a quality Earl shares with some of our greatest folk portraitists. But Earl is not one of their number, for he is as emphatically normative as they are ineluctably eccentric.

Ralph Earl's seated full-length of *Roger Sherman* (fig. 4) is an early work, almost certainly done before the artist went to England. It usually is said to have been painted in 1777, although its actual date of execution is undocumented. It owes an obvious debt to Copley and is similar to Trumbull's first portraits, which Earl probably knew. Roger Sherman's views were as simple and uncomplicated—and his expression of them as open and direct—as his mien was unadorned and awkward. One wonders if other more academically accomplished portraitists would have captured so perfectly, within such a simple geometry of design, the mind and body of this quintessential Everyman of the American Revoltion.

Among Earl's finest later works is his seated double *Portrait of Chief Justice Oliver Ellsworth and His Wife, Abigail Wolcott* (fig. 5), painted in 1792. Oliver Ellsworth had been a member of the Connecticut delegation to the Con-

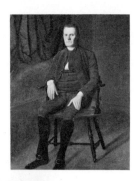

4
Ralph Earl
1751–1801

*Roger Sherman*
c. 1775–77

64⅝ x 49⅝ in.

Yale University Art Gallery, Gift of Roger Sherman White, B.A. 1859, M.A., LL.B. 1862

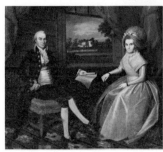

5
Ralph Earl
1751–1801

*Portrait of Chief Justice Oliver Ellsworth and His Wife, Abigail Wolcott*
1792

75⅞ x 86¾ in.

Wadsworth Athenaeum, Hartford, Connecticut, Gift of Ellsworth heirs, 1903

6
John Vanderlyn
1775–1852

*James Monroe*
1822

100 x 64 in.

Courtesy of the Art Commission of the City of New York

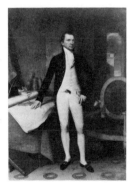

tinental Congress from 1777 to 1783 and subsequently was one of his state's representatives to the Constitutional Convention. He was an ardent supporter of the Constitution, a copy of which he holds in the picture. Ellsworth was one of Connecticut's first two United States senators, an office he held from 1789 to 1796. During this time his most important achievement was his draft of the bill organizing the federal judiciary. He left the Senate when Washington appointed him chief justice of the United States, a position he served in until 1801. Mrs. Ellsworth had married Oliver in 1772. Although she looks much older in the portrait, Abigail was only thirty-six, having borne the last of her nine children, twins, the year before her likeness was painted. Her husband also looks older than his forty-seven years. The couple is shown at Elmwood, their house in Windsor, Connecticut, which is also vignetted through the window.

Although the painting possesses the vestiges of Earl's English experience, the most emphatic artistic statement it makes is the simple maturation of the style already evident in his portrait of Roger Sherman. Indeed, Earl probably never would have gone abroad at all had it not been for the American Revolution, and would instead have plied his trade uninterruptedly in Connecticut and its environs in the provincial manner of many of his less-talented compatriots. If, in the end, this was the only style of which Earl was capable, it was, at the same time, entirely suitable for the equally provincial ambience in which he worked. Ralph Earl's portrait of Oliver Ellsworth faithfully records the personality of his subject, who was said to have been tenacious to the point of obstinacy, and whose judicial performance was characterized more by common sense than by legal learning. He was, after all, neither a John Jay nor a John Marshall, the more gifted men who preceded and succeeded him as chief justices of the United States.

The full-length portrait of *James Monroe* (fig. 6) by John Vanderlyn is another work in the great collection of state portraits

in the grand manner in the New York City Hall. It was painted in 1822, during Monroe's second term as president, six years after Vanderlyn had executed his bust-size likeness of the subject as president-elect. (The artist's claim that he had painted Monroe in 1803 cannot be corroborated.)

Vanderlyn had had his first painting lessons in the mid–1790s at an art school in New York run by an English-born artist named Archibald Robertson. When Gilbert Stuart permitted the young student to copy a few of his portraits, the one he did of Aaron Burr impressed its subject enough for him to make it possible for Vanderlyn to study with Stuart for a few months. In 1796 Burr, whose European connections were more with France than with England, paid his protégé's way to Paris. Here Vanderlyn remained for five years, the first important American artist to study in that capital rather than in London. He therefore was exposed to a neoclassicism that was different from that which Stuart and Trumbull had experienced, partly because it was a later variety, but more importantly because it was French.

Like Trumbull, Vanderlyn aspired to be a history painter, and it was principally in pursuit of this goal that he returned in 1803 to Paris, where he worked for the next twelve years. That he never fulfilled his ambition may, to no small extent, have been due to the nature of French Neoclassicism. Though deeply rooted in the stern catechisms of the French Revolution, it came to flower in the inescapably romantic atmosphere of Napoleonic imperialism. The rich complexity of such a style was ill-fitted to record the events of America's revolution with the painstakingly literal exactitude necessary to impart their straightforward lessons. When Vanderlyn finally was commissioned to paint one of the vast canvases for the rotunda of the United States Capitol, so late in his life that his genius was no longer equal to the task, it was for *The Landing of Columbus*, an episode from the almost mythic past eminently suited to a highly romantic interpretation.

Vanderlyn's *James Monroe* is a state portrait in the grand manner, whose neoclassicism is indeed imbued with strong romantic overtones. As such, it is as fitting a statement for its time as Stuart's "Lansdowne" portrait had been a quarter of a century earlier. In fact, in terms of its pose and setting, the *Monroe* makes a thinly veiled reference to the *Washington*. Possessing a mien not a little remote and forbidding, Monroe's presence as conveyed by Vanderlyn is suffused with an immense gravity, completely correct for the chief of a state solidly reestablished after the vicissitudes of the War of 1812, defiantly free of any further threats of foreign domination. Monroe's serenely self-confident expression, his hand resting on the map of a newly acquired territory, speaks not of a fledgling federal republic but of a mature nation set upon the course of empire.

*MARVIN SADIK*

Natural
Aristocrats
in a
Democracy:
1810–1870

*William H. Gerdts*

The portrait tradition established professionally in the eighteenth century grew stronger in the early years of the following century. With the growth of urban communities and increasing economic prosperity, almost every city and sizable town could support at least one quasi-official portrait painter, one who would paint the likenesses of community leaders and their families. In larger cities, particularly Philadelphia, New York, and Boston, which had become the centers of cultural as well as economic and social life, a fair number of practicing professional portraitists could be found at any time, though there was still usually a hierarchy based upon skill, patronage preference, and, not incidentally, the prices the portraitist could command.

Some of the few artists who came to the fore in the early nineteenth century could, and did, boast of European training, often gained in London; others studied as assistants or apprentices with native-born artists, some few of whom had in turn been European-trained. The establishment of some kind of connection with European antecedents may not have been necessary, but it was certainly desirable. As we have seen, the artistic tradition in Great Britain, to which America was heir, was primarily one of portraiture, and the ideal of portraiture in the first decades of the century remained British. In this period Sir Thomas Lawrence was the greatest of English portrait painters and, in fact, succeeded American-born Benjamin West as president of the Royal Academy in 1820. It was to Lawrence that West directed those Americans who journeyed to London to develop their skills as portraitists, as West himself was primarily concerned and identified with history painting. To be called "the American Lawrence" was the highest praise to which an American painter could aspire, and several of our finest vied for that title. Lawrence's portraits of Mr. and Mrs. Robert Gilmor (Robert Gilmor, vi), painted in 1818, though only bust portraits and not among the master's more inspired efforts, were considered among the most significant modern paintings in this country. The

American artistic community numbered among their greatest admirers.

The bulk of American portraiture, for a number of reasons, remained bust-length pictures, often painted in pairs of a husband and wife. Accommodation and cost were the most obvious and significant reasons, although the preference for the bust length was the patron's, not the artist's; most artists would have preferred to paint full-length likenesses. The advantages of the full-length, or even the group portrait, were many. Reimbursement was one, of course; all the artists had a fixed price scale for their portraits, a scale constantly being readjusted in terms of both the economic index and, when applicable, their increasing prominence. The scale ranged from a (mere) head, to a full-length, graduated according to size, since size was usually proportional to content. A portrait in which a hand was shown, however, was more costly than one that featured only the head; and two hands were not only better but also more expensive than one. The justification was the greater amount of time, effort, and skill involved.

Given the competition that existed among portrait painters in American cities, and the relative similarity of socio-economic status and expectations among patrons, the artists indeed sought opportunities to display that skill wherever possible. The larger and more elaborate the portrait, obviously, the greater were those opportunities. While costumes might vary only slightly from one male portrait to another, women's portraits allowed considerably more scope in fashion and thus also in color harmonies. Artists were eager to display their ability in reproducing fabric textures and in the manipulation of light-reflective surfaces. But full-length portraits also allowed for a greater variety of poses, for opportunities to introduce complex backgrounds, either richly furnished interiors or grand, even panoramic, landscapes, and sometimes they included devices that would

both define and enhance the personality and the interests of the sitter.

In turn, such displays could, and did, attract both critical acclaim and further patronage. Although any form of art might be commissioned, portraiture always has been based more completely upon previous commissions than, say, landscape, genre, or still-life painting. Any of these forms might be commissioned by a patron who admired a specific artist's skill, but the majority of such works in the nineteenth century were painted on speculation; portraiture almost never was. A patron who desired a likeness selected a particular artist either because the artist was the only one available or because his skill was particularly admired by the patron. That admiration was based in turn upon the artist's success at a previous, perhaps similar, portrait of another patron or upon the recommendation of a satisfied customer. Given the competition for commissions, it was important whenever possible to achieve "more than just another portrait," and the full-length allowed for such greater opportunities.

The significance of those opportunities became more complicated in the early nineteenth century with the establishment in major American cities —and occasionally even in small communities—of academies and other organizations where public exhibitions took place. The earliest such exhibition was that of the Columbianum in Philadelphia in 1795. A short-lived organization, the Columbianum was followed in Philadelphia by the Pennsylvania Academy of the Fine Arts; organized in 1805, it held its first public exhibition open to contemporary artists in 1811. In New York there was first the American Academy of the Fine Arts and then the more responsible and durable National Academy of Design, which held its first show in 1826. In Boston, the Boston Athenaeum introduced annual exhibitions in 1827.

The history of the development of the public exhibition in America during this period is tremendously complex and beyond the scope of this essay; nonetheless, it is one that deserves extensive study. What has seldom

been acknowledged is the importance that this development had for American art and for American artists. The artists, of course, including the portraitists, welcomed the opportunity to display their talents to a much wider audience. Art lovers and collectors, heretofore, had been able to admire a picture only in the private confines of a patron's home, on occasional visits to the artist's studio, or infrequently in window or interior displays of a book or frame shop—places that were themselves not too numerous in the early days of the republic.

These public displays were a partial response to the charges of both European and, occasionally, American critics that the nation had no cultural establishment to equal its enlightened political organization and growing economic power, and thus had not reached national maturity. But such public exhibitions had further consequences. They presented the artists with tremendously greater incentives to paint works of a speculative nature, because the opportunities of finding purchasers and even cultivating collectors were greatly enhanced. For, while portraits were traditionally commissioned, there was no practice of ordering works that employed themes. Now, the landscape painters and artists working with other themes had an outlet where they could display such pictures and either sell them there and then or at least attract prospective buyers to their studios.

Since the academies began when portraiture was almost the only seriously practiced art, the early exhibitions were composed largely of portraits; critics, artists, and patrons alike quickly recognized the monotony of such displays. Indeed, most, though not all, of the early professional landscape and still-life painters, such as Thomas Cole and Raphaelle Peale, had painted portraits until they found their true artistic destiny. Nevertheless, the concerted development of thematic expansion, as opposed to single and occasional efforts at landscape or still life, for example, coincided with the institution of public exhibitions, and this was not fortuitous.

Once thematic expansion took place, American artists and critics responded to the tradition of a hierarchy of

thematic artistic value not as a theoretical abstraction but as one applicable to the developing native arts. That thematic hierarchy was defined in the now well-known review of the second exhibition held at the National Academy of Design in 1827, written by Daniel Fanshaw:[1]

1. *Epic* . . . The Sybils and Prophets of M. Angelo.
   *Dramatic* . . . The Cartoons of Raphael. The Sacraments of Poussin. The Rake's Progress and other pictures of Hogarth.
   *Historic* . . . The Coronation of Josephine, by David. The Death of Chatham, by Copley.

2. *Historical or Poetic Portrait* . . . The Portrait of Mrs. Siddons as the Tragic Muse, by Sir J. Reynolds. Buonaparte Crossing the Alps, by David.

3. *Historical Landscape* . . . Saul Prophesying, by B. West. Elijah in the Desert, by Allston.

4. *Landscape and Marine Pieces, Compositions* . . . Many of the Landscapes of Claude and N. Poussin, and the Sea Pieces of Vanderveld.

5. *Architectural Painting* . . . The interiors of Peter Neefs.

6. *Landscape views and Common Portraits*

7. *Animals, Cattle Pieces*

8. *Still Life* . . . Paintings of inanimate nature, as furniture, jewelry, etc. Dead Game. Fruit and Flowers.

9. *Sketches*

10. *Copies*

This hierarchy is only a restatement and codification of principles established and promulgated by the French Academy in the seventeenth century and subscribed to by Sir Joshua Reynolds (1723–1792) in his *Discourses* (first published posthumously, Boston, 1821) presented to the students of the Royal Academy. The *Discourses* constituted something of an artistic bible to most English-speaking artists of the late

eighteenth and early nineteenth centuries. Succinctly explained, there are two factors involved in the establishment of the hierarchy: the value of a work of art is relative to the challenge it presents to the artist's skill in manipulating a variety of aesthetic problems and to the educational and, even more, inspirational effects the work has on the viewer.

One notes also that while the variety of historical themes—the "epic," the "dramatic," and the more narrowly "historic" transcription of historical events—occupy the topmost rung of the hierarchy, portraiture is deemed second in importance, but only a *certain* type of portraiture: the "historical or poetic portrait." This, of course, refers to those portraits that come closest to the most valuable painting of all, history painting. Considerably farther down on the scale, one finds landscape views and "common portraits" lumped together. Fanshaw does not bother even to provide examples in this category, as he did in all the previous ones, partly because they were obvious but also because they would be, as the category itself, undistinguished, unlike the likenesses of the renowned actress Sarah Siddons or the even more renowned Napoleon, whose portraits are the exemplars of poetic and historic portraiture.

The distinction between categories two and six, however, is more than the prominence of the subjects involved or even the implied distinction between public and private personalities, though we shall return to that shortly. We have noted that the common portraits are combined with landscape views. A step higher on the hierarchical ladder is a different category of landscape, termed "compositions." In today's parlance, all paintings have "compositions," all paintings are "composed," but in the early nineteenth century the term held a special implication. It meant that a landscape had been put together from a number of sources, some or all derived from nature, though perhaps also from the artist's imagination and recollection. This is what determined it as a composition, in contrast to a (mere) "landscape view." The view was only a transcription of nature,

while the composition was obviously superior, both in its demands upon the artist and its effect upon the viewer. That same distinction is implied in the alliance with portraiture. A "common portrait" demanded of the artist only transcriptive skills; but the poetic and historic portraits demanded and displayed not only the greatest formal technical ability, but also required imaginative input. To use another pair of favored contemporaneous descriptive phrases: the common portraits displayed talent, the historic portraits displayed genius.

It was the latter, of course, that the nineteenth-century portrait painter hoped to demonstrate, and he (very rarely, she) sought commissions for poetic and historic portraits where- and whenever possible. Official commissions were few and far between, but even the private portrait could be endowed with at least suggestions of poetry if not history; it could become a vehicle for the display of some aspects of genius. Naturally, however, a public commission was even more desirable than an elaborate private one, for a number of reasons. First of all, public commissions—when they were given at all—were often based upon competition, and the final choice, determined by a presumably knowledgeable body of judges, implied the superiority of the winner over his peers. Secondly, the public commission was usually well paid, and, while the honoring of the terms of payment was no more dependable than a private commission and often considerably less, the artist had the weight of public opinion and the possibility of press intervention behind him. Most significant, perhaps, were two further factors. First, the work would be assured some sort of public display, often of a permanent nature, and the artist would usually attempt to double the possibility of public exhibition by arranging to show the historic portrait in an academy annual as well as in its permanent home. The attempt was generally successful and, in either case or in both, he could be assured of often extensive review and perhaps praise, in the not very professional critical press.[2] If critically successful, the artist might be identified with the historical personage he had portrayed, an identification that would assure him fame,

even immortality. Further commissions might result, and at the least it would almost certainly lead to replications; the example of Gilbert Stuart as "the" painter of Washington and the subsequent replicas that provided a somewhat steady livelihood for Stuart were proof enough of that.

Such was the situation at the beginning of the nineteenth century.[3] If Sir Thomas Lawrence provided the ideal toward which the portrait painters of the period strived, nearer to home was the example of Gilbert Stuart who, more than any other single painter, had changed the outlook toward and the expectations of portraiture in this country for artist and patron alike. The early nineteenth century, the "Romantic" period, continued to seek the stylistic goals initiated in portraiture by Stuart on his return to America from the British Isles in 1793, an approach to the portrait that can indeed be described as romantic. Working in a formally colorful manner, with paint broadly applied, banishing the dark shadows and strong chiaroscuro of Copley, and initiating an idealizing, ennobling interpretation of his sitters, Stuart had an all-pervasive influence. This was in part due to his prolificness and in part to his successive appearances in New York, Philadelphia, Washington, and finally in Boston, with the result that his examples were spread throughout the urban centers of the country.

Stuart settled in Boston in 1805, where he lived until his death in 1828, so that during the first half of the period under discussion not only his influence but Stuart himself dominated Boston portraiture.[4] The clearest tribute to his genius as recognized by the citizenry of Boston is found in the memorial exhibition held at the Boston Athenaeum the year of his death. Not only was a one-man memorial show an unprecedented event in America at the time, but the two hundred sixteen works shown constituted an enormous display, rarely equaled for an American artist in the nineteenth century. The display, furthermore, quite naturally drew from his later works and therefore constituted primarily a gallery of Boston

portraiture, something of a social register of the period.[5]

Not surprisingly, Boston portraiture was often strikingly dependent upon Stuart's example. An artist such as James Frothingham was often little more than an imitator of Stuart, working in Boston until 1826 and then moving on to New York. A more original talent was Chester Harding, the first artist of national significance to emerge from the then-defined West, where he painted in Pittsburg, Kentucky, and in St. Louis between 1817 and 1821. He came east with the reputation of having painted Daniel Boone in the latter's old age (Massachusetts Historical Society, Boston; J. B. Speed Art Museum, Louisville, Kentucky). Stuart's presence in Boston induced Harding to seek additional professional experience, and between 1823 and 1826 he was in London, where he was influenced by Lawrence. He returned to two years of friendly rivalry with Stuart, who is known to have asked on Harding's return, "How rages the Harding fever?" After Stuart's death Harding was the most significant, though by no means the only, portrait painter in Boston. There he maintained a studio, although he moved his residence to Springfield in 1830. Harding was also a very significant figure in the artistic life of Boston. In the 1830s he established a gallery in his studio for the display of contemporary art, offering an alternative outlet to the Athenaeum displays.[6]

Many of Harding's portraits are like the artist himself, simple, natural, and unassuming, with more opaque coloring than Stuart's and lacking the master's sparkle. Harding's art is often clearly dependent upon the older portraitist's; in fact, Harding was called upon in the 1830s after Stuart's death to introduce paisley shawls, then very much the rage in fashion, into some of Stuart's portraits of women. What indeed may be Harding's masterpiece of portraiture, that of *Amos Lawrence* of about 1865 (National Gallery of Art, Washington, D.C.), depicts the Bostonian in a full paisley robe. The portrait of Amos Lawrence is a full-length, though a very relaxed and genial likeness

in the tradition of some of Copley's late American work, such as the portraits of Nicholas and Thomas Boylston (Harvard University). But such a portrait suggests an important distinction between Harding and Stuart, for Harding seems to have sought out rather than avoided the full-length likeness. In December of 1829 the Boston Athenaeum appropriated two hundred dollars which was authorized for a portrait of *Chief Justice John Marshall* (cat. no. 40) to be painted by Harding. One suspects that it would rather have been offered to Stuart had he not died the year before, since they had already commissioned three portraits from him. Negotiations began in early 1830 with Harding in Washington, after Marshall's consent had been secured, and then it was suggested to the artist that he paint a picture four-feet-ten-inches by four feet to hang as a pendant to the portrait of Benjamin West which Charles Leslie had copied from Lawrence. Harding replied with eagerness to accept the commission, as he had already painted several bust portraits of Marshall. He requested only that he be allowed to make it a full-length, for which he asked a stipulated sum, hoping for additional payment if the trustees found the work successful; he was finally paid the sum of three hundred fifty dollars. A year later Harding exhibited a full-length portrait of *Daniel Webster* (fig. 1) which was acquired by the Athenaeum. Harding also painted a full-size replica of the Marshall portrait almost as soon as he had completed the original; the replica was acquired by subscription for Harvard in 1846.[7]

Harding's portrait of Marshall would seem to be the finest of his full-length public productions, a more commanding effort than his likenesses of *Charles Sumner* (State Capitol, Albany, New York), *Henry Clay* (National Museum of American Art, Washington, D.C.), or Webster. In a general sense, it would seem to find a prototype in the most renowned of all American models, the Stuart "Lansdowne" *Washington* (cat. no. 22); given Harding's association with Stuart and the Athenaeum's exhibition of the Stuart alternate, *Washington at Dorchester Heights* (Museum of Fine Arts, Boston), at the first annual exhibition held there several years earlier, a formal associ-

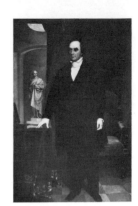

1

Chester Harding
1792–1866

*Daniel Webster*
1828, repainted 1849

94 x 58 in.

Boston Athenaeum, Purchase 1832. Photograph by George Cushing

ation with Stuart's example would have had special meaning for the artist as well as for Boston and the Athenaeum. In a larger sense, the Marshall portrait conforms to the accepted format for an official, civilian, standing, full-length interior portrait, a format so standard for the painting of statesmen, judges, and other political figures that the search for specific prototypes may be meaningless.

As in the Stuart portrait, Harding's subject stands with feet apart, firm of foot, in order to give the figure balance and stability. What is important to recognize is that these qualities, pictorially defining a physical stance, are also psychologically affirmative. That is, Marshall and Washington are balanced and stable individuals. Harding has posed Marshall with one hand holding a book on a table, the other on his waist, a variant of Stuart's Washington, who holds a sheathed sword in one hand and gestures in eloquence with the other. But Marshall was neither the warrior nor the public figure that Washington was. Marshall was a man of learning and of judgment, and the book suggests both knowledge and a record of his own court decisions.

The interior in which Harding has depicted Marshall is quite austere, certainly lacking the elaborate furniture and the grand manner columns of Stuart's painting. But Stuart is harking back to a Baroque tradition that Harding makes no effort to conjure up. Indeed, with the view between the columns outward toward the heavens, Stuart presents Washington as one with past and future, as part of eternity. Harding's Marshall is very much of the here and now. He exists in a workaday world; he has risen from the chair behind him to pose for the artist and present himself to the spectator; the book he has left reading is still open on the table to reabsorb his interest. The chair itself is a comfortable office model, with none of the massive framework and gilt embellishments of Washington's Empire model—almost an emperor's chair! But a chair, one way or another, appears for generations as a standard prop in such official portraiture. It is a working fixture; it explains where the subject performs his tasks

and suggests a modicum of comfort—it relieves the spectator's unconscious anxiety of the strain of eternal standing. It also becomes a space marker; it helps in carving out a viable, real space in which the subject may operate and yet fills that space concretely. It is almost always set on a diagonal, adding relief to the strict geometry of the room and abstractly adding a slight dynamism to an inherently static composition.

Marshall's hands are beautifully drawn and firmly placed on book and hip; they have strength and character, often a mark of a superior portraitist. The hand on the hip also spreads out Marshall's black robes so that all lines lead up to the powerful and confident visage. Harding has placed Marshall's head high in the canvas, accomplishing two purposes: he has elongated Marshall in a tradition age-old, and at the same time has elevated him above the viewer, who must look up at him; Marshall is thus superior to the common folk. In this regard, Harding is more successful than Stuart.

Marshall's features are set to insure the viewer full confidence. His eyes are piercing and keen, his jaw is firmly set. His features are rugged, even chiseled, the artist perhaps overcompensating; Marshall was after all seventy-six years old. Rugged form does not characterize all of Harding's male likenesses by any means, and even where he achieved similar corporeality in the Webster portrait two years earlier, he averted Webster's eyes from the viewer, unlike the firm visual contact one makes with Marshall. Webster, of course, was a statesman rather than a jurist, a more public figure, and a younger man; he is idealized by Harding in the direction of handsomeness rather than strength and confidence. To Webster's right, though not in the line of his gaze, stands Sir Francis Chantrey's recent statue of George Washington commissioned by the city of Boston, offered in an obvious sense for spiritual and political identification with Webster. Unfortunately, the contrast in size of the distant statue with the figure of Webster up close and Harding's inability to cope with the spatial disjunction create an awkward imbalance in the Webster portrait, happily avoided in the simpler

composition of the Marshall. In both, however, Harding's superior ability to handle the contrasting blacks of various clothing textures enlivens the pictorial description of the otherwise somber and prosaic male costume of the day.

Harding's portrait of Marshall is the finest full-length image of the great chief justice known to have been fashioned, but it did not become the standard image; this was an honor that would be achieved by Henry Inman when he painted Marshall on order from the Law Association of Philadelphia (today the Philadelphia Bar Association) the following year, 1831–32. Marshall was visiting Philadelphia for medical reasons then, and Inman had moved from New York City to a rural home in Mount Holly, New Jersey, maintaining a studio in Philadelphia and a partnership in a lithography firm with Cephas G. Childs. Inman's is a seated half-length portrait and thus far less elaborate than Harding's, but it constitutes the strongest likeness and the most brilliant piece of painting that Inman ever did, sharing in fact some of the most admirable qualities of Harding's slightly earlier portrayal. Its success can be measured in the wealth of replicas and copies made from it, one of which, painted for the Warrenton, Virginia, county courthouse in 1859 by William De Hartburn Washington, was elaborated into a full-length portrait complete with a podium supporting the seated Marshall, books strewn at his feet, and a grand column behind. Washington's copied image is an acceptable likeness, but the more relaxed pose of a seated figure interjected into a grandiose setting is incongruous. Yet, the Library Committee of Congress in turn in 1880–81 commissioned from Richard Norris Brooke a copy of the Washington full-length, so a shadow at least of Inman's great likeness penetrated the walls of the Capitol.[8]

Harding may have dominated portrait painting in Boston in the second quarter of the century, but he was hardly the only specialist. Francis Alexander, in particular, was a popular and very able portraitist, but he was more skilled at intimate romantic likenesses and certainly did not secure, if he ever sought, the larger

public commissions. The major artist in Boston contemporary with Harding, however, was not a portrait painter at all. Washington Allston, one of the most versatile American painters of the first half of the nineteenth century, was a specialist in history painting, a much admired landscapist, an occasional genre painter, and the artist who introduced the concept of ''pure'' figure painting into American art; in short, the first American artist who did not derive his livelihood primarily from portraiture.[9]

In actuality, Allston did paint portraits, but comparatively few, and only a small number of these were commissioned works; rather, his portraiture derived almost totally from family and friends. The known examples are almost all from two periods in Allston's career. The first consists of a group of portraits of his young wife, Ann Channing, and members of both his and her family, painted during his brief Boston residence of 1808 to 1811, between his two European sojourns. In all of these, Allston's motivations were similar: a combination of interpretive and technical problems to be solved and an expression of familial warmth and affection; by their very nature, they were not in the ''Grand Manner.''

The other group of known portraits dates from around 1814, some painted in London and others in Bristol, where Allston had his first one-artist exhibition, a rare phenomenon at the time on either side of the Atlantic. To that 1814 exhibition of figure and landscape pictures, Allston added several quite large and high-style portraits of his close friend *Samuel Coleridge* (National Portrait Gallery, London) and the surgeon of Bristol who had literally saved his life, *Dr. John King* (Fine Arts Museums of San Francisco); that same year in London he painted a portrait of his old teacher, *Benjamin West* (Boston Athenaeum). The last recorded portrait by Allston, the *Portrait of Samuel Williams*, was also his grandest (fig. 2). Williams, Allston's friend and his banker and financial agent in London, also represented many other Americans traveling abroad. The picture is traditionally dated 1817 and

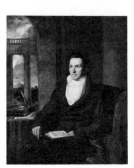

2

Washington Allston
1779–1843

*Portrait of
Samuel Williams*
c. 1817

56 x 44 in.

The Cleveland Museum of Art, Purchase, Mr. and Mrs. William H. Marlatt Fund

was certainly painted before 1818, when Allston left England. Dignity and benignity characterize Williams' attitude. The handsome, strongly structured head is turned in averted gaze which, combined with the book he holds and those on the table alongside his chair, suggest intellectual interests and deep thought. Behind the subject is a monumental arch and a classical colonnade, a sweeping architectural setting introduced for a variety of purposes. Sitting upright in his chair, Williams echoes the strength, solidity, and endurance of the architecture, suggesting not so much that his bodily person will endure but that his thoughts, his intellect, his morality, his virtue, and his memory will last. The architecture also allies Williams with the sense of civilization conjured up by classical reference, and the sweep and openness of the architecture of the past suggest the breadth and range of Williams' interests. This sense of tradition as opposed to the immediate, allied to Allston's richly colored and glowing technique derived from the Venetian Renaissance— especially from Titian—projects here a modern ''Old Master'' portrait, a work in the grand manner as much by virtue of its aesthetic associations as by its iconographic program or its homage rendered to a figure of prominence.[10]

The Williams portrait is certainly Allston's most elaborate. A fair question in regard to this and to a great many portraits is that concerning the roles of the artist, the subject, and the patron (though the last two are usually one and the same) in the choice and development of the iconographic and formal schemes of the picture. That is, are the elaboration of setting and the interpretation of Williams' personality here purely the invention of the artist, or were they suggested or prompted by the subject? Documentation to support such speculation is usually unavailable and it is not known to exist in this case, but Allston's picture hung in Williams' Fitzroy Square home in London along with Stuart's full-length ''Lansdowne'' portrait of *George Washington* (cat. no. 22), given to Lord Lansdowne by Senator William Bingham and sold in 1806 in the dispersal of the Lansdowne estate. Undoubtedly the Stuart was acquired by Williams because of his admiration for Washington; it

nevertheless suggests a taste for the grand manner. The Allston portrait of Samuel Williams may have played its part in perpetuating in America the artistic traditions embodied in Allston's art. Although it was painted in England, it passed into the possession of Williams' brother Timothy, in Boston, who exhibited the work at the Boston Athenaeum in 1835, at the Allston exhibition at Chester Harding's studio-gallery in 1839, and at several other Boston art exhibitions.

In Philadelphia, Thomas Sully dominated the field of portraiture throughout the Romantic period and even beyond; his was a long lifetime of almost ninety years, and he produced an oeuvre of over 2500 paintings. From the 1810s to the middle of the century he was certainly the city's leading portrait painter and arguably the country's most prominent; a Philadelphia citizen would commission a portrait from another artist only if he could not afford Sully's prices or if, perhaps unaccountably, he found Sully's style too mannered or disagreeable. I say "unaccountably" because Sully's was "the" Philadelphia style. Those other artists who practiced there worked in partial imitation and certainly emulation of him, and their degree of success was probably a measure of their popularity.[11]

The question arises as to regional styles and their identifications; that is, can one recognize a Philadelphia, or a Boston, or a New York portrait. Probably this is possible to some degree but for pragmatic reasons. Certain artists, in portraiture as in other themes, tended to dominate the scene in any one place, at any one time. They established the fashionable mode and thus achieved the greatest success. Consequently, others followed their stylistic lead. A Boston portrait may be recognizable in the early nineteenth century if it is especially Stuart-like, a Philadelphia one if it suggests Sully, even if the master himself was not the artist of it. It would be erroneous, however, to seek an explanation of the style or the appearance of a portrait in the religious, cultural, national, or philosophic background of the population; there is nothing particularly Quaker about

Sully's portraits, Puritan about Stuart's and Harding's, or Yankee-commercial about those of Jarvis and Inman.

Charles Willson Peale had been the major portraitist in Philadelphia in the early Federal period, and he remained a major force in the artistic and cultural life of the community well into the nineteenth century. His basically Neoclassic style, however, reminiscent of Copley's American work, was effectively displaced by the suave, idealizing manner introduced by Gilbert Stuart during his Philadelphia residence of 1795 to 1803. This was a great period for the city, of course, serving briefly as the nation's capital—a prime motivation for Stuart's activity there, since he was enabled to paint his three life portraits of Washington at the time. In turn, Stuart's presence and his new, fashionable style may partially have prompted Peale's retirement from active portrait painting.

The young Sully, who had been born in England and who grew up in Charleston, South Carolina, only knew Stuart for a few weeks in 1807; in the following year Sully settled permanently in Philadelphia. Stuart, however, encouraged him to seek out the sophistication of London training and Sully went abroad for a year in 1809. Like all young Americans, he sought out Benjamin West, but West in turn directed the young man to Sir Thomas Lawrence. Although West did, indeed, train many American portrait specialists, Stuart among them, his overwhelming interest was history painting, while Lawrence was the greatest portraitist of his age in the English-speaking world. John Hoppner and William Beechey, too, were influential upon the young Sully, but it was Lawrence who provided the ultimate model for his future art. It was a predictable but, nevertheless, wise choice.

Lawrence was at the height of his powers when Sully made his appearance in London; when Hoppner died the following year, Lawrence would be without rivals in England. Lawrence continued the tradition of Grand Manner portraiture in England, unbroken from the time of Van Dyck and, arguably, from that of Holbein. More immediately, he was the heir to Sir Joshua Reynolds,

but a subtle difference had altered the nature of British portraiture. More and more, Lawrence and his generation catered to a bourgeois society with aristocratic pretentions, rather than to an aristocratic society. This society appreciated the brio and dash of Lawrence's brushwork, the vivid colorism of his palette, the outgoing rather than introspective interpretation of personality; these qualities would be adopted in a slightly hesitant fashion by Sully on his return to Philadelphia. He would, indeed, soon be referred to as "the American Lawrence."

A year after his return from abroad, Sully was able to demonstrate his achievement, for he was commissioned to paint an elaborate full-length depiction of the great English actor *George Frederick Cooke as Richard III* (cat. no. 28), the performer's greatest Shakespearean role. The commission came from a group of the actor's friends and supporters who purchased the work for the Pennsylvania Academy of the Fine Arts.[12]

Cooke was one of the greatest figures on the English stage and his appearance in America was a much-heralded event. His American debut in the part of Richard III afforded Sully an ideal identification for Cooke. It also allowed him to present his subject in eclectic, elaborate costume, rich in textures and colors, exotic in the extreme in comparison with contemporary dress. This portrait permitted Sully to develop a significant background in a corridor leading to Westminster Abbey, the somber ecclesiastical nature of which contrasts with the vivacity of the central figure, as the downcast religious image behind him sets off the scheming malignity of Richard's (and Cooke's) expression. Cooke eschewed the traditional magnifications of Richard's perverse nature in physical terms, the malformed limbs and the hunchback, concentrating his interpretation in the psychological. Sully adds his own symbolism in the broken column base at the right, indicative of Richard's evil nature here housed on sanctified ground.

Portraits of theatrical figures were common enough in British art, particularly from the mid-

eighteenth century and the time of David Garrick, who was not only England's most famous actor but a patron of the arts as well. Garrick was portrayed in his day both in "straight" portraiture and in roles for which he was renowned, while his female vis-a-vis, Sarah Siddons, was the subject of the brush of the greatest portrait painters of the late eighteenth century, most notably in Sir Joshua Reynolds' *Mrs. Siddons as the Tragic Muse* (Huntington Library and Art Gallery, San Marino, California). This may be the greatest portrait of a person of the theater ever done, as it may also be Reynolds' most successful attempt to wed portraiture and history, truly achieving that category of "historical or poetic" portraiture. It should be noted, however, that it is a special form of the genre, for it is neither a "straight" portrait of Mrs. Siddons nor a portrayal of her in a customary role.

American artists, too, depicted people of the theater; indeed, one of Gilbert Stuart's most effective images made in England was his likeness of Mrs. Siddons (National Portrait Gallery, London). A particularly notable precursor to Sully, and in the Philadelphia portrait tradition, was Charles Willson Peale's portrait of Nancy Hallam in the role of Fidele in Shakespeare's *Cymbeline* (Colonial Williamsburg, Virginia), painted in 1771 when the American Company was performing in Annapolis. The picture was a showpiece in Peale's exhibition room subsequently, and then in his museum display, so precedent had certainly been provided. And the young Charles Robert Leslie first came to public attention for his watercolors of Cooke in theatrical roles in Philadelphia in 1811, at exactly the same time that Sully was painting his great picture.[13]

The tradition thus existed, and Cooke was in America, but the choice of Sully merits further explanation. The principal explanation would surely lie in his relative success immediately previous to the Cooke portrait with a similar work, his depiction of William B. Wood in the character of Charles de Moor from Schiller's *The Robbers* (Corcoran Gallery of Art, Washington, D.C.), begun in Au-

gust 1810, almost immediately on Sully's return to Philadelphia. Wood was an important figure in Philadelphia theater, not only a principal local actor but also manager of the Chestnut Street Theater. Sully cast Wood even more into his theatrical role, surrounding him with half a dozen supporting figures and reclining in a rocky landscape, equally as theatrical but hardly as dignified as Cooke's depiction.[14]

Sully must certainly have realized that the Cooke commission, far more than the likeness of Wood, would certainly "make" his reputation. On a pure public relations level, the theatrical figure had a popular audience which would become attracted and attached to a successful image, and, in the case of the heralded Cooke, tremendously so. A successful theatrical portrait was a test of ability and it truly rated categorization as an "historical or poetic portrait," for in it the artist was challenged to create a triple image in one: he should present the likeness of the actor (or actress) still recognizable and distinctive; he should project the character of the subject being portrayed, in historical and traditional terms, for audience satisfaction; and he should, if possible, suggest the specific interpretation of that subject by the specific performer.

If Lawrence was Sully's ideal, moreover, he provided the artist with specific prototypes immediate to Sully's acquaintance with him, for among Lawrence's most commanding images were several of the great tragedian John Philip Kemble, portrayed as Coriolanus in 1798 (Guildhall, London), and as Hamlet in 1801 (fig. 3). Lawrence's Kemble portraits are very different from Sully's works already described, for they are sparer and more brooding images, more heavily weighted toward interpretation than exposition, while the viewer looks up toward them, as if from below as well as beyond the footlights. Washington Allston copied the Lawrence likenesses of Kemble as Coriolanus. Kemble's daughter, Frances (Fanny), herself became a well-known actress and, visiting America in 1832, became a close friend of Sully's and the subject of a whole series of theatrical interpretations of Shakespearean figures by the artist. Sully also copied a Stuart portrait of her

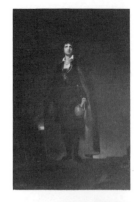

3
Sir Thomas Lawrence
1769–1830

*John Philip Kemble
as Hamlet*
c. 1801

120½ x 78 in.

The Tate Gallery,
London

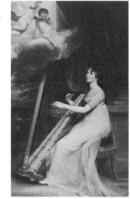

4
John Singleton Copley
1738–1815

*Mrs. Richard
Crowninshield Derby
as St. Cecilia*
1803–04

94½ x 58 in.

Dr. and Mrs.
Henry C. Landon, III

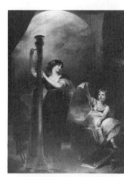

5
Sir Thomas Lawrence
1769–1830

*Caroline, Princess of
Wales, and
Princess Charlotte*
1802

47 x 32 in.

Buckingham Palace,
London
(Copyright reserved)

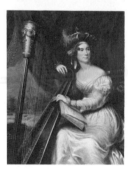

6
Charles Bird King
1785–1862

*Mrs. John Quincy Adams*
c. 1824

51½ x 42 in.

National Museum of
American Art,
Smithsonian Institution, Washington, D.C.,
Gift of Mary Louisa
Adams Clement in
memory of her mother,
Louisa Catherine
Adams Clement

father in the character of Richard III (Sir Henry Halford, 1868) in 1867, toward the end of Kemble's life. Sully's portrait of Cooke appears to have achieved great success; a lugubrious testimonial to this was witnessed the year it was painted, for Cooke died in New York in September of 1811, and the Sully painting was placed on the shrouded stage of Philadelphia's Chestnut Street Theater while tributes were offered to the deceased thespian.

Unlike Gilbert Stuart, Sully was not fazed by the challenge of the full-length portrait and painted many of them during his career, probably more than most or any of his contemporaries. The full-length portrait, for a variety of sociological and socio-economic reasons, was more often of male than female imagery. Yet, Sully painted a number of full-length portraits of women, and certainly none more celebrated today than that of the *Lady with a Harp: Eliza Ridgely* (cat. no. 29) painted during three weeks in May of 1818.

Miss Ridgely's portrait exemplifies both the style of Sully's art and his interpretation of the female subject at its fullest and best. Not a literal transcription of the subject, Eliza Ridgely here is impossibly tall with feet too tiny to support so heroic an image. Her skin is smooth, her arms are boneless, her head a perfect oval, and her features perfect, too. Certainly Eliza Ridgely resembled this image, but it is true idealization, constructed according to Sully's own ideal of femininity which is, in turn, a version of the admired one of the age.

She is elongated according to the traditions of superiority already described. That imposing verticality is also reinforced by the unbroken lines of her fashionable Empire gown and by the architecture at the right. Most noticeably, that architecture is compositionally balanced by the harp at the left on which she leans and at which she plays; while the architecture is impersonal and severely geometric, the harp reinforces, even duplicates, the young woman's physical elevation upward and echoes the soft sweet curves of her

feminine form. It is an elegant instrument as she is an elegant person; like Miss Ridgely, it is delicate, too, its taut strings barely discernible, while the sensuous extension into the realm of beautiful sound suggests a further parallel with the subject's loveliness.

The harp here is not only a compositional element of significance but also carries symbolic function. It suggests Miss Ridgely as a woman of cultural accomplishment; she can play the harp, she can produce the beautiful music; she plucks the strings as well as holds the instrument, and to indicate that this is no idle pastime she holds a tuning key in her other hand to right the strings to maximum effectiveness.

The introduction of a harp into portraiture is not an invention of Sully's, of course, though he himself had used it earlier, in the bust portrait of 1815 of Angelica Livingston of New York. It should be pointed out, first, that the harp implies culture, not intellect; it appeals to the emotions, not the mind. It belongs very much in the realm of womanhood, and men are not depicted with musical instruments but with books, papers, and maps. They chart the material course, woman the spiritual and emotional one. Likewise, women are more often shown, as here, against a broad and panoramic landscape, one that inspires the soul; men more often appear in their studies and libraries, surrounded by books, the food of the mind. Exceptions to these conventions abound, of course, but they hold true in the main; the portraits of John Singleton Copley offer particularly abundant evidence of this, with many of his female sitters placed in a landscape or again at an open window, while their spouses are deeply engaged in their darkened studies.

Copley comes to mind, too, with a prototype for Eliza Ridgely, his portrait painted in 1803–04 of *Mrs. Richard Crowninshield Derby as St. Cecilia* (fig. 4), seated at a harp. Again, Lawrence offers what may be the definitive iconographic model in his 1802 portrait of *Caroline, Princess of Wales, and Princess Charlotte* (fig. 5); Princess Caroline stands tuning a harp here. Lawrence utilized the

motif again in his portrait of *Lady Elizabeth Conyngham* of the early 1820s (Trustees of the Londesborough Settled Estates, on loan, City of Birmingham Art Gallery, England), and it appears also in William Beechey's portrait of *Jane Read* of about 1813 (Spencer Museum of Art, University of Kansas). The association of woman and harp reappears in American art in Charles Bird King's portrait of *Mrs. John Quincy Adams*, painted in the early 1820s (fig. 6). Despite the literal allegorization of Copley's image of Mrs. Derby, the subject herself shares a certain specificity and even domesticization with King's Mrs. Adams; both lack the quality of the ideal that establishes Sully's work as an archetypical image of romantic young womanhood. King even identifies the song Mrs. Adams is playing: "Oh! Say Not Woman's Love is Bought," and, while it may establish Mrs. Adams as an accomplished singer and harpist, it interjects an anxiety of moral message happily absent from Sully's Eliza Ridgely.

Sully continued to incorporate the image of ideal womanhood into such later portraits as that of *Mrs. Reverdy Johnson* of 1840 (Art Museum, Princeton University), though here with some recognition of the greater maturity of his subject. A very different projection is found in another of his later full-length portraits, that of the great Boston merchant and that city's most prominent art collector, *Colonel Thomas Handasyd Perkins* (cat. no. 30), a work commissioned by the Boston Athenaeum in 1831 and finished the following year. The original commission was given to the aged Gilbert Stuart, as the leading Boston portraitist, to hang with his portrait of the subject's brother, James Perkins, already in the Athenaeum collection. To induce Stuart to get on with the commission, he was given space in the Athenaeum building to paint the picture. All Stuart achieved, however, was a bust portrait for the family. Then, after a delay of several years, the Athenaeum approached Sully, probably influenced by the chairman of their acquisitions committee, Isaac Davis, a long-time friend of Stuart and of Allston, who

had met Sully when the latter first visited Stuart in Boston in his youth.[15]

The choice of Sully here is an interesting one, with some important ramifications. By 1832 Sully was one of the best known of all American portrait painters, and with Stuart's death in 1828, perhaps the most highly regarded. Yet, Sully was a Philadelphia artist first and foremost. An almost constant consideration in the awarding of public and even private art commissions, including those for portraits, was regional, state, and local pride, though of course the convenience of proximity for sittings was an additional concern. Bostonians chose Boston artists, New Yorkers chose New York painters, and Philadelphians, Philadelphia portraitists. The clearest application of this was to develop in the awarding of national commissions for the Capitol, where regional considerations dictated the choice of the artists to paint the rotunda pictures. Later, when Statuary Hall was instituted in 1864 with two sculptured figures allowed to each state, artists were sought to fill those commissions, often with only the most tenuous state connections (and sometimes equally tenuous claims on professional standing!).

The choice of Sully, therefore, for even a semipublic commission such as that of the Athenaeum of the portrait of Colonel Perkins, was a break with established tradition; it testifies both to Sully's national fame and to the dearth of first-rate portrait painters in Boston after Stuart's demise. Perhaps the Athenaeum committee felt they had awarded enough commissions to Harding, or perhaps not all the committee were satisfied with his likenesses. Then too, Davis and Perkins may have injected their personal preference for Sully's style, or perhaps it was felt that he would most closely approximate the graceful elegance they would have hoped to see embodied in a Stuart portrait.

If they sought such elegance, they should not have been disappointed. Sully has painted Colonel Perkins with all the dash, the rich colorism, and fluid brushwork that they might have expected of Stuart at his greatest. The technique is Sully's own, of course, reveling in the manipulation of the bright, primary colors and bathed in a golden light which allows for only the most transparent shadows. The paint is laid on in a "buttery" fashion, rather than in Stuart's slightly drier manner with dragged, irregular edges to the brush strokes.

Historians have noted a constant relaxation in Sully's paintings over the years. They become ever less structured, the figures more ephemeral; and certainly, Perkins' image justifies Charles Leslie's comment to Sully that "your pictures look like you could blow them away."[16] Certainly, the figure does not display the solidity and volume of some of Sully's earlier full-length portraits, such as the several he painted for West Point or the 1812 likeness of *Samuel Coates* (Pennsylvania Hospital, Philadelphia). The technical relaxation in Sully's method is totally consistent with his interpretation of the subject; while Coates stood upright in his study, Perkins sits sprawled out on a gold plush-covered Empire sofa, almost absorbed into his surroundings.

Yet, he is still a commanding image. His relaxation signifies not weakness but his contentment, his mastery of all he surveys. His arms are outstretched following the outline of the sofa, but also in sweeping positions as if to gather in his surroundings. Perkins wears a richly textured outercoat, and his top hat is on the sofa by his side. The implication is that he has just sat down and will shortly depart, still a man of activity despite his advanced years, not one content merely to sit back and enjoy his environment. He has paused to read his mail perhaps—it rests with his hat on the sofa—while at the right are a large amphora and a portfolio, presumably of drawings or engravings, indicative of his taste and of his collecting; he is a man of culture and knowledge. His surroundings, as those in Samuel Williams' portrait by Allston, do not describe Perkins' home nor even the halls of the Athenaeum but rather "halo" Perkins with a great Roman arch, implicitly "triumphal," while establishing a solidity missing in the portrait itself, echoing the sweep of Perkins' pose and allowing the artist to effect a view into the sky beyond. Here Sully indulges in rich chromatic effects while suggesting Perkins' alliance with immortality, with the "great beyond," the broadly, softly brushed clouds seeming to lead directly from the archway to the heavens.

Philadelphia portraiture of the period took on a fairly systematic structure, though this is here oversimplified. If a patron did not care to choose Sully, he might apply for a portrait to his stepson-in-law, John Neagle, whose prices were somewhat lower than Sully's. When Sully adjusted his, ever upward, Neagle did so correspondingly. Down the ladder of sophistication, prestige, and cost, a patron might apply then to Jacob Eichholtz when he was in Philadelphia; if not Eichholtz, then perhaps Bass Otis; and if not Otis, then Robert Street. Though the market fluctuated with economic conditions—art commissions were always among the first to be sacrificed in hard times—there was generally enough work to support such a structured scale of portraiture. Commissions for major works, however, even private full-length portraits and certainly public and semipublic ones, were usually given to the more renowned figures and correspondingly fewer to those on the lower rungs of prestige.

Neagle, however, was well up there, and his stepfather-in-law was very supportive of his efforts. Furthermore, Neagle himself was strongly influenced by Sully and worked very much in his manner, and successfully. He began to practice professionally in 1818, going off on a *wanderjahre* as far as Kentucky, since Sully was garnering all the Philadelphia commissions, but he settled in his native town in 1821 as a practicing portraitist, starting his career with paintings of visiting Indians and with theatrical portraits. In 1825 he went to Boston to visit Gilbert Stuart, for the dual and interrelated purposes of showing Stuart his portrait of *Matthew Carey* (Mrs. Howard Gardiner, Philadelphia) for advice and criticism and for the opportunity of painting the great aging master. The portrait that resulted is one of Neagle's finest works. The experience was a profound one for his art. In

some of Neagle's best paintings, the influence of Sully's soft creamy technique is somewhat enhanced and enlivened by a more vigorous paint handling and a more incisive characterization which almost certainly derives from his brief contact with Stuart.[17]

That incisiveness certainly informs Neagle's most famous painting, his likeness of Patrick Lyon of 1827.[18] The story behind *Pat Lyon at the Forge* (fig. 7) is a romantic one, often told, that Lyon had insisted he be depicted working at his forge rather than as a gentleman, in response to his brief imprisonment while a young man. Lyon had been falsely jailed for theft because he had installed the lock system of the Bank of Pennsylvania in Philadelphia which was subsequently robbed in September of 1798; Lyon was thus familiar with the safety precautions that had been taken. He successfully defended himself, and, in the heroic image he commissioned from Neagle almost three decades later, asked to have himself portrayed as an "honest workman," the jail seen in the background. Beneath his workman's apron he is dressed in his Sunday best—clean shirt and brightly polished, buckled shoes—still a gentleman after all. By the commissioning date of 1825, Lyon had retired from his forge and was a wealthy man.

The figure itself is a massive, dominating one, dramatized as a local Vulcan pausing before the fire of his forge, which vies with the figure of Lyon for the central attention of the viewer. He is shown strong and brawny, holding his mallet against an anvil, symbols of strength, in this case of both physique and character. The young assistant at the left is introduced in the tradition of "supporting" players, enhancing the central and upright position of Lyon himself. This assistant or apprentice is behind and lower than Lyon, and he bends slightly in working the bellows. Yet, he is also closer to the cupola and roof of the jail and is perhaps a generalized suggestion of the youth Lyon himself had been when the momentous event occurred. For the Lyon shown in the painting is sparsely thatched and with ruddy nose, the fifty-seven-year-old patron.

Neagle's style appears to have followed a course

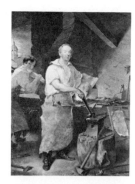

7
John Neagle
1796–1865

*Pat Lyon at the Forge*
1827

94½ x 68 in.

Courtesy of the Pennsylvania Academy of the Fine Arts, Philadelphia

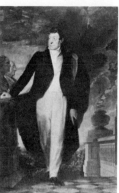

8
Samuel F. B. Morse
1791–1872

*Marquis de Lafayette*
1824

96 x 64 in.

Courtesy of the Art Commission of the City of New York

somewhat similar to Sully's, an increasing lessening of structure with softer, more sfumato effects as time went on. This mastery of high-style portraiture is attested to in the image of *Miss Anna Gibbon Johnson* of 1828 (cat. no. 37), Neagle's most fashionable known work. While he has suggested the varying elegant textures of furs and velvets well enough, he appears even more concerned with the specifics of style, especially the broad-brimmed hat with the meticulously delineated, sinuous feathers, a concentration that suggests the dictates of the wealthy young sitter. Certain features in Anna Johnson's portrait are idiosyncratically Neagle's own: his tendency to emphasize a high brow, a long, thin nose, and a small chin. The smooth flesh painting suggests again his debt to Sully, but the richer color and direct gaze are even more Stuart-derived. The color and directness really relate most of all to the work of Sir Thomas Lawrence, though Neagle did not travel abroad and would have had only limited opportunity for firsthand acquaintance with his work in this country. Lawrence-like also is the device of silhouetting the figure not only against a vast expanse of sky, but on a parapet, towering over a landscape of great depth. Dorinda Evans has convincingly suggested the influence of Thomas Cole's early Romantic landscapes in the background and the symbolic implication of a pilgrimage through life, as Anna stands ready to walk down the long flight of stairs to the landscape.[19] She is putting on her gloves, ready to depart on a journey that takes her incidentally from the very real world of the foreground, garbed in her fashionable raiments, down to the symbolic voyage of life; for Miss Johnson it should be a very elegant journey! A further source of inspiration, however, for the composition—positioning the subject at the head of a flight of steps leading into a panoramic landscape—would almost surely be the most famous American portrait of the decade, Samuel F. B. Morse's portrait of the *Marquis de Lafayette* (fig. 8).

Neagle's most "official" grand manner portrait, and in fact the most public of all of his images as well as the most standard, is that of *Henry Clay* (cat. no. 38). On

Clay's retirement from the Senate in 1842, Neagle was sent to Ashland, Clay's home in Lexington, Kentucky, on a commission to paint a full-length portrait of the distinguished statesman. There he painted a bust portrait and a series of full-length studies which resulted in the finished painting the following year.[20] The likeness in the full-length is a strong one, but the studio procedure of adapting studies for a final work done apart from the sitter is only too apparent. Not only is the head too small for the body in the artist's attempt at traditional elongation, but the three-quarter turn of the head to the left is contrasted with a vigorous swing of the body to the right. This gives dynamism to the figure— undoubtedly to indicate that Clay was still vigorous in his later life—but the dual conception is too evident.

Clay, like Pat Lyon, is accompanied by an anvil, both a symbol of strength and a reference to his background. The major symbol in the foreground is a globe with an American flag partially covering it, indicative of Clay's role as a statesman. Behind is a column, again a sign of great strength and of classical erudition, echoing the uprightness of the figure who stands on a stone parapet or podium, as resilient as the subject himself. Neagle has clearly divested the setting of any semblance of specific, historical reference, substituting easily readable, generalized symbols. Behind Clay are a plow and some cattle and even further back, across a great plain, a ship upon the sea, silhouetted against the sunset sky— for this is the sunset of Clay's life. The middle ground refers to Clay's vast agricultural interests in Kentucky as well as to his background, but it is more, and it is allied with the flag in the foreground. Clay is meant to be seen as a man of the people and a product of the American soil, however much he might have achieved great leadership. Agriculture and trade, in fact, are emphasized as the basis for a prosperous America in the plow and the sailing vessel, an America already aware of her manifest destiny, with the oceangoing vessel seen even beyond the "Western" farm, referential also, of course, to Clay's

expansionist policies in Congress. The original portrait of 1843 was ultimately acquired by Philadelphia's Union League Club; a replica is now appropriately in the United States Capitol, purchased in 1871 from the photographer Matthew Brady.

Lesser portrait artists in Philadelphia, as in other major cities, might paint pleasing and satisfactorily composed and structured likenesses, but they seldom endowed them with much psychological depth. Even more significant for our study, they rarely received commissions important enough to be developed with grand manner trappings and interpretations. Jacob Eichholtz is a case in point. Born in Lancaster, Pennsylvania, he profited from the advice of the visiting Sully in 1808 and from that of Stuart, whom he visited in Boston in 1811, however harsh and discouraging that advice was. In 1812 Eichholtz set himself up as a professional painter in Lancaster, with much traveling beyond, and between 1823 and 1832 he established a quite comfortable livelihood in Philadelphia, before returning for his final years to Lancaster. Yet, despite a large, even impressive oeuvre, he painted only a few three-quarter-length portraits and, except for a few children's portraits, only one adult full-length portrait.[21]

This commission, then, Eichholtz' portrait of *Bishop John Stark Ravenscroft* of 1830 (cat. no. 39), must rank as the artist's most ambitious painting. Eichholtz is said to have attended Christ Church, Philadelphia, in order to study Ravenscroft while he was preaching. This may be a confusion with Christ Church, Raleigh, however, for when the portrait was commissioned by Charles P. Mallett, Sr., warden of St. John's Church, Fayetteville, North Carolina, Ravenscroft was rector of the Raleigh church as well as bishop of North Carolina. Eichholtz began the painting in 1829 and finished it the following year; by the time he exhibited it at the Pennsylvania Academy in 1830, Bishop Ravenscroft had died. The reason for Mallett's choice of Eichholtz is unrecorded, but it may be due to his having just painted the portrait of *William Heathcote DeLancey* (American Scenic and Historic Preservation Society, New York), later to be consecrated

bishop of the new diocese of Western New York, or particularly that of Henry Ustick Onderdonk, assistant bishop of Pennsylvania (unlocated).

Though the Ravenscroft portrait has been decried as over-elaborate and unconvincing, it is, nevertheless, an impressive pictorial statement.[22] The likeness itself is one of the strongest that Eichholtz ever painted, solidly modeled with intense, piercing, deep-set eyes. The somewhat niggling detail of the bishop's glasses atop his head must be recorded fact, suggesting that the subject was nearsighted and had no need for the glasses when addressing a congregation; his left hand rests upon a book, presumably a Bible. The bishop is shown in the act of preaching or exhorting his audience, and he is dynamically posed, his right arm upraised in contrasting syncopation with the downward plunging left, his right foot forward in front of his left, anchoring the figure, yet suggesting a forward, empathetic movement.

The commanding impression is strongly abetted by the manipulation of the bishop's clerical robes. The mantle-like chimere he wears gracefully but forcefully leads the eye up to his head and gesture, while the billowing sleeves enlarge the figure to a commanding presence. The setting, with the priest's chair, the Gothic ecclesiastical architecture, and the church silver all reinforce Ravenscroft's public and spiritual position; the specificity of the setting and accessories are perhaps a sign of a more literal artist. The ministerial and episcopal portrait often implies a certain projection of spiritual inspiration and constitutes a special subgroup in American art that awaits in-depth study.

The situation in New York for portrait painters during the early nineteenth century was not so clear cut as it was in Philadelphia or Boston.[23] New York had begun to assume, by the second decade of the century, leadership in cultural development as it had in the economic sphere. There were, consequently, a great many professional portraitists and their number was increasing. They offered

a diversity of styles, within a general approach that has been designated as "Romantic Realism," a basically realistic style tempered by some suggestions of ideality and generality, and formally characterized by painterly qualities. Naturally, the appearance of so many portrait painters on the scene led to some degree of rivalry. Fortunately, this was offset by the growth of formal and informal organizations in the city. These included social clubs, such as the Bread and Cheese, founded in 1822, followed by the first Sketch Club in 1829, which continues to this day as the Century Association. In clubs such as these the artists mingled among themselves as well as with literary figures, businessmen, and politicians, in sum, with individuals who were often also their patrons. Most important for the artists of New York was the National Academy of Design, established in 1826. Unlike the Pennsylvania Academy, it was run by the artists themselves, with patrons and other interested persons as honorary members. Such banding together tended to ameliorate the rivalries, especially for important public commissions, when these infrequently appeared. More significantly, the cultural cross-fertilization produced by the social intimacies and exchange of ideas developed a unique intellectual climate in New York, which has long been designated as "Knickerbocker," after the pen name of Diedrich Knickerbocker used by Washington Irving in his satirical *A History of New York* of 1809.[24]

In this period, one dependable source of prestigious public patronage existed in New York City, the picture gallery at New York City Hall.[25] This ever-growing collection consisted of portraits of the mayors and governors of New York, together with likenesses of other figures of outstanding significance. That collection is still in city hall, and it may today seem difficult to apprehend its significance, as it is so little viewed and so little attention is devoted to it by present-day authorities. Yet, in its own time, it constituted the most significant goal of the portrait artist. First of all, it was the only public display on continual view in New York, assuming a role, equally surprising,

like that played by Foundling Hospital in London beginning in the 1740s. Secondly, the artists were always chosen after great deliberation, sometimes after competitions, as attestations to their superiority, and of course the works usually were large, impressive likenesses to which they gave their all. While New York had no truly "official" portrait painter, some claim to that position could be made by the numbers of portraits in the city hall collection painted by any one artist. John Trumbull was the first artist to assume that role and the first of his thirteen portraits was commissioned in 1790 for the old city hall; the present structure was completed in 1812. While almost every New York artist of this period got his share of commissions—John Vanderlyn, Samuel Waldo (with one assigned to him along with his partner, William Jewett), Samuel F. B. Morse, Robert Weir, Rembrandt Peale, and Frederick Spencer—only two are noted with half a dozen or more commissions: John Wesley Jarvis and Henry Inman. Not surprisingly, these two were generally ranked, successively, as the leading portrait painters in New York between 1810 and 1845.

John Wesley Jarvis was born in England but grew up in Philadelphia, studying with Edward Savage. He turned to painting in the early years of the nineteenth century, forming a partnership with the miniaturist Joseph Wood in New York. Jarvis began to come to the fore in New York portrait painting in 1808, a propitious moment for him if not for the art. John Trumbull returned to Europe that year and Vanderlyn, Samuel Waldo, and Rembrandt Peale were also there. Among the young artists of New York, Jarvis was left with the field and began to achieve a certain amount of prominence with portraits of notable figures in New York and elsewhere; in 1809 he painted *Washington Irving*, who was just then on his way to fame (Sleepy Hollow Restorations, Tarrytown, New York).[26]

Jarvis' real success came, however, during the War of 1812, again in part at least fortuitously. In 1813 the Corporation of the City of New York decided to commission a gallery of heroes, those naval

officers who had won such spectacular victories over the English in the early days of the conflict. Either local patriotism did not figure in their thinking at all or they had decided that none of the portraitists practicing in New York was up to the task of painting not only full-length figures but likenesses imbued with the proper spirit of heroic patriotism. In any case, the artists they chose were Gilbert Stuart of Boston and Thomas Sully of Philadelphia, the latter having just demonstrated his ability with the portrait of the actor Cooke. Stuart was asked in 1813 to paint the two commanders of the ship *Constitution*, Captain Isaac Hull and Commodore William Bainbridge. After Sully had finished a commission from the city for a half-length portrait of Colonel Jonathan Williams at the end of 1813, he was assigned the full-length portrait of Commodore Stephen Decatur and went to New York in July to take the portrait, a romantic image in sparkling uniform, with New York Bay and Castle William in the background. But Stuart in Boston, having begun the likeness of Hull, quarreled with Bainbridge, and promptly refused to continue. The Corporation of the City then applied to Sully to take over the painting of these likenesses, but Sully, fearing to offend the great American master of portraiture, proposed that the two work together, Stuart painting the figures and Sully providing the accessories, since it was known that Stuart had an aversion to spending time on backgrounds and the like. When Stuart did not acknowledge Sully's offer, the latter also withdrew from further consideration.

The corporation then turned to Jarvis, who immediately accepted, certainly realizing that the chance of a lifetime was being offered. Although documentation does not exist, it seems likely that Jarvis took over the work known to have been begun by Stuart; there are no further reports of this work of Stuart's, the *Hull* having been partially completed, and these first two likenesses of Hull and Bainbridge taken over by Jarvis from Stuart are far more Stuart-like than any of the rest of the series. In 1815 Jarvis

was commissioned for portraits of *Commodore Thomas Macdonough* and *General Jacob Brown* and in 1816 for the most elaborate and famous of the series, that of *Commodore Oliver Hazard Perry at the Battle of Lake Erie* (fig. 9); in 1817 he received payment for the last of the series, *General Joseph Gardner Swift*.

These were Jarvis' great works, and they became a featured attraction of the city of New York. William Dunlap wrote that Jarvis "painted those full-length portraits of military and naval heroes which will keep him in public remembrance for a short-lived immortality, by their location in the City Hall of New York, and their great merit... They are historical portraits, painted with skill and force...."[27] Space does not permit here a study of their individual merits and the differences of conception. All are full-length figures in commanding pose and full uniform, against a background of swirling smoke and clouds signifying battle, their confidence and ease assuring the viewer of their triumphant success. In the background of each are further appurtenances pertaining to their particular histories and victories, the compositions becoming successively more elaborate, with secondary figures introduced into the last three. The *Perry* is the most heroic of all, the figure not stiff and upright but extremely animated, showing Perry leaving the disabled *Lawrence* on a small skiff manned by three sailors for the distant *Niagara*; a battle flag with the words "DON'T GIVE UP THE SHIP" behind Perry is a tribute to the illustrious predecessor for whom his disabled vessel had been named.

Jarvis was to paint only one other grand manner portrait, the likeness of James Monroe's vice-president, *Daniel D. Tompkins*, in about 1820 (fig. 10). Tompkins was a former governor of New York whose city hall likeness already had been rendered by John Trumbull, just prior to the latter's 1808 departure for Europe. Jarvis depicted Tompkins posed against a vast panorama of New York Bay, with Fort Tompkins on Staten Island visible in the distance. In addition, Jarvis painted a number of smaller military portraits; some of them perhaps served as the basis for his

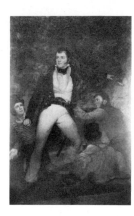

9
John Wesley Jarvis
1780–1840

*Commodore Oliver Hazzard Perry at the Battle of Lake Erie*
1816

96 x 60 in.

Courtesy of the Art Commission of the City of New York

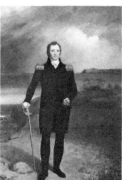

10
John Wesley Jarvis
1780–1840

*Portrait of Daniel D. Tompkins*
c. 1820

90 x 58 in.

Courtesy of the New-York Historical Society, New York City

city hall commissions, others may have resulted from them. These include some unlocated ones, such as his portraits of *General William Henry Harrison* and a *Lieutenant Elton*, and known ones of *Colonel George Croghan* (Mrs. Christopher Wyatt, New York), *Commodore John Rogers*, and the *Portrait of Samuel Chester Reid* (cat. no. 31). Captain Reid's is the most attractive of those so far located and the one most in the spirit of the *Heroes of the War of 1812*, painted in 1815 while the artist was in the midst of his *Heroes* series. It is a private commission, painted along with one of his wife and daughter; but Reid was a feted public figure for his refusal to surrender to the enemy in the Azores, and the New York legislature had voted him a sword. Reid is shown grasping his sword firmly, defiantly, against a background of broken masts, spars, and a proudly billowing United States flag, all amidst the smoke of battle. It is an appealing likeness and a tribute to gallant patriotism, but Jarvis was basically a prosaic if able portrait painter; the grandeur of the grand manner escaped him always.

The closest Jarvis came to creating an iconic image was in the Tompkins portrait; later than the others discussed, it may not be totally by him. In 1814 Jarvis took on as an apprentice the teenage Henry Inman, who was destined to surpass his teacher both in the quality of his work and as New York's most lauded portrait painter. In the last years of Inman's apprenticeship, when presumably the Tompkins portrait was done, Inman is believed to have aided his master considerably in his more ambitious works. He may well have painted the background of this portrait; he may also have done more than that and be partially responsible for its great dignity.

Jarvis was, by nature, a bohemian; he liked his liquor, his women, a good time, and was generally not mindful of social priorities. Inman, by contrast, was referred to in his time as one of Nature's gentlemen; growing up in Utica, his father was something of a figure of ridicule for his steadfast refusal to trade in English costume and ways for the preferred republican modes. After Inman left his apprenticeship, he became, far more than his

master, an important figure in the Knicker-bocker cultural world, but he was also at ease with the best families of New York, many of whom became his patrons—the Eckfords, the Drakes, the Livingstons, and others. By the mid-twenties he had begun to assume Jarvis' mantle of prominence. He was esteemed in New York as Sully was in Philadelphia, and like his colleague, he too became known as "the American Lawrence." His esteem for that British master was reported to amount to almost blind veneration. In a letter of April 17, 1833, to Robert Gilmore in Baltimore, Inman wrote: "I quite long to pay another visit to the 'shrine of my pencil's idolatry.' I mean the portraits of Sir Thomas in yr. possession."[28]

Inman was also to provide the city hall portrait collection with six additions, plus a seventh completed by his pupil Daniel Huntington after Inman's untimely death at the beginning of 1846. Only two of these were full-length portraits, however, and they are certainly two of Inman's most spectacular achievements; they are also his two gubernatorial portraits, the others being mayoral. The earlier of the two—the portrait which effectively signified Inman's preeminence—was that of *Martin Van Buren* (fig. 11), governor of New York for only one year, 1829, before he resigned to become secretary of state. It is the extreme of elegance, the figure stylishly dressed and very spare and tall, elongated out of true proportion and yet convincingly rendered and dramatically illuminated, standing in front of a cloth-covered table with a book and elegant inkstand atop. The typical state chair is not present, and instead Inman has chosen the alternate indoor-outdoor view; the figure stands in front of an elaborately carved balustrade with an urn, the bottom of a tremendous fluted column soars upward at the right, and a dramatic romantic sky is seen in the distance. This was incorrectly noted in the contemporary press as Inman's first full-length portrait and was in general warmly received, though not without reservations both formal and interpretive.[29]

Strangely, however, this did not become the standard likeness of Van

Buren, though that too was by Inman—a bust portrait painted about the time that he assumed the presidency in 1837, and one of Inman's most replicated portraits. Van Buren was a widower when he served his term in the White House, and he had for his hostess his daughter-in-law, Mrs. Abraham Van Buren, born Angelica Singleton, who married his son in 1838. Inman painted *Angelica Singleton Van Buren* in 1842, and the picture now hangs in the White House (fig. 12). It is Inman's most beautiful and most impressive female portrait and a truly "Grand Manner" portrait of a woman. Marvelously sympathetic in its rendition of the lovely lady's beauty, charm, and grace, it conforms to the standards we have already described in Sully's earlier portrait of Eliza Ridgely: smooth skin, swan-like neck, a perfect oval for the head, repeated in the lovely arches of eyes and brows. Garbed and festooned in the purity of white—a patterned silk gown, trimmed in lace—Angelica holds a lace handkerchief, and white feather plumes cascade down her dark brown hair. This "symphony in white" is relieved only by her jewelry, the pink roses at her sleeve, and a yellow-chartreuse mantle which covers her arms. She is posed against a column, and to her right is a marble bust by Hiram Powers of her father-in-law, adorned with a wreath, in this case commemorative rather than memorial. Behind the sculpture is the inevitable broad expanse of cloudy sky, for Van Buren's memory will belong to the ages, to the infinite.

In 1843 Inman completed his second full-length portrait destined to hang in city hall, that of *William Henry Seward* (fig. 13), who was governor of the state from 1838 to 1842. Seward did not seek reelection and returned to his home and law practice in Auburn, New York, where Inman painted him the following year. Perhaps it was the country environment that inspired Inman to choose a novel interpretation of his subject; Seward is shown not as a man in or out of office but as a country squire. He is still a commanding presence, tall, thin, very elongated, and elegant, too, in white stock, black frock coat, holding his gloves, with his top hat and letters on a chair at the left. He is placed in a garden setting,

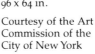

11
Henry Inman
1801–1846

*Martin Van Buren*
1830

96 x 64 in.

Courtesy of the Art Commission of the City of New York

12
Henry Inman
1801–1846

*Angelica Singleton Van Buren*
1842

42½ x 33½ in.

White House Collection, Washington, D.C.

13
Henry Inman
1801–1846

*William Henry Seward*
1844

98 x 66 in.

Courtesy of the Art Commission of the City of New York

with the landscape of rolling hills carrying the eye back to a great distance. Even the typical seat accompanying a figure of importance has been transformed into an elegant garden chair.

The portrait represents what was for the period the essence of aristocratic manhood. The figure was not completed in Auburn but in the artist's New York studio, for it was not the specifics of Seward's form that Inman wished to express but an ideal of masculine elegance. The eyes are confident, the nose and face long, the mouth thin and firm, the forehead broad, emphasizing the intellect. Seward's garments are spotless, and the white stock sets off the head well. By 1843 this was an anachronistic item of dress, one chosen not by the subject but by Inman, who stated that: "I never paint a man in a black cravat if I can help it. On canvas, especially with a dark background, it looks as if his head was cut off."[30]

The Seward portrait was an important commission for Inman, one he hoped would bring him back to public favor, the artist having lost ground after a bankruptcy in the wake of the disastrous economic recession of 1837 and increasing ill health. The common council of New York had not made a decision on a portraitist to portray Seward by February 1843, when the ex-governor made a visit to the city. Seward's friends were fiercely divided, and finally they decided upon a competition. A group of portrait painters was invited to portray Seward; the decision on the city hall portrait would be left with the common council. The other works would be distributed to the ex-governor's friends. Only Chester Harding and Inman appear to have actually taken up the challenge, Harding journeying to Auburn in March of 1843, Inman arriving shortly afterward. Though Harding's portrait, delivered to the Seward family and ultimately left at the Albany state capitol, is a slightly awkward and somewhat prosaic affair, certainly not one of the Boston painter's best efforts, the decision was not reached on the grounds of artistic merit. In fact, the committee deciding the issue could not make up their minds, and so Inman suggested to Harding, "Let's toss for it." Harding assented, Inman

drew forth a half-dollar, and when heads came up, Inman won. His picture was then formally turned over to the common council and hung in the governor's room![31]

Seldom, of course, does the success of a public portrait depend upon the chance toss of a coin. It is perhaps typical of Inman's charm that he would suggest so light-hearted a solution for so significant a decision. Full-length public commissions were not easy to come by; even what has often been deemed his most trenchant likeness—perhaps his finest portrait, that of *John Marshall,* painted in 1831 and discussed earlier—was only a half-length, though Inman invested it with rare dignity and commanding presence. In Inman's case, as in that of so many of the portrait painters of the period, full-length portraits were rare except for images of children, and these were often not life size. Between the Van Buren and Seward portraits, Inman had been commissioned by the alumni of Union College, Schenectady, to paint a full-length portrait of the esteemed and venerable president of that institution, *Eliphalet Nott* (cat. no. 41). If Nott is not so dashing and romantic as the two governors, he is a striking and dignified figure; the setting is surprisingly austere, but this only rivets the viewer's attention more firmly to Nott himself. His intellectual and administrative roles are signified in his academic costume and the sheaf of papers in his hands, while the bas-relief with a forge, below the window, may refer to Nott's inventions in heating and steam power. A heavy red drapery cascades into the room behind him, setting off the rich blacks of his costume and also leading the eye to and out the window, where a view of Union College, taken from the original plans, is seen in the distance. The circular pantheon in the center of the complex had not yet been built; but its dependence upon the library building of Thomas Jefferson's University of Virginia would have been recognized by all viewers at the time, and the association between Nott and Jefferson thus established. Eventually, a very different round building was built at Union College after the Civil War and named the Nott Memorial.[32]

Inman painted a full-length portrait of *William Penn* for the Penn Society in his Walnut Street stu-

dio in Philadelphia. It was completed by March of 1832, in time to be shown at the Pennsylvania Academy that year. Among the possible sources for the portrait were engravings after Benjamin West's famous picture of *Penn's Treaty with the Indians* of 1772 and the statue of Penn by John Bacon the elder, presented to the Pennsylvania Hospital by the grandson of the founder and installed in 1804. But Inman was in Philadelphia seeking out other commissions also; the appearance of so formidable a rival must certainly have disconcerted Sully, who must have been pleased that Inman settled rather out in the New Jersey countryside, and even more so when Inman returned to New York City late in 1834. The reception of Inman's portrait of Penn was decidedly mixed, and in any case it was necessarily a reconstruction; nevertheless, the loss of such a prestigious commission was a blow to Sully, and the commission of 1838 for a portrait of Victoria, the new monarch of Great Britain, by the St. George's Society in Philadelphia must have been very soothing balm. Sully began his original study in May of 1838 and began the full-length from it back in Philadelphia at the end of the year; he also painted a full-size replica and presented it to the St. Andrew's Society of Charleston, South Carolina. For this commission, Sully received the same fee that Inman had for his Penn portrait, one thousand dollars. It might be noted, too, in the continuing "competition" between the two artists, the premier portraitists of Philadelphia and New York respectively, that Inman had unsuccessfully hoped to have a commission to paint Victoria on his only trip abroad in 1844–45.

Even Inman had few opportunities for the full-length portrait. His first may have been his major venture into theatrical portraiture, the depiction of the great English actor *William Charles Macready as William Tell* (fig. 14). Inman was obviously "debuting" in grand manner theatrics along the same path earlier trod by Sully—a comparison particularly apt since both Macready and George Cooke were English, and Macready had in fact made his first great impression as Richard III. He came to America in 1826, and Inman's portrait was finished

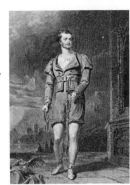

14

Asher B. Durand
1796–1886

Steel engraving of
*William Charles Macready*
*as William Tell*
after a painting by
Henry Inman

3¹³/₁₆ x 2⅝ in.

Collection
William H. Gerdts

by 1827, in time to be exhibited at the National Academy that year and later in Boston to almost universal critical applause.³³

Still, city hall remained the most significant patronage goal of the period, particularly for New York artists. As we have seen, military heroes shared honors and wall space there with mayors and governors, and distinguished visitors were commemorated in portraiture as well. In the second decade of the nineteenth century there was no more celebrated American than Andrew Jackson, the hero of the Battle of New Orleans, the victor over the Spaniards in the Seminole Wars that led to the cession of Florida to the United States, and later the president of the country. When Jackson made a triumphant tour of the country in 1819, his visit to New York City caused the local art establishment to vie for the taking of his likeness, the ultimate goal being, of course, a city hall commission. Both Waldo and Jarvis painted exceptionally spirited likenesses of Jackson (several examples by each; one example of each, Metropolitan Museum of Art, New York), which might have served for a truly heroic grand manner portrait for city hall, but John Vanderlyn received the commission instead; his final full-length, completed in 1820, is a stiff and labored affair. Waldo and Jarvis both received commissions to replicate their likenesses, and Waldo at least did have the opportunity to enlarge his to a full-length portrait for the New Orleans Custom House, but that picture has long since been lost. Not surprisingly, it was Sully who was commissioned to paint Jackson's portrait in Philadelphia (Historical Society of Pennsylvania, Philadelphia), and Rembrandt Peale, then resident in Baltimore, painted the portrait for the city council there.³⁴

Jackson's triumphal tour was the precedent for the longest and most elaborate such celebration ever to take place, the return visit of the Marquis de Lafayette to this country in 1824–25. The motivations for Lafayette's trip do not concern us here, but wherever he visited and stayed, great celebrations took place and countless memorials were created in his honor, from wearing apparel to triumphal arches. Cities naturally vied for outstand-

ing likenesses, and artists competed among one another. Sully journeyed to Washington, D.C., to take Lafayette's likeness for the city of Philadelphia. When the common council in New York requested Lafayette to sit for his portrait, petitions were immediately forthcoming from Sully in Philadelphia, from Jarvis, Inman, Waldo, Charles Cromwell Ingham, James Herring, and Rembrandt Peale, but it was Samuel F. B. Morse, the pupil of Allston and West, who won the coveted commission in January of 1825. He was to produce a full-length portrait for seven hundred to one thousand dollars, plus half the profits of an engraving to be made by Asher B. Durand. The loss of this commission effectively ended Jarvis' reign as first painter in and to New York, though it was Inman, not Morse, who was to succeed him.

Lafayette's image had a higher meaning to America than did that of Jackson, for he embodied the principles for which the nation had fought successfully fifty years earlier, and he was one of the last survivors of that glorious revolution. As the heroes of the struggle were dying off, the need to enshrine their memories and when possible record their likenesses became more and more apparent. It is not coincidental that Rembrandt Peale's "new" national image of Washington was created at this same time, as we shall see, or that John H. I. Browere began in 1817 to record in sculpture the features of such revolutionary leaders as Thomas Jefferson and John Adams.³⁵

Morse painted Lafayette's portrait (fig. 8) not in New York but in Washington, where Morse learned the news of the death of his young, beloved wife. Despite, or perhaps because of this, he put all his effort and interest into the picture and created the greatest portrait of his career, the archetypical American grand manner portrait. *Lafayette* towers over the viewer, striding vigorously forward, while dominating the almost infinite landscape behind him as well as the monumental flight of stairs that he has just ascended. Morse had "invented" for America the device of a state figure striding forward atop an outdoor staircase he had climbed, towering over the viewer, in his portrait of James

Monroe of 1819–20, painted for the common council of South Carolina; he combined this arrangement with attributes derived from Stuart's "Lansdowne" *Washington* (cat. no. 22). The pose and movement, however, can be traced back to Sir Joshua Reynolds' 1769 portrait of Frederick, the fifth Earl of Carlisle, in Castle Howard (fig. 15), which in turn is a staircase adaptation of the *Apollo Belvedere*, a source Reynolds had previously used in his portrait of the *Honourable Augustus Keppel* of 1753–54 (National Maritime Museum, Greenwich, England). By adapting a classical pose and implying a similar grandeur, Reynolds was very consciously endowing his Grand Manner portraits with the aura of history. Morse was doing no less, though he substituted the icons of the new republic and the New World for the trappings of tradition and nobility which inform the portrait of the Earl of Carlisle.

In the Lafayette portrait Morse has tremendously elongated this actually quite short man. Although he is in the twilight of his life, symbolized by the sunset sky, he is still physically powerful—the ascension of the staircase itself is implied proof of this. Lafayette, though still very much flesh and blood, belongs to the ages; on his left are busts of his deceased contemporaries Washington and Franklin, and a third pedestal awaits that of Lafayette himself, the last of the great revolutionary leaders. The implications of a trinity should not go unnoticed. Morse's creation is an original one for America, for he has transferred the energies of heroic military portraiture to a state image of eternalized grandeur. It was not to be equaled.[36]

The immediate precursor of the great Lafayette portrait in Morse's oeuvre was his likeness of the renowned Yale professor of chemistry and natural history *Benjamin Silliman*, completed in 1825 (cat. no. 36). Silliman had been a teacher of Morse, and the artist has depicted his subject at the podium, lecturing on geological specimens from the Gibbs mineral collection that Silliman had recently acquired for Yale. Morse has endowed the picture with the homilies of university lecturing, the books and papers, the eyeglasses and the watch

to time the lecture, but he has also created an icon of learning—indeed, of universal learning—in Silliman's image. The expression is impassive, unusual for Morse. The figure towers above his lecture notes and lectern, as he does above the viewer. And while the classroom situation may be "real" enough, the great brocaded grand manner drapery hung behind him is not only the exaggeration of a traditional portrait device, it acts as a theatrical curtain being pulled away to reveal the infinitude of the marvelous world at the command of the great savant: the world of geology, botany, meteorology, all viewed in the panoramic prospect beyond; yet it is also the "real" world, as the audience would identify West Rock outside of New Haven as the principal landscape feature.

The name Rembrandt Peale has arisen a number of times in this essay. Rembrandt was one of the many children of Charles Willson Peale, and the one destined to achieve the greatest success in his own lifetime. Toward that goal, he was tremendously supported by his father, who enabled him to have the opportunity of painting George Washington from life in 1795, at the time his father's last life portrait was painted. Further opportunity for study occurred in London, in 1802, with West and at the Royal Academy. Like his father, he was also deeply involved with the museum business, and in fact, the English trip also was motivated by an opportunity to exhibit one of the famous mastodon skeletons in London.[37]

At the end of the first decade of the century Peale was again in Europe, this time in Paris, where he was fired by the challenge of becoming a history painter, a goal in which subsequently he had varying success. Even before he became acquainted with such eminent French artists as Jacques Louis David and the sculptor Houdon, and took their likenesses, however, his portrait style had developed qualities radically different from the English-inspired norm of most Americans, and was rather in the manner of the French Neoclassicists. This is the case for instance, in the portraits of *Jacob Gerard Koch* and *Jane Griffith Koch* of Philadelphia (cat. nos. 32 and 33). The power exuded in the portrait of Mr. Koch particularly is

very French; he is conceived in terms of massive volumes, though the artist has tried a foreshortened pose and the positioning of arms and accessories to hide to some degree the massive bulk of the figure. This quality, combined with a surface smoothness that obliterates most brushwork and an intense but impassive candor in Koch's gaze, allies the picture to that later masterwork of French Neoclassic portraiture, Jean Auguste Dominique Ingres' portrait of *Louis-François Bertin* of 1832 (Louvre, Paris).

The Koch portraits are, of course, domestic productions. They were painted for private home decoration and in a strict sense do not qualify as grand manner productions; they are modest in size, the full half-length only a shade larger than the most standard bust portrait size. Yet Peale has endowed both husband and wife with many of the traditional trappings of the grand manner: the curtain, the column, and the view into the infinite beyond. Furthermore, they share these elements to exactly the same degree, so that when they were hung in a home opposite one another and facing each other, they would achieve an impressive symmetry adding to their formality of conception.

Peale differentiates the characters of husband and wife by presenting Mrs. Koch more sympathetically, not only with a slightly melancholic expression but with a slight tilt of the head, more languid gestures, and a more relaxed costume. His interpretation of Mrs. Koch is formally repeated in the emphasis upon drooping oval forms, the subject's head and body, her headdress, and the chair-back behind her. In contrast, her husband is more expansive, almost explosive.

It is difficult to ally Peale with any one major community, for he changed residences frequently. After his return from studying abroad he worked in Charleston and Baltimore and later in Washington, New York, and Boston, even while Philadelphia was his home. In 1810, when he came back from France, he was again in Philadelphia, where the Koch portraits were painted. In 1813, however, he moved to Baltimore where he remained

for eight years, opening a museum there in the following year and maintaining it until 1822. In 1816, the War of 1812 over, the city council of Baltimore commissioned Peale to paint portraits of four of the men who had served heroically in the defense of the city and its final victory, a gallery of heroes obviously inspired by the group of military paintings Jarvis had painted just previously for New York City Hall. Peale's pictures were more modest affairs, half-length portraits, but imbued with the proper heroism; three years later he was asked to add two more to the gallery, including that of Andrew Jackson.[38]

From Baltimore, Peale returned to Philadelphia in 1822, and three years later he was in New York City, where he joined the increasing numbers of fine portrait painters working there. He made several more journeys to Europe at the end of that decade and the beginning of the next, finally settling permanently in Philadelphia in 1833. Ten years earlier, however, Rembrandt had devised a pictorial invention that would not only insure his livelihood but would represent the ultimate national pictorial icon. He formulated a portrait of George Washington based only to some degree upon his own early effort of 1795; rather, it is a composite of the known likenesses of Washington, his father's last portrait of 1795 especially, combined with a strong injection of Neoclassic idealization.

This, the "Porthole" *Washington*, as it has become known (fig. 16), and for good reason, was replicated by Peale many times; the total number he painted is not known. The image was available facing right or left, and there were three basic adaptations: Washington in civilian costume, with a great black mantle over his shoulders; Washington in military uniform; and the latter, depicting Washington astride a horse. The enframing, too, could show variations, though always Washington was seen through *trompe l'oeil* oval stonework. This might be simply rendered, or it might be surmounted with a stone head of Zeus and the words "Patriae Pater"—father of his country—carved into the stone below. The military renderings were the more popular, judging by the known number of

replicas, which Peale continued to paint throughout his long life; the artist himself suggested that he had painted seventy-nine copies (meaning replicas) of his original picture.

To advertise his "invention" Peale not only painted replicas to order but took the most elaborate one on tour in 1823, the version that was acquired by Congress in 1832 (fig. 16). Touring had been a success for his great moral extravaganza, *The Court of Death*, of 1820, and he hoped for equally enriching results with his Washington portrait. The work was advertised in brochures, along with testimonials to the accuracy of the likeness from artists, politicians, judges, and the like, including John Marshall. Charles Willson Peale's own assurances as to its merits were not among the least enthusiastic. Odes were composed celebrating the image, and both lithographs and engravings of the portrait were also offered for sale to those who could not afford an oil replica.[39]

With what he referred to as "the National Portrait," Peale was of course challenging Gilbert Stuart's accepted image of Washington, and after 1828 he was able to advertise himself as the last living artist who had painted Washington from life. Although lifelikeness was a necessary virtue for the American audience, it was really beside the point for the image that Peale had painted and the ideal he wished to project. Peale, who really had a thwarted ambition to be a history painter, here achieved a truly historical portrait. It was one not only in its historical subject; it achieved the goals of the history painter in the prescribed manner. It was indeed a "composition"; it does not look like Peale's original life portrait, and if it did, it would be more a likeness and less the inspirational projection of patriotism and supreme moral fortitude that the artist intended.

Washington's face is loosely based upon the various painted and sculptured images of him done previously, but it is actually of no specific age. He has the white mane of a sage, but the strongly modeled face is that of a man in his prime and the clear eyes and firm jaw reject the

inroads of age. The head is turned to the left and Washington looks out, not at the viewer, but at some larger goals, some greater destiny, though the body is firm and erect and squarely centered. Light aggressively carves out the features of Washington, who is as solid as the stonework that surrounds him, and if that stonework is deceptively real, then Washington is no less so. But the stonework functions in another more symbolic sense. It separates Washington from the viewer, and though he is a very real figure, not a wraith who has gone to his reward, he is in another world. It is a timeless one, and on the other side of the porthole is the realm of the ideal, of memory, of eternity. Washington is an American deity; this was reinforced in those examples of Peale's image that surmounted his enclosure with the keystone of Zeus, a pairing that Horatio Greenough also chose in his heroic statue of *Washington* (Smithsonian Institution, Washington, D.C.), modeled in part upon the reconstructions of the Phidian Zeus a decade or so later. The heavy aggressive modeling and smooth brushwork which is Peale's own may be unappealing today, but it does not seem to have been in its own time, judging by the large numbers of replicas commissioned of the work. Though Peale does not seem to have practiced ''portholing'' extensively, one could order a ''Porthole'' *Martha Washington*. He also painted a ''Porthole'' *Lafayette* in 1825 (Metropolitan Museum of Art). But perhaps the most attractive of all of these images is that of *John Oliver* (cat. no. 34), painted in 1824 after Oliver's death for the Hibernian Society of Baltimore, of which Oliver had been president. In this case, Oliver leans out of his porthole in a somewhat more familiar manner, extending an elbow, if not a hand, from his world of the departed to the viewer in the here and now, and a direct gaze establishes empathy that is lacking in the Washington portraits. Peale also alleviates the harshness of the heavy stonework enframement by surrounding the porthole itself with a decorative molding and an attractive simulated stone garland above the subject, in the manner of

decorative carvings for marble mantelpieces of the time. One may be grateful today that Rembrandt Peale's formula for the grand manner portrait did not take hold of the public imagination in a large way—galleries and corridors filled with porthole portraits is a fearsome thought—but it was a novel creation which embodied, perhaps all too clearly, the theories and purposes of historical portraiture.

As one moves away from the major urban centers of the Northeast during the early years of the century, forays into the grand manner become fewer, though sometimes quite impressive exceptions can be located. Charleston, South Carolina, particularly, contained an extremely sophisticated society, and an ambitious one, with a long tradition of involvement in the arts. Like its Northern counterparts, Charleston witnessed attempts at promoting the fine arts in academies and exhibitions, though these were of short duration. A reflection of the New York City Hall portrait collection can be found in similar works commissioned from some of the same artists for the city hall in Charleston, such as Trumbull's *George Washington*, ordered in 1791 (cat. no. 27), Morse's *James Monroe*, ordered in 1819, and Vanderlyn's *Andrew Jackson*, ordered in 1824 (cat. no. 35).[40]

In private commissions, portraits embodying notions of grandeur were also commissioned. Some were by Northern artists who were in Charleston on extensive visits, such as Samuel F.B. Morse. Others were by local residents, where reflections of work of major artists, sometimes charmingly provincial, can often be seen. A case in point is the likeness of *Jane Ball Shoolbred* by the twin-brother artists of Charleston, James and Robert Bogle (cat. no. 42). In 1843 the two went their separate ways, James to New York and Robert to New Orleans, but until then they were active participants in Charleston's art life.

The Ball family of South Carolina was one of the most prosperous and prominent. Hugh Swinton Ball owned a major art collection, including Henry Inman's most ambitious painting, his *Bride of Lammermoore* of 1834 (private collection, California); Ball's own portrait was a dashing half-length which Inman painted

earlier, in 1829. But Jane Ball Shoolbred's likeness by the Bogle brothers harks back rather directly to Sully's portrait of *Eliza Ridgely*. One can, of course, deride the Bogles' achievement by pointing out the relative inadequacies of their portrait in comparison with Sully's accomplishment: the tilted floor on which Jane Shoolbred seems uneasily posed, the unconvincing spatial environment, and the inability of the Bogles to foreshorten the harp as Sully so effectively did. Certainly, the rather plain and slightly anxious Mrs. Shoolbred does not achieve the ideality of the beauteous Eliza Ridgely; the Bogles' creation is not an inspired one, nor do they project the inspiration of the muses achieved through the communion with music as Sully did so well. Yet it is not simply a matter of lesser competence or provinciality on the part of the Bogles that makes their young musician look so different. Roughly twenty-five years and a change of aesthetic separate the two portraits. Sully's portrait belongs to the Romantic era, with its softly faceted forms, flowing line, melting shadows, and sweeping movement. In contrast, the Bogle portrait partakes of the sober rationality of the classical era in American architecture, decorative arts, and painting. Rather than emotion, geometry reigns in this period, firmly bounding clear volumes, which are further defined by distinct local colors. The wall decoration and the monumental column remind us that Charleston embraced the classical style more completely than almost any other American city. The style to some extent shaped the manner of artists such as the Bogles toward the solid, the stable, and the precise. Portraits of this period attributed to George Flagg partake of this general style as well.

One encounters relatively few successful grand manner portraits in the classical style, probably because its clarity and discrete surfaces precluded romantic sweep. No intervening atmosphere, no encroaching obscurity soften the particular in the interests of a general effect. But how to handle those stubbornly solid forms? The leading New York portraitist in the classical style,

Charles C. Ingham, often went too far in the direction of idealization, so that many of his portraits lack force of personality. The Bogles, on the other hand, were driven toward the Charybdis of material fact. This is certainly what Jane Shoolbred looked like, and the Bogles' handling of her satin dress is eminently successful as is their transcription of the marvelously elaborate Empire harp, which an instrument maker could reproduce from their picture. In place of Sully's gentle landscape panorama, the Bogles have substituted the harbor of Charleston. In a word, for all their high ambitions, the Bogles have created a monumental "common portrait" in comparison to the "poetic portrait" of Sully—the one, a transcription, the other, truly a composition and an interpretation.

Robert Bogle moved on to New Orleans in the 1840s, where he certainly must have run into formidable competition. There, too, able portrait painters were engaged in a flourishing trade in the pre-Civil War days, artists such as the Norwegian emigrant Adolph D. Rinck and the Belgian Jacques Amans. In the previous decade, the Frenchman Jean J. Vaudechamp was active in New Orleans, creating such an impressive masterwork of portraiture as his likeness of *Antoine Jacques Philippe de Marigny de Mandeville* (fig. 17), who had married the daughter of the first American governor of Louisiana.[41] The brilliant portrait of Marigny in full uniform is an outstanding example of the military image, though sympathetic in interpretation and relaxed in pose, placed in an outdoor setting. The distinctive art of New Orleans is only now under scholarly study.

Elsewhere in the South and West, able but often more prosaic painters were taking the likenesses of local inhabitants, with occasional excursions into more ambitious interpretations. Ralph E. W. Earl, the son of the Connecticut painter Ralph Earl, arrived in Nashville, Tennessee, in 1817 to paint Andrew Jackson's portrait (fig. 18) and, marrying Mrs. Jackson's niece, remained with the family in Washington during Jackson's presidency and in Nashville before and after. Earl primarily turned out images of Jackson for

17

Jean Joseph Vaudechamp
1790–1886

*Antoine Jacques Philippe de Marigny de Mandeville*
1833

46 x 35 in.

From the Collection of the Louisiana State Museum, New Orleans

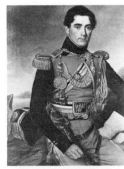

18

Ralph E. W. Earl
1788–1838

*Andrew Jackson*
1835

35⅞ x 27⅞ in.

National Museum of American Art, Smithsonian Institution, Transfer from the National Institute, Washington, D.C.

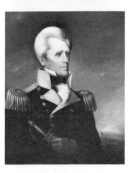

19

Matthew Harris Jouett
1787–1827

*Marquis de Lafayette*
1825

104 x 72 in.

Courtesy of Kentucky Historical Society, Frankfort

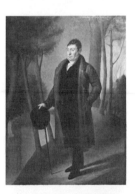

20

Ary Scheffer
1795/97–1858

*Marquis de Lafayette*
1823

92 x 62 in.

Architect of the Capitol, Washington, D.C.

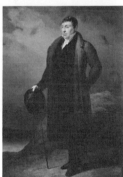

private parties and as state images, earning the title of "The King's Painter." Many of these are bust portraits, but others are full-length images of him in military uniform, in presidential guise, and as a Tennessee gentleman and landowner.[42] In neighboring Kentucky, Matthew Harris Jouett profited from conversations with and advice from Gilbert Stuart in Boston and immediately set up a studio in Lexington, where he dominated the field of Kentucky portraiture to such an extent that the young John Neagle quickly abandoned attempts to establish himself there on a visit in 1818. Like his mentor, Stuart, Jouett was quite content to concentrate upon the likeness of his subject and pretty much avoided anything larger than a half-length portrait. His one foray into the grand manner occurred in response to a commission from the Kentucky legislature for a full-length portrait of the *Marquis de Lafayette* (fig. 19), ordered in January of 1825. Jouett went to Washington with the intention of painting the likeness there, but Lafayette was too busy to give him sittings. Jouett's portrait is primarily a copy of the well-known, even standard likeness that had been painted by the Dutch-Parisian master Ary Scheffer (fig. 20), which had been donated to the nation by the artist the previous year. Subsequently, in May, Lafayette visited Lexington and Jouett had an hour's sitting with him; but the pose and composition of his portrait, now in the Kentucky statehouse in Frankfort, are basically Scheffer's, though Jouett incorporated a wooded forest background and Washington's tomb at Mt. Vernon to suggest the New World and Lafayette's revolutionary connections.[43]

In what was then the West, there were two or three principal urban centers, again each with several able portrait specialists. James Reid Lambdin was the principal portrait painter in Pittsburgh, while Cincinnati, "The Athens of the West," boasted a rich and thriving artistic community under the patronage of the local Maecenas, Nicholas Longworth.[44] Aaron Corwine, John Frankenstein, Miner Kellogg, James Beard, and William Henry Powell were all taking likenesses there

before the middle of the century, but Longworth's own monumental full-length was painted by the mulatto Robert Duncanson, an artist more impressive in his landscape specialty.

The little-known semi-primitive artist George Markham was active in St. Louis before several Eastern portraitists settled there about the middle of the century—Sarah Miriam Peale, who had studied under her cousin, Rembrandt Peale; the Portuguese-born Manuel Joachim de Franca; and Henry Inman's student Ferdinand Boyle. But the leading portrait painter resident in Missouri was the most famous Western artist of the period, George Caleb Bingham.[45] Bingham's reputation then and now was established primarily on the basis of this great scenes of Western river and political life, but the majority of his paintings were actually portraits, and his development from inspired but untrained primitive to strong professional is clearly traced in his many known works. The majority of Bingham's portraits were, naturally, private commissions. But he painted a number of impressive full-length works, some of which, however, are not life-size but much smaller, paintings which would have been referred to in the middle of the nineteenth century as "cabinet-size," though in portrait painting the "cabinet portrait" more generally referred to a likeness only slightly larger than a miniature (i.e., of dimensions between a half foot and a foot).

The outstanding example of this format in Bingham's oeuvre is unquestionably the 1844 portrait of *John Cummins Edwards* (cat. no. 43).[46] Edwards was governor of Missouri and had befriended Bingham when the latter was working in Washington, D.C., four years earlier while Edwards was a U.S. congressman. Bingham painted Edwards in Jefferson City, the state capital, and in the background of the Edwards portrait the capitol building is shown in an otherwise unspecific landscape. Edwards' image itself is an extremely impressive one, strong and determined, and totally impassive. The figure is—again—elongated, unnatural in proportion

but effective and iconic; while he holds his hat in his right hand and his left foot comes forward, he is otherwise totally frontal and symmetrical. This, together with the intense straightforward gaze, eye-to-eye with the viewer, is an important aspect of the power of the image. Any divergence from a central axis lends an informal air to a portrait image; conversely, extreme frontality pictorially establishes an essentially ceremonial and even iconic image, which can be seen as early as the sculpture of the ancient Egyptians and the mosaic programs of the Byzantine Empire.

Edwards is silhouetted against a broad expanse of sky as he stands in what is referred to as a "plateau" landscape; that is, he is posed on a high foreground which drops off immediately below him so that only the very bottom of his cloak cuts the horizon line and even it is hanging just above the outline of the foreground plane. The governor dominates the landscape—the State of Missouri—as he does the statehouse below and behind him at the left. He also towers above the viewer and his background consists of all the heavens, of the infinite. The total compositional program, the forward-striding figure elevated above both landscape background and spectator, suggests an indebtedness to the most impressive of earlier American state images, Morse's portrait of the Marquis de Lafayette. The difference is, of course, one of scale. There is always the possibility, however, that the Edwards portrait presently known is a completed study for a lost life-size image; Bingham, Ralph E. W. Earl, and a number of artists created such preliminary studies as part of their methodologies. Bingham's portrait, however, bears witness that the monumentality inherent in and expected of the grand manner image need not necessarily be dependent upon dimensions; Bingham's small portrait of Governor Edwards has more of the grand style than the full-length likeness of Jane Shoolbred by the Bogle brothers. Perhaps significantly, Bingham achieved this degree of effectiveness in an image that is not life-size but of a size comparable to those figures that were beginning to populate his Western genre paintings at exactly this time.

■

By the 1840s, the nature of and attitudes toward art in America had undergone considerable revision since the beginning of the Romantic period. In 1810 portraiture was just about the only viable art form for a painter to practice; by 1845 the increasing numbers of art exhibitions in large communities, and even occasionally in smaller ones, contained works of a great variety of themes. Critical reaction was becoming decreasingly concerned with portraiture, which often was found repetitive and generally not sufficiently reflective of America's cultural aspirations—certainly not to the degree embodied in nativist landscapes, heroic national historical pictures, or even genre subjects that contained qualities indigenously American. A detailed explanation of the formal and ideological changes that overtook American art is far beyond the scope of this essay, but it is worth noting that along with a thematic realignment went a changed pictorial appearance. The Romantic emphasis upon interpretation and ideality was often replaced in portraiture by an increased specificity, a new "Realism."[47] This has frequently been interpreted as a result of the influence of photography—the daguerreotype was introduced in 1839—but in fact, the new attitude toward the portrait and the expectations of its appearance were probably the result of the same scientific spirit that engendered the camera, a demand for an exactitude of image, each development distinct from the other. The human face and figure were each maps to be precisely delineated, as landscapists such as Frederic Church were called upon by their critics to be geologists when painting rocks, botanists when delineating trees, and meteorologists when reproducing clouds and skies. Important here, too, was the lessening of American dependency on the English aristocratic portrait tradition as nationalistic emphases became entrenched, though the earlier British influence was replaced in part at mid-century by a brief admiration for the hard, precise style practiced and taught in Düsseldorf, Germany.

While the most vaunted painters of the period 1845 to 1865 were landscape, genre, and history paint-

ers, portrait specialists were still busily active. It is true, though, that the art of miniature painting was in fact largely replaced by photography. Many of the miniature painters turned to that new portrait form, sometimes coloring photographs in watercolor. But the painting of the portrait-in-large, the life-size image, continued to flourish; it merely did not attract very many of the more original and creative young artists. New York, too, became more and more the center of portrait activity for official images, though able artists were taking likenesses professionally as far away as Chicago and Bangor, Maine.

In New York City, Charles Loring Elliott succeeded to the position ceded by Henry Inman on his death in 1846; indeed, Inman is reported to have said of the young Elliott that, "When I am gone that young man will take my place."[48] Elliott not only replaced Inman in public and critical esteem but in his style and approach toward portraiture, which was at first heavily dependent upon Inman's English-inspired Romanticism but came to be the exemplar of the new Realist mode. Inman, in fact, was aware of the changes that would overtake portraiture at the mid-century, changes which Elliott's art came to embody, and which Inman recognized in Elliott's portraiture. He observed: "He has the true idea of portrait painting. If it were possible for me to live my life over again, in some respects I would change my style." In what respect, he was asked. "In this: each face should be a study of itself, no aim at a peculiar touch should betray me into a conventional style."[49]

Elliott was particularly a portraitist of mature males, though probably his most famous and certainly his most exhibited portrait is that of *Mrs. Thomas Goulding*, painted in 1858 (National Academy of Design, New York). Mrs. Goulding is a half-length portrait, but Elliott had no hesitation in tackling the full-length, as three of his mayoral and gubernatorial portraits for New York City Hall well prove. Elliott, in fact, painted portraits of six of the mayors and governors of New York, more than any other mid-century portraitist—another indication of his reputation.

Perhaps the finest of all of his essays into this grand manner format, however, is the image of *Matthew Vassar*, painted in 1861 (cat. no. 50). Vassar stands on the terrace of his home, a convenient setting since a semi-interior at the left accommodates the ubiquitous armchair which holds his hat and gloves and over which a very grand brocaded drapery falls. Directly behind the upright Vassar a tall unfluted column continues the rigid vertical axis of the man upward, beyond the top edge of the painting; the column separates the more interior left half from the distant landscape view at the right, with a view of the college which Vassar founded and which enshrines his name and memory. The geometric pattern of the marble tile floor below him and the small mat on which he immediately stands allowed Elliott a triumph of virtuoso foreshortening; both pattern and mat reinforce the angular outline of the figure of Vassar himself, who looks out directly at the viewer and points across his body to the college in the distance.[50]

Unlike the somewhat bland smoothness of facial treatment by earlier masters such as Inman and Sully, Elliott emphasizes the powerful, three-dimensional volume of Vassar's head, with a strongly modeled chin and a prominent nose. The expression is serious, without the usual bemused benignity of Inman's figures. The face is deeply individualized, Vassar's receding hair is unkempt, the aging eyes shadowed, and the skin untaut below them; the artist does nothing to hide the wrinkles around the mouth and the slight sagging of the cheeks. The hands are slightly pudgy, somewhat lined. Yet, the image is not a mere example of practiced verisimilitude. In the somewhat staccato outline of the pose and gesture of the figure, the dramatic power of the coated figure, and the intense "set" and glance of the head, Elliott has transcended mere naturalism to produce an image of great dignity, a pictorial counterpart to that greatly expressive monument produced by Elliott's counterpart in sculpture, John Quincy Adams Ward's image of *Henry Ward Beecher* of 1891

(Borough Hall Park, Brooklyn). Henry T. Tuckerman might have had the portrait of Matthew Vassar in mind when he wrote of Elliott's sitters, "... when an old man whose face is ploughed with the thought and cares of an adventurous life, and yet alive with the latent fires and marked with the strong will of robust maturity, sits to Elliot [sic], the portrait becomes not only a noble likeness, but a grand study of character and of color."[51]

Elliott's reputation was scarcely greater at mid-century than that of Daniel Huntington, and both of them seem to have garnered commissions for portraits of elderly men particularly and excelled in painting them. Huntington, however, who lived a far longer life than did Elliott and produced an incredibly large oeuvre, was a much more versatile painter than Elliott. He first attracted attention in New York for some rural landscapes done in the late 1830s, and in the next decade was recognized primarily as a painter of large history paintings and moral allegories. After a large one-man exhibition held in 1850 in the Art-Union rooms in New York, he devoted his talent principally to portraiture. The result of this diverse activity was that most subsequent literature on Huntington's art was involved with his subject paintings, although he was, in fact, a painter of literally thousands of portraits. He was also a most influential figure in the art world of New York, president of the National Academy of Design from 1862 to 1870 and again from 1877 to 1890, and became identified with the more conservative art and policies associated with that institution at the time.[52]

Huntington was a founder of the Century Club in New York, the major social organization of New York artists and the successor to the original Sketch Club; he was also its president for sixteen years. It was fitting, therefore, that a group of members presented the club with Huntington's great portrait of *Asher Brown Durand*, painted in 1857 (cat. no. 45), depicting Durand seated in a landscape and painting a view of Franconia Notch on his easel. The scene on the easel is, in fact, a

section of a large landscape entitled *Franconia Notch*, painted by Durand that year for the great New York collector Robert L. Stuart; it hangs today at the New-York Historical Society. The portrait, moreover, is a composite picture, for Durand, not Huntington, painted the landscape on the easel.[53]

       We are concerned here, of course, with the picture as portrait, but the introduction of the landscape painting within the total composition is of special significance. As noted, Huntington himself had been recognized as a distinguished landscape painter, and the collaboration of Durand in painting the picture on the easel was not merely to identify him as a specialist in landscape painting but also to recognize Durand as the American who pioneered in outdoor landscape painting. Until Durand took to painting out-of-doors, landscape painters in this country drew and sketched on excursions into the countryside but only put brush to canvas in the studio. Durand was reputed to be the first actually to paint finished studies in nature, which he would then transfer to larger and more elaborate compositions back in the studio. Thus, what Durand painted on the easel is what Durand himself actually might have painted out-of-doors in preparation for the final exhibition piece for Stuart.[54]

       Such a landscape, then, is very much Durand's ''invention,'' very much a part of the total subject here. It therefore compositionally balances the relaxed and confident artist posed at the right under a tree, while his brushes and palette, the latter beautifully foreshortened, establish the connection, both literal and symbolic, between the artist and his creation. Huntington was extremely comfortable with the seated pose, being able to imbue it with ease and yet with tremendous dignity. Among other exceptional portraits he painted in that format are those of *George Peabody* (Chamber of Commerce of the State of New York, New York; and cat. no. 46), of *Gulian Verplanck*, and his own late *Self-Portrait* of 1890, a companion to that of Durand's at the Century Club.

       Durand's head in the portrait is a noble one, and

Huntington has succeeded in expressing great vigor while yet not denying his colleague's years. In the case of Huntington, we have an artist who expressed his philosophy of portrait painting quite succinctly. He wrote:

> A portrait may be liked by the family of the sitter, while not liked by his friends, and vice versa. I always wish to know for what purpose it is wanted before I begin to paint it. If it is to be owned by his family, I give the man a more familiar and conversational look; if by a society, I try to represent his active public character. The face of almost every business-man has two characteristic expressions—one rather serious and earnest, the other sweet and cheerful with gleams of humor and affection…The living character of the sitter, which is what the portrait-painter strives for, doesn't depend absolutely upon either correctness of color or of drawing, but upon the general expression…Absolute truth is undoubtedly in one sense the most desireable in a portrait, if the artist can know and feel it. The real character, not the obvious character, is what he tries to represent; the capacity, capability, potentiality of the man—what the man was, so to speak, designed to be. Still, it seems proper that his finest traits should be emphasized in a portrait, since every side of his character cannot be given in the same picture…That painting, it seems to me, is of a higher order which discerns the germs of truth in the sitter's character, and brings them out.[55]

In addition to completing for New York City Hall the portrait of Mayor James Harper which Henry Inman, Huntington's teacher, had left unfinished on his death in 1846, Huntington also was commissioned for the portrait of Governor Edwin D. Morgan for the repository. Almost equally popular at mid-century was Thomas Hicks, who contributed four mayoral and gubernatorial portraits; that of *Hamilton Fish* of 1852 (fig. 21) is a paradigm for the grand manner official portrait in the mid-century. Fish is shown in total confidence in expression and pose, recognizably standing in the governor's office surrounded by the symbols of officialdom, such as a bas-relief of

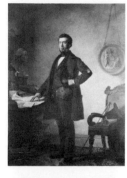

the state seal, while his statesmanship is sanctioned by a bust of Washington on his desk. Similar though less dramatic is Hicks' *Portrait of George T. Trimble* (cat. no. 44), the superintendent of schools in New York City, painted two years later, in 1854. Trimble is also shown in his office with all the appropriate trappings, but his doors open onto a broad urban scene, with New York Public School No. 1 opposite and hoards of little children happily congregating and playing on the sidewalks and streets. A small but pertinent detail in both pictures is the wastepaper basket— and perhaps strangely, the *same* wastepaper basket. It has been pointed out that the Fish portrait contains the first known representation in an American portrait of such a container—an object not then one of common domestic use—and the *Trimble* probably the second.[56] Its inclusion is not an idiosyncrasy of Hicks', but it does figure in his iconographic scheme. At a time when paper was less common and less wasted, the need for such a receptacle was the connotation of a busy man, active in his official time- and paper-consuming job.

Sully might paint Queen Victoria, and the mid-century portrait specialists just discussed might have an occasional foreign sitter of note. Huntington painted an impressive likeness of George William Frederick Howard, Earl of Carlisle, in 1851. But George Peter Alexander Healy became the first American portrait painter of truly international renown. Boston-born, he prepared for that rise to cosmopolitan fame by going to Paris to study with the eminent Baron Antoine Jean Gros in 1834, an unusual destination and course for an American at that time. Healy's rise was swift. By the time he returned to this country ten years later he had painted royalty and statesmen of both England and France; he had come back home at the request of the French king Louis Philippe to paint a series of presidential portraits.[57]

The fall of the French monarchy in 1848 persuaded Healy to remain in this country, and he moved to Chicago in 1854 at the personal invitation of the mayor, William Ogden; he was the first artist of note in that midwestern

community. After the Civil War he returned to Europe, living in Rome and Paris and resuming the role of international portrait painter, with occasional trips back to his native country. With such a career, Healy's art was truly an embodiment of the grand manner; that is, his portraits were very often official and elaborate, whether they were portraits of state or portraits of society. In the latter category, he painted a good many large and elaborate portraits of women, far more than his home-developed and home-nourished contemporaries. That of *Mrs. R. H. Winslow,* painted in 1859, is such a likeness (cat. no. 48). Healy has done nothing to disguise the bulk of this prominent figure in Washington society but rather stresses her bulk to create an impressive, commanding image of social leadership. Her costume is dark and simple, and accessories are also reduced to a few basic items—a fall of brocade drapery at the right and the white lily of purity at the left. The year 1859 seems to have been a particularly brilliant one for the artist; he was much engaged in paintings for Washington society and also painted the likeness of *President James Buchanan* (National Portrait Gallery, Washington, D.C.) in accordance with a congressional appropriation. Indeed, as an international portraitist, Healy served in a role that was precursor to that held by John Singer Sargent in the next generation.

The mid-century period—the years between about 1840 and the late 1860s—saw the rise in America of a major school of historical painting, although a hundred years of subsequent neglect have almost wiped out the memory of these works, the aspirations they embodied, and the reputations of most of the artists involved in creating them. The one painter who succeeded in avoiding such total historical obliteration, and the one to have recently enjoyed some modicum of revival, was the leader of the movement and the historical painter most recognized in his own time, Emanuel Leutze. Some contemporaries would have deemed him the most significant and most famous of all American painters. He was the artist also who most fully absorbed and represented the artistic techniques and ideals of the school in Düsseldorf, Ger-

many, where he was almost the first of many American student artists.[58]

While historical painting constituted Leutze's greatest interest and embodied his highest achievements, he was also a superb portrait painter. Since he not only studied but painted for much of his career in Germany, remaining abroad from 1841 to 1851, again from 1852 to 1858, and briefly returning in 1863, many of his works were not only painted in Germany but exhibited there and some entered German collections. This is true even of some of the historical pieces, though many of these he sent back to America for exhibition and possible sale. The portraits he painted abroad were, for the most part, of Germans, and naturally stayed in Germany.[59]

After studying in Philadelphia with John Rubens Smith, Leutze began his professional career as a sometimes itinerant portraitist working particularly in Virginia, where his art constituted a slightly provincial variation of the Romantic portraiture of his day being practiced by Sully and others.[60] But once he had developed his mature art in Düsseldorf, it absorbed the hard linearism and the sometimes melodramatic grandeur characterizing the teaching and practice among native German painters. A restrained sentiment enters into the beautifully constructed portrait images he painted there, most often of relatives in his own family or that of his bride, Julia Lottner; it was she he depicted most often. But the masterpiece of Leutze's German portraiture is that of his father-in-law, *Colonel Heinrich Lottner* (fig. 22), painted during his second Düsseldorf stay in 1853. Though Lottner had retired from service eleven years earlier, he is depicted as the essence of the military man, rigidly upright, erect in bearing, bemedaled—but not too bemedaled—and at attention. His heavy cloak over his left shoulder and the downward plunge of his right arm, holding his military hat, balance one another and have great weight. The head is powerfully modeled, staring straight out, a completely objective but marvelously distinctive likeness. The background is completely bare, completely undistracting. The precision of

form and outline defines the abstract essence of the Prussian military officer; it is also one of the many elements here that so clearly identify Leutze's heritage from the German Renaissance tradition of Holbein, a tradition that coincidentally underlies the earliest known American portraiture in the seventeenth century.

In America, Leutze seldom achieved this degree of inspiration in terms of profound psychological penetration or definition of type and class as well as the individual, though his technical mastery remained very much intact. Only rarely, as in his 1862 portrait of *Nathaniel Hawthorne* (National Portrait Gallery, Washington, D.C.), did something of the informal geniality of his own family portraits enter into his later American likenesses. In his great image of *Chief Justice Roger Brooke Taney* (fig. 23), actually painted with the use of a photograph, Leutze produced the portrait masterpiece of his career, a spectral image who appears to look out at and beyond the viewer, frontal and rigidly symmetrical within an equally rigid and geometric setting.

Otherwise, Leutze's American portraiture was, for the most part, respectable naturalism in the service primarily of public figures or, more informally, of artist friends. Among the most notable of these sitters was *William Henry Seward*, painted twice by Leutze, in 1859 (cat. no. 47) and again in 1861 (New-York Historical Society, New York). Leutze had just arrived in Washington in 1859 after landing in Boston. He was in the nation's capital hoping to receive a commission for the decoration of the Capitol building, while Seward was a United States senator serving there. Leutze's portrait of his friend Seward painted that year is one of his best, most ambitious, and formal, a full-length seated likeness of the statesman at work, Seward appearing to have had his attention just called away from his worktable. A great deal of slightly fussy decoration surrounds Seward, wooden moldings and pilasters on the walls behind and a patterned carpet on the floor, all as sharply delineated as the central figure of the senator himself.

Leutze also painted a number of commemorative portraits,

23

Emanuel Leutze
1816–1868

*Chief Justice Roger Brooke Taney*
1859

58 x 44½ in.

Courtesy of the Harvard Law School Art Collection

24

Emanuel Leutze
1816–1868

*Washington at Dorchester Heights*
1853

108 x 81½ in.

Trustees of the Public Library of the City of Boston

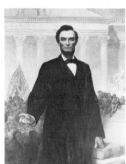

25

Emanuel Leutze
1816–1868

*Abraham Lincoln*
1865

69 x 50 in.

The Union League Club, New York

figures of Washington and of the recently assassinated Abraham Lincoln, which fall somewhere between portraiture and history painting; in any case, they are certainly grand manner. The earlier and more successful was that of *Washington at Dorchester Heights* (fig. 24), a reconstruction of March 4, 1776, when Washington moved onto the high grounds overlooking British-held Boston. Leutze's Washington is an iconic, idealized figure, impassive and determined, leaning upon a cannon, symbolic of strength. He exudes power— his military coat and great cloak almost pulling apart—and the figure is restrained between cannon barrel and the gun's great wheel, while his soldiers, much smaller and behind him, engage in contrasting activity. Gilbert Stuart's reconstruction of the same subject painted in 1806 and owned by the city of Boston is an obvious prototype here, but Leutze's picture is even more iconographically related to Charles Willson Peale's still earlier portrait of *Washington after the Battle of Princeton* of 1779 (cat. no. 20), where Washington also leans on a cannon. Peale's Washington, however, is a much more human, more relaxed figure; Leutze's has assumed a stance of heroic resolution, and Washington is deified in the impassivity of a quasi-religious image.[61] At hand was the plaster mold taken from Houdon's clay bust of Washington, which Leutze had used in *Washington Crossing the Delaware* (Metropolitan Museum of Art, New York), but in *Washington at Dorchester Heights* Leutze has created a more youthful image, a revolutionary winter Apollo, not so much historic leader as divine icon. Of Leutze's somewhat bizarre and equally iconic portrait of *Abraham Lincoln* (fig. 25), one might best spare the artist's memory and avoid repeating the aggressive diatribes of that earliest of professional American art critics, Clarence Cook, who noted that the only redeeming factor he could find in regard to the picture was that it was privately, not publicly, owned.[62]

In Philadelphia and in Boston, there does not seem to have arisen a new crop of young portrait specialists who came to dominate the field to the extent that a group in New York did, though this aspect of those cities' artistic history awaits

study. Sully appears to have retained his dominance of the situation in Philadelphia, while Chester Harding appears to have maintained his popularity in Boston for many years, though he had relocated to Springfield in the western part of the state as early as 1830. In Boston, at least, there did appear in the 1850s several able young portrait painters, such as Joseph Ames and Moses Wight. The best of their work suggests high competency and real distinction, and it is to be regretted that their careers remain so little studied. They may be important artists in establishing a separate Boston tradition. Ames seems to have admired the very individual art of Washington Allston, whose portrait he painted around 1840 (private collection), and his own then quite popular portrait work may be significant in establishing some transition for the ascendancy in that sphere of William Morris Hunt, with whom Ames shared a broad and rich painterly mode, quite unlike the sharp meticulousness, strong chiaroscuro, and aggressively solid modeling of Elliott and others in contemporary New York.

Allston's heritage may be a more significant factor in Hunt's art than has generally been acknowledged; the aforementioned Clarence Cook coupled them together when he wrote a laudatory obituary of Hunt for the *New York Tribune* on September 9, 1879. But the more immediate distinction of Hunt's painting style derives from his study in France, first with Thomas Couture and then with the Barbizon peasant painter Jean François Millet, before he returned to America in 1855. In 1856 he settled in Newport, Rhode Island, remaining there until 1862, when he moved to Boston. Having married into the socially prominent Perkins family, he joined the *haut monde* that summered in Newport. Hunt took on portraiture there, and later, as a major component in his art, though he is best known for his figure paintings. Still, it is estimated that he painted about 200 portraits and was certainly the major portrait specialist in New England for about two decades.[63]

Hunt's portrait of *Judge Lemuel Shaw* of 1859 (cat. no. 49) established the artist in this field, in a work commissioned by the Essex Bar Association of Salem, Massachusetts. Hunt has posed Shaw here in the act of making a court summary, for which the judge was noted to be exceptionally able. The massive standing figure holds a brief in one hand, the other rests on a legal tome on a draped table. Except for carpet and wall molding base below, the rest of the painting is quite bare. Although Hunt painted figures of prominence—statesmen and society women—he tended to eschew the trappings and accessories of profession and position that contemporaries deemed so necessary and that make up the stock paraphernalia of grand manner portraiture. Even the poses his figures assume are undeclamatory. Just as he avoided niggling and fussy accessories, so the figures themselves are conceived in broad, generalized masses, forms simplified into large units—a heritage certainly from Millet—while his richly applied paint, using color to model forms, follows the method of Couture. The face itself is individualized, yet even here the features are generalized, not the detailed ''map'' that Elliott, Hicks, or Huntington would have delineated. Hunt introduced sfumato effects to soften interior contours, a practice that ultimately suggests Leonardo da Vinci, but probably was observed in the work of Correggio, whom Hunt greatly admired. In any case, the final product is a projection of image, not likeness.[64]

Perhaps the most striking and distinctive technical aspect of the picture is the utilization of a light, almost white background, against which the heavy dark figure is brilliantly contrasted. This imbues the image with tremendous drama and power, without resorting to strong and harsh chiaroscuro. It is a feature not to be found in all of Hunt's portraits, but it was utilized by the artist for many of his finest and most effective works, beginning with the Shaw portrait. The origins of this approach are not known, though some works of Couture suggest a partial prototype for it. Another source is very likely, however. It is known that Hunt used photographs for a great many of his portraits, not necessarily just for the painting of posthumous works but photographs taken for his express use, to combine with live sittings and save the sitters' time. Examples of such photography are known in which the sitter was posed against a brilliant white sheet, to catch a maximum of detail for the artist's working photo. Hunt certainly had sittings from Shaw, as drawings and oil studies suggest, but he may well have utilized photography here also. In any case, Hunt's methodology and aesthetic were not totally consistent. Some of the portraits in which he is known to have used photographs still maintain the more traditional darker background. Others, in which he certainly had life sittings, adopt the innovative light or white background, although the technique in the first place may be inspired by photography. That approach also allowed, as in the Shaw portrait, for emphasis upon a strong yet quite decorative contour to define his figure. While his ''blurring'' of form and feature may also derive from photography, it may equally well be Hunt's original response to that medium by avoiding the hard precision associated with the new art.[65]

Society women figure along with prominent public figures among Hunt's more ambitious efforts. In such a lovely work as his likeness of *Mrs. Robert C. Winthrop, Jr.* (Museum of Fine Arts, Boston), painted in 1861, two years after Judge Shaw's, the brilliant off-the-shoulder violet dress Mrs. Winthrop wears is silhouetted against a traditional dark background; but that of *Mrs. Robert Shaw Sturgis* (private collection), painted probably about a year later, is shown in an outdoor setting, her dark hair and deep blue dress silhouetted against the bright lightness of the cloudy sky. Posed about to ascend a staircase, her image achieves a monumentality suggested by imminent elevation. Yet in most of Hunt's portraits, especially those of lovely women such as Mrs. Sturgis, there is a quality of charm and of deep humanity which in some ways undercuts the premise of grand manner portraiture. They may wear the styles of François Xavier Winterhalter's portraits of the Empress Eugénie and her court (Musée National du Château de Compiègne, France), but they eschew

the associated pomp for a projection of quiet sympathy.

A survey of mid-century American portrait painting may be concluded with observations on a new form of grand manner portraiture that entered the realms of our art at that time. This is the commemorative group portrait. This form was not, in fact, an invention of the mid-century in America. It can be traced back to much earlier prototypes, those by Rembrandt and Frans Hals in the Dutch seventeenth century being perhaps the best known. Also, as more immediate precedents, one can cite such works as John Singleton Copley's *Death of the Earl of Chatham* (Tate Gallery, London), painted in 1781, or John Trumbull's *The Declaration of Independence* (fig. 26), the large version painted in 1818 for the Capitol in Washington. While these last are true history paintings, they have incorporated into them very careful, specific likenesses of the individuals involved. They embody the group portrait which was continued well into mid-century with a good many once-famous paintings: George Catlin's *Virginia Constitutional Convention* of 1829–30 (Virginia Historical Society, Richmond); Tompkins Matteson's *Compromise* of 1850 (unlocated); George Flagg's *Laying of the Atlantic Telegraph Cable* of 1858 (Connecticut Historical Society, Hartford); Thomas Prichard Rossiter's *Prince of Wales at the Tomb of Washington* of 1860 (National Museum of American Art, Washington, D.C.); Emanuel Leutze's *The Alaska Treaty* of 1867 (Foundation Historical Association, Inc., the Seward House, Auburn, New York); Thomas Hill's *Driving the Last Spike*, begun in 1875 (California Department of Parks and Recreation, on loan to the California State Museum of Railroad History, Sacramento); and Cornelia Fassett's *Electoral Commission* of 1877 (Capitol, Washington, D.C.). The Civil War was the source of a good many such history-group portraits; among these are Francis Carpenter's two best-known works, his *Reception in the White House in Lincoln's Presidency* of 1863 (White House, Washington, D.C.), and *Lincoln Reading the Emancipation Proclamation* of 1864 (Capitol, Washington, D.C.); Ole Balling's *Grant and His Generals* of 1865 (National Museum of American Art, Washington D.C.); and George P.A. Healy's *The Peacemakers* of 1869 (White House, Washington, D.C.), Lincoln himself figuring in this last. Although the popularity of such works, and certainly the attraction of prints after them, depended a great deal on their topicality, many such works reflect events that happened earlier. These include such pictures as Albion Bicknell's *Lincoln at Gettysburg*, an event of 1863 painted in 1881 (Malden Public Library, Malden, Massachusetts); Robert Hinckley's *Ether Day* (Francis A. Countway Library of Medicine, Boston), begun in 1882 and finished in 1893, depicted the application of anesthesia in 1846; and Daniel Huntington's *Atlantic Cable Projectors* of 1894–95 (Chamber of Commerce of the State of New York, New York), the cable having been laid in 1858. In such retrospective works the degree of historical portrait accuracy must necessarily have been variable.[66]

In any case, these usually very large paintings fall somewhere within the shadowy area between history and portrait painting. But the mid-century witnessed a variant form produced in this country. In pictures that were certainly more portrait than history painting, well-known and honored figures of the period were grouped together somewhat artificially in thematic commemoration; these were based on actual portraits of the individuals that were neither reconstructions nor approximations. The most famous commission for such works came from William B. Wright, a wealthy manufacturer and sometime United States senator and mayor of Newark. A collector and resident of Hoboken, he commissioned four paintings in 1857 from four well-known artists with some specialization in portraiture. Daniel Huntington was to paint *Men of Science*; George Baker, the *Artists of America*; Thomas Hicks, the *Authors of America*; and Thomas Prichard Rossiter, the *Merchants of America* (fig. 27). Only this last ever materialized, a painting of thirty-one bankers, manufacturers, railroad executives, and the

26

John Trumbull
1756–1843

*The Declaration
of Independence*
1818

144 x 216 in.

Architect of the Capitol,
Washington, D.C.

27

Thomas Prichard
Rossiter
1818–1871

*Merchants of New York
(Merchants of America)*
1857

108 x 192 in.

Courtesy of the
New-York Historical
Society, New York City

like, men such as Peter Cooper and Albert Gallatin.[67]

Though the immediate precedents in the nineteenth century for such works were such well-known French programs as Ingres' *Apotheosis of Homer* (Louvre, Paris) and, more immediate and better-known, Paul Delaroche's *Hemicycle* in the Palais des Beaux-Arts in Paris, the Wright commission is reflective of the fierce nationalism of the time, the wish to validate and document, pictorially, the progress, even the superiority, of the country in business, science, and the arts. Also in 1857, Christian Schussele, an Alsatian trained in Paris before he came to America in 1848 to become a well-known genre and history painter, was commissioned by Jordan Mott of New York to paint his *Men of Progress* (cat. no. 51).[68] In this picture, completed in 1862 (large version, Cooper Union for the Advancement of Science and Art, New York), scientists and inventors in all fields appear together to celebrate the contributions presented to the world by America's greatest minds: Peter Cooper, Samuel Colt, Charles Goodyear, John Ericsson, Cyrus McCormick, Elias Howe, and Mott himself, a very successful figure in ironwork manufacturing.[69]

Schussele's training and proven ability in the naturalistic grouping of many figures, already practiced in his genre work, and his accomplished sense of history stood him in good stead in his complex composition. Despite the unreality of the premise, the different individuals are harmoniously grouped in a variety of believable poses, each anatomically realized and interrelated convincingly. They are grouped within a vast, columned room, presided over by a painted portrait of Benjamin Franklin, as though present at a colloquium of great minds; Franklin's portrait was added along with Ericsson's likeness in 1862 after the latter's ironclad *Monitor* revolutionized sea warfare. The overall projection is solemn but lively, a worthy tribute to the achievements of the young nation. Surely on this basis Schussele was commissioned in 1863, the year after *Men of Progress* was completed, to

paint *Washington Irving and His Friends at Sunnyside* (Sleepy Hollow Restorations, Tarrytown, New York), based upon a sketch made by Felix O. C. Darley. The conception was derived from a painting of *Sir Walter Scott and His Friends at Abbotsford* (Scottish National Portrait Gallery, Edinburgh) by the Scottish artist Thomas Faed, painted in 1854; Scott had sent Irving a mezzotint of that work.[70] In turn, such group compositions of the famous and respected look forward to later masterworks, such as John Singer Sargent's painting of *The Four Doctors* for Johns Hopkins University, completed in 1906.

■

A discussion of the critical attitudes toward portraiture in general and grand manner portraiture in particular, during the period under consideration, is beyond the scope of this essay. Suffice it to say that there was constant debate over the relative merits not only of many of the portraits exhibited in the growing numbers of public exhibitions and of the abilities of the portraitists themselves, but also over the relevance of portraiture compared to other artistic themes—the age-old hierarchy of thematic values. There were also the understandable discussions, usually and increasingly in a critically negative sense, of the merits of presenting such a repetition of portraiture in those exhibitions. Yet, some critics stood up for portraiture and ranked it high. One critic in the *New York Mirror* in 1829, for instance, wrote that: "An historical scene is a fiction, merely. Be it ever so true to nature, it is still the fiction of the painter. But a portrait is truth itself."[71] And as late as May 1854, a writer in *Putnam's Monthly Magazine* stated that: "Portraiture is, in truth, the highest order of art and the most beneficent, as it is the only legitimate kind of painting."[72]

The salutory purposes that a display of grand manner, official portraits could have were recognized and welcomed in discourses by several of the leading public figures in this country in the early decades of the nineteenth century, and their words were respected enough to be immortalized in print. In an address to the

American Academy of Fine Arts in New York in 1816, ex-Senator and ex-Mayor De Witt Clinton said:

*The deliberations of our statesmen—the exploits of our heroes may be revived and perpetuated—deeds of mighty import, the offspring of ethereal minds, and the parents of immortal glory—and here the Portrait Painter, the Statuary, and the Engraver, may transmit to posterity the likeness of those men who have acted and suffered in their country's cause. The portrait collection of this city, by comprising many of the principal heroes of the country, is entitled to great praise in its tendency to stimulate to noble deeds, and to encourage the Fine Arts, by displaying to advantage the compositions of our best painters, and its merits would be greatly enhanced if it were extended so as to embrace illustrious men, who have done honour to the Arts and Sciences, or who have distinguished themselves in other respects as men of extraordinary talents or virtues.[73]*

Eight years later, Clinton's political opponent, the well-known writer Gulian Verplanck, addressed the American Academy to present a sweeping assessment of the role and worth of portraiture. He said:

*The historical portrait is a medium between portrait and history; and where naturally, and without affectation, it can be combined with action (as has been happily done by Jarvis in his picture of Commodore Perry [New York City Hall], in the boat leaving his shattered ship, to hoist his flag on board another, in the memorable fight on Lake Erie), it gives room for the highest powers of the art...In our public places and squares, in our courts of justice and halls of legislation, the eye should every where meet with some memorial of departed worth, some tribute to public service or illustrious talent...*

*But, although it is in the hand of the great epic painter, who fixes upon his canvas the*

sentiment of religion, or the high con-
ceptions of poetic fancy, that the pencil
has gained its chief honours, it is in
another and much humbler department,
that this art appeals more directly to the
patronage, the judgment, and the natu-
ral affections of all of us. It is perhaps
in portrait painting, that we are to look
for some of its best and most extended
uses . . .

       Though it is sometimes applied
to the gratification of vanity, it much
oftener ministers to the best feelings of
the human heart. It rescues from obliv-
ion the once-loved features of the ab-
sent or the dead, it is the memorial of
filial or parental affection, it perpetuates
the presence of the mild virtue, the
heartfelt kindness, the humble piety,
which, in other days, filled our affec-
tions and cheered our lives . . .

       But Paint-
ing becomes public and national when it
is employed in perpetuating the expres-
sion of the mind speaking in the fea-
tures of the brave, the good, the truly
great—of those whose valour made us
free, or by whose wisdom we may be-
come wise; of the heroes of our own
country, or of the patriots of our own
history, of the sages and men of genius
of all countries, who have left us those
works, which form the intellectual pat-
rimony of civilized man—of the heroes
of humanity, of the benefactors of the
human race. Then it becomes, indeed, a
teacher of morality; it assists in the
education of our youth; it gives form
and life to their abstract perceptions of
duty or excellence; and, in a free state
and a moral community, where the arts
are thus made the handmaids of virtue,
when the imagination of the young
patriot calls up the sacred image of his
country, it comes surrounded with the
venerable forms of the wisest and best
of her sons.[74]

WILLIAM H. GERDTS
Professor of Art History
City University of New York

Footnotes

1.

Daniel Fanshaw, "The Exhibition of the National
Academy of Design, 1827," *The United States
Review and Literary Gazette,* vol. 2, July 1827, p. 244.

2.

A study of the history of early American art
criticism has not yet been undertaken, though
there have been many recent signs of growing
interest. Until the 1860s, most direct art criticism,
such as exhibition reviews—as opposed to occa-
sional essays on the state of arts—was written
anonymously and was often from the pen of the
newspaper or magazine editor, who might or
might not be fairly conversant with the arts.
Clarence Cook may be considered the first pro-
fessional American art critic, writing particularly
for the *New York Daily Tribune* in the 1860s and
later. See John Peter Simoni, *Art Critics and
Criticism in Nineteenth-Century America,* Ph.D.
diss., Ohio University, Athens, 1952.

3.

Portrait painting in America between the begin-
ning and the last decades of the nineteenth cen-
tury has received little general treatment. The
one exhibition and catalogue to study this subject
in recent years was *The American Portrait from
the Death of Stuart to the Rise of Sargent,* with an
essay by William John Hennessey, Worcester Art
Museum, Mass., 1973.

4.

For Boston artists, including the portrait painters,
see the six articles by William Howe Downes
that appeared in the *Atlantic Monthly,* vol. 62,
July–Dec. 1888, pp. 89–98, 258–66, 382–94, 500–
10, 646–56, 777–86. See also by Downes, "Boston
Art and Artists," in *Essays on American Art and
Artists,* New York, 1896, pp. 264–81; Samuel L.
Gerry, "The Old Masters of Boston," *The New Eng-
land Magazine,* n.s. 3, Feb. 1891, pp. 683–95.
See also the exhibition catalogues *Boston Painters,
1720–1940,* with an essay by William B. Stevens,
Boston University School of Fine and Applied
Arts, 1968; and *The Boston Tradition: American
Paintings from the Museum of Fine Arts Boston,* with
an essay by Carol L. Troyen, American Federation
of Arts, New York, traveling exhibition, 1980.

5.

See Mabel Munson Swan, *The Athenaeum Gallery,
1827–1873: The Boston Athenaeum as an Early Patron
of Art,* Boston, 1940, pp. 62–73, for the Stuart
memorial exhibition.

6.

The basic study on Harding is by his daughter,
Margaret E. White, ed., *A Sketch of Chester Hard-
ing, Artist, Drawn by His Own Hand,* Boston and
New York, 1890, based upon Harding's *My
Egotistigraphy,* Cambridge, Mass., 1866. See also
"Chester Harding," *Atlantic Monthly,* vol. 19,
Apr. 1867, pp. 484–88; Osmond Tiffany, "Chester
Harding: The Self-Made Artist," *Lippincott's Mag-
azine,* vol. 13, Jan. 1874, pp. 65–74; and Robert
Shackleton, "A Benvenuto of the Backwoods,"
*Harper's Monthly,* vol. 133, July 1916, pp. 267–77.

7.

For the Harding portraits of Marshall, see Andrew Oliver, *The Portraits of John Marshall,* Charlottesville, Va., 1977, pp. 64–82.

8.

Oliver, *Portraits of Marshall,* pp. 134–63, for the Inman portraits and its replicas and copies.

9.

For Allston, see Edgar Preston Richardson, *Washington Allston: A Study of the Romantic Artist in America,* Chicago, 1948, and, more recently, William H. Gerdts and Theodore E. Stebbins, Jr., *"A Man of Genius,": The Art of Washington Allston (1779–1843),* exh. cat., Museum of Fine Arts, Boston, 1979.

10.

The Williams portrait is discussed in Gerdts and Stebbins, *"A Man of Genius,"* p. 86. See also Roger A. Welchans, "Washington Allston Portrait of Samuel Williams," *Bulletin of the Cleveland Museum of Art,* vol. 60, Jan. 1973, pp. 4–8.

11.

For art in Philadelphia, including portrait painting, see *Philadelphia: Three Centuries of American Art,* exh. cat., Philadelphia Museum of Art, 1976. For Sully, see the artist's "Recollections of an Old Painter," *Hours at Home,* vol. 10, Nov. 1869, pp. 69–74; Charles Henry Hart, "Thomas Sully's Register of Portraits, 1801–1871," *Pennsylvania Magazine of History and Biography,* vol. 32, 1908, pp. 385–432; vol. 33, 1909, pp. 22–85, 147–215; Henry Budd, "Thomas Sully," *Pennsylvania Magazine of History and Biography,* vol. 42, 1918, pp. 97–126; Edward Biddle and Mantle Fielding, *The Life and Works of Thomas Sully,* Philadelphia, 1921; and the *Catalogue of the Memorial Exhibition of Portraits by Thomas Sully,* Pennsylvania Academy of the Fine Arts, Philadelphia, 1922. The National Portrait Gallery, Washington, D.C., is planning a major Sully exhibition for the near future.

12.

For the Cooke portrait, see especially Biddle and Fielding, *Life and Works of Sully,* pp. 22–23. See also *Portraits of the American Stage, 1771–1971,* exh. cat., National Portrait Gallery, Washington, D.C., 1971, pp. 22–23.

13.

For the Peale portrait of Nancy Hallam, see Charles Coleman Sellers, Charles Willson Peale with Patron and Populace," *Transactions of the American Philosophical Society,* n.s., vol. 59, pt. 3, 1969, pp. 65–66. For Leslie's involvement with Cooke, see Charles Robert Leslie, *Autobiographical Recollections,* ed. Tom Taylor, Boston and London, 1860, pp. 16–19.

14.

For the Wood portrait, see *Portraits of the American Stage, 1771–1971,* pp. 20–21.

15.

Swan, *Athenaeum Gallery, 1827–1873 . . . ,* pp. 15–16.

16.

Leslie's comment has been reported many times; the source is Sully's *Journal,* typescript in Manuscript Division, New York Public Library. Sully himself published the remark in his "Recollections of an Old Painter," *Hours at Home,* p. 72. It was made in 1837, during Sully's sojourn in England to paint Queen Victoria.

17.

For Neagle, see Thomas Fitzgerald, "John Neagle, the Artist," *Lippincott's Magazine,* vol. 1, May 1868, pp. 477–91; John Neagle, *Exhibition of Portraits,* exh. cat., Pennsylvania Academy of Fine Arts, 1925; Virgil Barker, "John Neagle," *The Arts,* vol. 8, July 1925, pp. 7–23; Marguerite Lynch, "John Neagle's 'Diary'," *Art in America,* vol. 37, Apr. 1949, pp. 79–98; and Ransom R. Patrick, *The Early Life of John Neagle, Philadelphia Portrait Painter,* Ph.D. diss., Princeton University, 1959.

18.

Ransom R. Patrick, "John Neagle, Portrait Painter, and Pat Lyon, Blacksmith," *Art Bulletin,* vol. 33, no. 3, 1961, pp. 187–92.

19.

*Philadelphia: Three Centuries of American Art,* exh. cat., Philadelphia Museum of Art, 1976, pp. 279–80.

20.

Charles Henry Hart, "Life Portraits of Henry Clay," *McClure's Magazine,* vol. 9, Sept. 1897, p. 944.

21.

Eichholtz has the distinction of being the subject of one of the earliest biographical essays devoted to an artist of basically only local reputation. It was written by one Russel, *Port Folio,* vol. 5, no. 4, Apr. 1811, pp. 340–42. He was much noted a century later in various articles in the *Lancaster County Historical Society Papers,* most importantly the study by William U. Hensel, "Jacob Eichholtz, Painter," published in vol. 16, 1912, pp. 1–39; portions of this were reprinted in the *Pennsylvania Magazine of History and Biography,* vol. 37, 1913, pp. 48–79. See also Edgar Preston Richardson, "Portraits by Jacob Eichholtz," *Art in America,* vol. 27, Jan. 1939, pp. 14–23; John Calvin Milley, *Jacob Eichholtz, 1776–1842: Pennsylvania Portraitist,* master's thesis, University of Delaware, Newark, 1960; and Rebecca J. Beal, *Jacob Eichholtz, 1776–1842: Portrait Painter of Pennsylvania,* Philadelphia, 1969.

22.

See Milley, *. . . Eichholtz, 1776–1842 . . . ,* p. 124. The various accounts mentioned above offer slightly varying identifications of the sources of the Ravenscroft commission.

23.

As New York became the center of artistic practice and development, its artistic history became a subject probably too complex to be dealt with retrospectively. Thus, there have been surveys of the art of individual communities and art colonies elsewhere in New York State, of certain regions and counties, and even of the whole state itself, but none specifically devoted to the art of New York City. The general surveys of William Dunlap and Henry T. Zuckerman, of course, deal extensively with New York City art, including portraiture, for the period under discussion. See also "Our New York Painters," in Charles Lanman, *Letters from a Landscape Painter,* Boston, 1845, pp. 233–55; "New York Artists," *Knickerbocker Magazine,* vol. 48, July 1856, pp. 26–42; and various writings by Thomas Bangs Thorpe, especially his "New York Artists Fifty Years Ago," *Appleton's Magazine,* vol. 7, May 1872, pp. 572–75, and the series he contributed to *Baldwin's Monthly,* vols. 11–14, Nov. 1875–May 1877.

24.

For a study of Knickerbocker cultural life of the period, see James T. Callow, *Kindred Spirits,* Chapel Hill, N.C., 1967. Among earlier sources, John Durand's *Prehistoric Notes of the Century Club,* New York, 1882, is particularly significant.

25.

For the city hall portraits, in addition to the several catalogues prepared by the Art Commission of the city of New York, the following articles should be noted: Edith Gaines, "Portraits in New York's City Hall," *Antiques,* vol. 80, Oct. 1961, pp. 346–49; Donald J. Gormley, "Portraits in City Hall," *Pace,* winter 1965, pp. 5–8; and Edith and Harold Holzer, "Portraits in City Hall, New York," *The Magazine Antiques,* vol. 110, Nov. 1976, pp. 1030–39.

26.

For Jarvis, see the definitive study by Harold E. Dickson, *John Wesley Jarvis: American Painter, 1780–1840,* New York, 1949. Prior to this study, several sections of which were published elsewhere, there was John Walker Harrington, "John Wesley Jarvis, Portraitist," *The American Magazine of Art,* vol. 18, Nov. 1927, pp. 577–83; and Theodore Bolton and George C. Groce, Jr., "John Wesley Jarvis: An Account of His Life and the First Catalogue of His Work," *Art Quarterly,* vol. 1, autumn 1938.

27.

William Dunlap, *History of the Rise and Progress of the Arts of Design in the United States,* 3 vols., New York, 1834; new edition, 3 vols., New York, 1965, vol. 2, pp. 220–21.

28.

Inman was written about and praised a great deal by writers in the years immediately after his early death. The year he died there appeared a long account by Charles Edward Lester in *The Artists of America,* New York, 1846, as well as a full recounting of his career in the *Catalogue of Works by the Late Henry Inman; with a Biographical Sketch,* New York, 1846. The following year, a chapter was devoted to Inman by Henry T. Tuckerman in *Artist-Life: Or*

*Sketches of American Painters,* New York, 1847, later expanded into his *Book of the Artists,* New York, 1867. See also "Biographical Sketch of Henry Inman," *International Art-Union Journal,* no. 1, Feb. 1849, pp. 9–11; and "Henry Inman," *Bulletin of the American Art-Union,* Aug. 1850, pp. 69–73. In more recent times, the major study of Inman's career is Theodore Bolton, "Henry Inman: An Account of His Life and Work," *Art Quarterly,* vol. 3, autumn 1940, pp. 353–75. Bolton prepared a supplement to that volume, "A Catalogue of the Paintings of Henry Inman," pp. 401–18. The present author has published six articles on Inman, but none of them dealt with his career generally or surveyed his career as a portraitist. Lester refers to Inman's veneration of Lawrence in *Artists of America,* pp. 46–47; the reference to the Gilmor letter is in the Thomas Seirs Cummings scrapbook, Century Association, New York City.

29.

Thomas Sully was particularly harsh on the Van Buren portrait, criticizing its bad composition and judging it no credit to Inman; see his *Journal* entry for May 16, 1830, Manuscript Division, New York Public Library.

30.

Frederick W. Seward, *Autobiography of William Henry Seward,* New York, 1877, pp. 677–78.

31.

William H. Gerdts, " 'Heads or Tails': The Seward Portrait in City Hall," *Art Quarterly,* vol. 21, spring 1958, pp. 68–80.

32.

Rita Feigenbaum, *American Portraits, 1800–1850: A Catalogue of Early Portraits in the Collections of Union College,* Schenectady, N.Y., 1972, pp. 70–72.

33.

The one serious exception here was the critic who wrote under the name of "Middle-Tint, the second," who distributed handbills attacking the portrait of Macready; see Thomas Seirs Cummings, *Historic Annuals of the Anational Academy of Design,* Philadelphia, 1865, pp. 76–68.

34.

For the portraits of Andrew Jackson, see Charles Henry Hart, "Life Portraits of Andrew Jackson," *McClure's Magazine,* vol. 9, July 1897, pp. 795–804; and Susan Clover Symonds, *Portraits of Andrew Jackson: 1815–1845,* master's thesis, University of Delaware, Newark, 1968. The Waldo portraits are discussed in Russell Walton Thorpe, "The Waldo Portraits of Our Seventh President," *Antiques,* vol. 53, May 1948, pp. 364–65. For the Jarvis portrait, see Dickson, *...Jarvis: American Painter...,* pp. 213–15.

35.

Because of his dual professional roles in art and science, the bibliography on Morse is extensive.

These include: Samuel Irenaeus Prime, *The Life of Samuel F. B. Morse,* New York, 1875; *Samuel F. B. Morse: His Letters and Journals,* ed. Edward Lind Morse, Boston, 1914; *Samuel F. B. Morse, American Painter,* with an essay by Harry B. Wehle, exh. cat., Metropolitan Museum of Art, New York, 1932; Carlton Mabee, *The American Leonardo: A Life of Samuel F. B. Morse,* New York, 1943; Oliver W. Larkin, *Samuel F. B. Morse and American Democratic Art,* Boston, 1954; and the following periodical articles, "Our Artists—No. IV: Morse," *Godey's Lady's Book,* vol. 33, Nov. 1846, pp. 211–13; James Wynne, "Samuel F. B. Morse," *Harper's Monthly,* vol. 24, Jan. 1862, pp. 224–32; Samuel F.B. Morse," *Appleton's Journal,* vol. 6, July 1871, pp. 1–3; Edward Lind Morse, "Samuel F.B. Morse, The Painter," *Scribner's Magazine,* vol. 51, Mar. 1912, pp. 346–59; and Waldo Hopkins, "Samuel F.B. Morse: Artist, Then Inventor," *American Collector,* vol. 8, Aug. 1939, pp. 10–11. The primary source for Morse's art now, however, is Paul Staiti, *Samuel F.B. Morse and the Search for a Grand Style,* Ph.D. diss., University of Pennsylvania, Philadelphia, 1979. Staiti had previously published several articles dealing specifically with Morse's portraiture in South Carolina in the years preceding the Lafayette commission.

36.

The definitive study of the portraits painted of Lafayette in America in 1824–25 is now Marc H. Miller, *Lafayette's Farewell Tour of America, 1824–25: A Study of the Pageantry Amid Public Portraiture,* Ph.D. diss., New York University, 1979. In addition to his discussion of the Lafayette imagery in chapter three, Miller's discussion of "American Public Portraiture, 1766–1823," pp. 154–90, is one of the best treatments of the general theme of this catalogue and exhibition.

37.

Charles Edward Lester, *Artists of America,* pp. 221–31, also included a chapter on Rembrandt Peale. Most important for a study of Peale's art are his "Reminiscences," which appeared in *Crayon,* vol. 1, 1855, pp. 22–23, 81–83, 161–63, 226–27, 290–91, 369–71; vol. 2, 1855, pp. 127, 175, 207; vol. 3, 1856, pp. 5, 100–102, 163–65; and other notices by and on Peale in *Crayon,* vol. 4, 1857, pp. 278–79, 307–308, 339, 370–71; vol. 7, 1860, pp. 24–25, 114; obituary, Nov. 1860, p. 328. See also the article on Rembrandt Peale that appeared in the *Cosmopolitan Art Journal,* vol. 1, Sept. 1857, pp. 156–57. Later studies include two unpublished master's theses, Norman Geske's *Rembrandt Peale: A Case Study in American Romanticism,* New York University, 1953; and Eleanore McSherry Fowble, *Rembrandt Peale in Baltimore,* University of Delaware, Newark, 1965.

38.

See Fowble, "Peale in Baltimore," pp. 98–115, for the Baltimore City commissions.

39.

*Portrait of Washington,* ed., Rembrandt Peale, Philadelphia, 1824. While Rembrandt Peale's life

portrait of Washington of 1795, like all life portraits of Washington, has been much studied and discussed, the later composites into a "national likeness" (as Peale termed his 1823 image) have not received more than passing scholarly attention. For a number of replications, see *Catalogue of Valuable Original Paintings by the Late Rembrandt Peale,* auction cat., Thomas & Sons, Philadelphia, November 18, 1862, p. 9.

40.

For art in Charleston and in South Carolina generally, see the study by Francis W. Bilodeau, Mrs. Thomas J. Tobias, and E. Milby Burton, *Art in South Carolina, 1670–1970,* Charleston, 1970; and the two compendiums of essays edited by David Moltke-Hansen, *Art in the Lives of South Carolinians,* Charleston, 1978 and 1979. Still the standard study of the painters, including the portraitists, there is Anna Wells Rutledge, *Artists in the Life of Charleston through Colony and State from Restoration to Reconstruction, Transactions of the American Philosophical Society,* vol. 39, pt. 2, 1949.

41.

See essay by Lynn W. Farwell in *Jean Joseph Vaudechamp,* exh. cat., Louisiana State Museum, 1968. Jessie Poesch is presently engaged in a study of Louisiana art. Previous published studies concerned with the portrait painters of the period include: Isaac Monroe Cline, *Art and Artists in New Orleans during the Last Century,* New Orleans, 1922; Ben Earl Looney, "Historical Sketch of Art in Louisiana," *Louisiana Historical Quarterly,* vol. 18, 1935, pp. 382–96; Roulhac B. Toledano and W. Joseph Fulton, "Portrait Painting in Colonial and Ante-Bellum New Orleans," *Antiques,* vol. 93, June 1968, pp. 788–95; Cara Lu Salam, *French Portraitists: New Orleans, 1830–1860,* master's thesis, Louisiana State University, 1962; and *250 Years of Life in New Orleans, The Rosemonde E. and Emile Kuntz Collection and the Felix H. Kuntz Collection,* exh. cat., Louisiana State Museum, 1968.

42.

For Earl, see Jerome R. MacBeth, "Portraits by Ralph E. W. Earl," *Antiques,* vol. 100, Sept. 1971, pp. 390–93; and the essay by Harold Spencer in *The American Earls,* exh. cat., William Benton Museum of Art, University of Connecticut, Storrs, 1972; and Symonds, "Portraits of Andrew Jackson...," pp. 28–36.

43.

The Jouett bibliography is quite extensive, reflecting Kentuckians' pride in their art and artists, which appears to be greater than exhibited by most states, over the course of the years. See particularly Samuel Woodson Price, *The Old Masters of the Bluegrass,* Louisville, 1902; Edward Asher Jonas, *Matthew Harris Jouett, Kentucky Portrait Painter (1787–1827),* Louisville, 1938; and more recently the essay by William Barrow Floyd in *Matthew Harris Jouett: Portraitist of the Ante-Bellum*

*South*, exh. cat., Morlan Gallery, Mitchell Fine Arts Center, Transylvania University, Lexington, Ky., 1980. Floyd discusses the Lafayette commission on p. 67.

44.

There have been a number of periodical articles dealing with Cincinnati artists, but the most recent and scholarly study is *The Golden Age: Cincinnati Painters of the Nineteenth Century Represented in the Cincinnati Art Museum*, exh. cat., with essays by Denny Carter and Bruce Weber, Cincinnati Art Museum, 1980.

45.

The history of art in Missouri awaits a scholarly study. Bingham has been the subject of a good many periodical articles and several books. The articles usually deal only with his genre pictures. The books are: Fern Helen Rusk, *George Caleb Bingham: The Missouri Artist*, Jefferson City, Mo., 1917; Albert Christ-Janer, *George Caleb Bingham of Missouri: The Story of an Artist*, New York, 1940; John Francis McDermott, *George Caleb Bingham, River Portraitist*, Norman, Okla., 1959; E. Maurice Bloch, *George Caleb Bingham: The Evolution of an Artist*, 2 vols., Berkeley and Los Angeles, 1967; Albert Christ-Janer, *George Caleb Bingham: Frontier Painter of Missouri*, New York, 1975.

46.

For the Edwards portrait, see Bloch, . . . *Bingham: Evolution of an Artist*, vol. 1, pp. 185–86.

47.

This change of the aesthetic in portraiture is discussed by William John Hennessey in *The American Portrait from the Death of Stuart to the Rise of Sargent*, exh. cat., Worcester Art Museum, Mass., 1973, p. 36.

48.

For Charles Loring Elliott, see E. Anna Lewis, "Charles Loring Elliott, N.A.," *Graham's American Monthly Magazine*, vol. 44, June 1854, pp. 564–68; and a series of obituary articles: Lewis Gaylord Clark, "Charles Loring Elliott," *Lippincott's Magazine*, vol. 2, Dec. 1868, pp. 652–57; Charles E. Lester, "Charles Loring Elliott," *Harper's Monthly*, vol. 38, 1868, pp. 42–50; and particularly the article by Thomas Bangs Thorpe, "Personal Reminiscences of Charles L. Elliott, Artist," and *New York Evening Post*, September 30, 1868, p. 1, and October 1, 1868, p. 1. The remark by Inman is quoted on September 30. For a modern account of Elliott's life and career, see Theodore Bolton, "Charles Loring Elliott: An Account of His Life and Work with a Catalogue of His Portraits," *Art Quarterly*, vol. 5, winter 1942, pp. 58–96.

49.

Thorpe, "Reminiscences of Elliott," September 30, p. 1.

50.

See *The Autobiography and Letters of Matthew Vassar*, ed. Elizabeth Hazelton Haight, New York, 1916, pp. 16, 59–60, 67–69.

51.

Tuckerman, *Book of the Artist*, p. 301.

52.

The earliest articles on Hungtington deal primarily with his subject pictures. They are: "Our Artists—No. 1: Huntington," *Godey's Lady's Book*, vol. 33, Aug. 1846, pp. 68–71; E. Anna Lewis, "Art and Artists of America: Daniel Huntington, N.A.," *Graham's American Monthly*, vol. 45, Aug. 1854, pp. 140–44; G. Silomo, "Daniel Huntington, *Sartain's Union Magazine*, vol. 11, Aug. 1852, pp. 128–30. The later articles give more due to his portraiture: "Daniel Huntington, Ex-President N.A.D.," *Scribner's Monthly*, vol. 2, May 1871, pp. 44–49; "An Artist on Art," *Appleton's Journal*, vol. 18, Dec. 1877, pp. 537–43; S. G. W. Benjamin, "Daniel Huntington, President of the National Academy of Design," *American Art Review*, vol. 2, pt. 1, pp. 223–28; and pt. 2, pp. 1–6, 1881. Benjamin also devoted a section to Huntington in *Our American Artists*, Boston, 1881, pp. 17–21. A recent study of his portraiture is Agnes Gilchrist's "Daniel Huntington: Portrait Painter over Seven Decades," *Antiques*, vol. 87, June 1965, pp. 709–11.

53.

See Daniel Huntington, *Asher B. Durand: A Memorial Address*, New York, 1887, p. 34.

54.

In fact, no oil study from nature has been indentified for the section of *Franconia Notch* on Durand's easel in Huntington's portrait, although an oil study for the middle ground and distance is also in the collection of the New-York Historical Society and was likewise owned by Stuart. It is as though the outdoor study on the easel *is* in fact the one used by Durand in composing his large (six-foot-wide) picture, though of course, such an independent oil study may yet surface.

55.

See "An Artist on Art," *Appleton's Journal*, vol. 18, Dec. 1877, p. 537.

56.

Harold L. Peterson, *Americans at Home: From the Colonists to the Late Victorians*, New York, 1971, plate 98 and commentary. Thomas Hicks never enjoyed the biographical commentary bestowed upon such contemporaries as Huntington and Elliott, or upon his today more famous cousin in whose employ he served, the famous primitive artist Edward Hicks. The one article of note on Thomas Hicks is George A. Hicks' "Thomas Hicks, Artist: A Native of Newtown," *Bucks County Historical Society Collection of Papers*, vol. 4, 1917, pp. 89–92.

57.

This literature on Healy was basically prepared "in family." See his own *Reminiscences of a Portrait Painter*, New York, 1970; the volume by his daughter Mary Healy Bigot, *Life of George P. A. Healy by His Daughter Mary*, Chicago, 1915; and that by his granddaughter Marie de Mare, *G. P. A. Healy, American Artist*, New York, 1954. See also James William Pattison, "Centenary of George Peter Alexander Healy," *Fine Arts Journal*, vol. 28, Apr. 1913, pp. 227–42; and *Healy's Sitters*, exh. cat., Virginia Museum of Fine Arts, Richmond, 1950.

58.

Most of the literature concerning Leutze, published in his own time and in ours, has been concerned with his historical work. The primary studies are an unpublished work by Raymond Stehle, "The Life and Works of Emanuel Leutze," 1972; and Barbara Groseclose's *Emanuel Leutze, 1816–1868: Freedom Is the Only King*, exh. cat., National Collection of Fine Arts, Washington, D.C., 1975, based on her study, *Emanuel Leutze, 1816–1868: A German-American History Painter*," Ph.D. diss., University of Wisconsin, Madison, 1973. See also Ann Hawkes Hutton, *Portrait of Patriotism*, Philadelphia and New York, 1959. Ms. Groseclose also published "Emanuel Leutze: Portraitist," *The Magazine Antiques*, vol. 108, Nov. 1975, pp. 986–91.

59.

The exhibition held in the Museum Schwäbisch-Gmünd, West Germany, *Emanuel Leutze, 1816–1868: Bildnisse und Zeichnungen*, 1968, consisted only of portraits.

60.

Leutze's early portraits are discussed by Raymond Stehle, "Virginia Episodes in the Life of Emanuel Leutze," *Virginia Magazine of History and Biography*, vol. 75, Jan. 1967, pp. 2–10. These were attractive portraits but not at all "Grand Manner."

61.

Groseclose, . . . *Leutze: Freedom Is the Only King*, 1975, exh. cat., pp. 43–44, discussed the *Dorchester Heights* at length and with thoroughness. The picture was shown in New York City in 1853 in the Washington Exhibition, an interesting undertaking featuring pictures of Washington and organized as a nationalistic counterpart to the extensive Crystal Palace Exposition held at the same time, modeled on the first great international exposition held in London in 1851 and the earliest one to take place in America. The proceeds from the Washington Exhibition were meant to be used to purchase Leutze's picture for the New York Gallery of the Fine Arts, which

collection was ultimately incorporated into the New-York Historical Society. The Leutze, however, never entered the collection of the New York Gallery.

**62.**

Cook was the art critic for *The New York Tribune*, and his diatribe against Leutze's *Abraham Lincoln* appeared on June 13, 1865. Cook was aesthetically of Ruskinian persuasion and was vehemently opposed to Düsseldorf and Düsseldorf-inspired art, of which he viewed Leutze, correctly, as the leading American exponent.

**63.**

The literature on Hunt is prodigious. To mention only the most significant items, see: Henry Clay Angell, *Records of William Morris Hunt*, Boston, 1881; Helen Mary Knowlton, *Art-Life of William Morris Hunt*, Boston, 1899; Martha A. S. Shannon, *Boston Days of William Morris Hunt*, Boston, 1923. Among the many early and memorial articles written about Hunt, including several by Knowlton, see Maria Oakey, "William Morris Hunt." *Harper's Monthly*, vol. 61, July 1880, pp. 161–66; Frederic P. Vinton, "William Morris Hunt: Personal Reminiscences," *American Art Review*, vol. 1, pt. 1, Dec. 1879, pp. 49–54; and Sarah Wyman Whitman, "William Morris Hunt," *International Review*, vol. 8, Apr. 1880, pp. 389–401. In more recent times, Martha Hoppin has devoted much research to Hunt; see her *William Morris Hunt: Aspects of His Work*, Ph.D. diss., Harvard University, 1974; and her essay and that by Henry Adams in *William Morris Hunt: A Memorial Exhibition*, exh. cat., Museum of Fine Arts, Boston, 1979. Hoppin dealt at length with Hunt's portraits in her dissertation and essay, and was specifically concerned with them in "William Morris Hunt: Portraits from Photographs," *American Art Journal*, vol. 11, Apr. 1979, pp. 44–47.

**64.**

The Shaw portrait has been much written about over the years. See Knowlton, *Art-Life of . . . Hunt:* pp. 33–36; and the Hoppin dissertation, *. . . Hunt: Aspects of His Work*, pp. 71–89 particularly.

**65.**

Hoppin, ". . . Hunt: Portraits from Photographs," examines in depth the relationship of Hunt's portraits to photography but puts little emphasis upon the relationship of such visual aids to the innovative light, and white, background. Since the general history of American portraiture has been so little studied, a concern with the nature of portrait backgrounds in art historical literature is nil. For a related issue in regard to still life, see William H. Gerdts and Russell Burke, *American Still-Life Painting*, New York; Washington, D.C.; London; 1971, p. 93.

**66.**

The history of the American group portrait has never been subjected to scholarly study, to the knowledge of the author or of the staff of the National Portrait Gallery.

**67.**

See *Crayon*, vol. 4, Apr. 1857, p. 123; and *Cosmopolitan Art Journal*, vol. 2, Dec. 1857, p. 38, and Mar.–June 1858, p. 14, for the Wright commission. The Rossiter painting is discussed by Edith Rossiter Beevan, *Thomas Prichard Rossiter, 1818–1871*, Ruxton, Md., 1957; typescript, Archives of American Art, p. 15; and Ilene Susan Fort, *High Art and the American Experience: The Career of Thomas Prichard Rossiter*, master's thesis, Queens College of the City University of New York, 1975, pp. 97–100.

**68.**

For Schussele, see the early article by George W. Dewey, "C. Schussele," *Sartain's Union Magazine*, vol. 10, June 1852, pp. 462–63; and the recent one by Reverend Bernard E. Michel, M.A., *Christian Schussele: Portrayer of America, Moravian Historical Society Transactions*, vol. 20, pt. 2, 1965, pp. 249–67.

**69.**

"Men of Progress," *Scientific America*, vol. 75, July 1896, pp. 60–61; and " 'Men of Progress'—But Who Are They?" *New York Times Magazine*, March 11, 1962.

**70.**

"Art: Mr. Irving and His Literary Friends," *The Round Table*, vol. 1, Dec. 1862, p. 27; and *Washington Irving and His Circle*, exh. cat., M. Knoedler & Company, New York, 1946, pp. 61–62.

**71.**

*New York Mirror and Literary Gazette*, January 24, 1829, p. 255.

**72.**

*Putman's Monthly*, vol. 3, May 1854, p. 566.

**73.**

De Witt Clinton, *A Discourse Delivered before the American Academy of the Arts, by the Honourable De Witt Clinton, LL. D. (President)*, 23 October, 1816, New York, 1816, p. 17.

**74.**

Gulian C. Verplanck, *Address, Delivered before the American Academy of Fine Arts*, New York, 1824; portions rearranged from pp. 23–29.

Achieving
the Nation's
Imperial
Destiny:
1870–1920

*Michael Quick*

The half century between 1870 and 1920 saw profound changes in the United States. During that period the country rose to world power, its might based upon a rapidly developing economy. American agriculture and manufacturing flourished in international markets, and entrepreneurs and investors who contributed to this financial growth became wealthy in proportion to the expanded trade. The sizable fortunes were vastly more numerous than before 1870, and the really large fortunes were truly immense.

The period was characterized not only by great wealth but also by a different sense of the use of wealth. It was employed for living on a vastly expanded scale. Not only was it used for the personal enjoyment of lavish pleasures but also, and perhaps primarily, for conspicuous display. One extravagant mansion topped another as leading families competed for scale and grandeur. This development in life-styles is made clear in the contrast between two group portraits of members of a leading family. When Seymour Guy painted *The William H. Vanderbilt Family* (fig. 1) in 1873, the wealthiest family in the nation still lived in what appears to be a twenty-foot brownstone townhouse. The ladies wear Paris gowns that were doubtless expensive; but the house itself, with its furnishings of merely conventional good quality, is one in which any established merchant or professional might live. In sharp contrast is the scale of living depicted in *The Baptism* (fig. 2), painted by Julius Stewart in 1892, just nineteen years later, and said to be a group portrait of a branch of the Vanderbilt family that lived in Paris. The setting is princely, with its tapestried walls and painted ceiling, gilt furniture of period designs, and the women's even more sumptuous materials and jewelry.

A similarly striking point of contrast between the two group portraits is the difference in size and scale of the paintings themselves. The earlier portrait is painted with miniaturistic precision on a canvas that measures 47 by 59½ inches. *The Baptism*, in contrast, celebrates the perpetuation of the dynasty within a picture area measuring 79¼ by 118¼ inches, its foreground figures fully

1

Seymour Joseph Guy
1824–1910

*The William H. Vanderbilt Family*
1873

47 x 59½ in.

Courtesy of Biltmore
House and Gardens,
Asheville,
North Carolina

2

Julius L. Stewart
1855–1919

*The Baptism*
1892

79¼ x 118¼ in.

Los Angeles County
Museum of Art,
Museum Purchase
with funds from
several donors

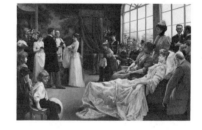

life-size. The new palaces could accommodate, and indeed seemed to require, large portraits. The porphyry walls and tessellated floors demanded the most impressive, or even fancifully staged, presentation that the long tradition of state portraiture could provide. The period also saw the considerable expansion of universities, museums, and charitable foundations,[1] and the building of ever more and larger government buildings, all contributing to an expanded demand for portraiture in the grand manner.

A significant factor in setting the mode of private portraiture in this country was the example of Great Britain, then at the peak of empire, power, and prestige, and clearly the international model for style in high society. Drawing upon its legitimately aristocratic portrait tradition, Great Britain produced a rebirth of grand manner portraiture to express the opulence of its own Edwardian ostentation. Other European nations showed a similar taste. While it was hardly an influence upon portrait painting in this country, Germany's use of state portraiture represented an international yearning to legitimize the phenomenal prosperity of the period. United Germany's new monarchy, the period's most assertive, was deified by state portraits that pressed the limits of expectations and even credibility.[2]

In America the generation of artists which supplied this expanded market for formal portraiture was the best-trained in our history. Virtually all of the leading portraitists had studied in Europe. They returned with both a fluent mastery of technique and a lively consciousness of current attitudes toward portraiture, as well as a thorough knowledge of the history of the form. For Americans, Munich and Paris were the two principal centers for the study of art. Munich was temporarily the more active and significant of the two during the early 1870s and was ultimately of disproportionate significance to American portraiture, because the emphasis upon portraiture at the Royal Academy there must have predisposed many of its best American students to practice that specialty later. In contrast to the Parisian

ateliers, which taught mastery of the figure and figural composition, the Munich academy centered its introductory curriculum on the painted head study. Students learned to understand the structure of the head and to build its forms quickly. During the early 1870s an experimental approach to direct painting, sparked by an admiration for Frans Hals, swept the students in an enthusiasm for portrait painting. Many of the chief masterpieces of Wilhelm Leibl and other leading talents of their generation in Germany were inspired portraits. The outstanding American students, Frank Duveneck, William M. Chase, and J. Frank Currier, likewise directed their considerable talents toward dramatic approaches to portraiture. The history of art was also a subject taught at the Royal Academy and a particular interest of the American students; it influenced their more ambitious portraits, such as Duveneck's painting of his father-in-law in a pose from Titian (figs. 3 and 4).[3] Rembrandt, Frans Hals, and the Flemish, Italian, and Spanish Baroque painters all provided models that shaped the portraiture of the Americans. It should be noted, however, that the portraits they painted while in Munich were modest in format. Their dark backgrounds and enveloping chiaroscuro offered no scope for either grand settings or the dramatic potential of physical movement. Their impact derived from their intense realism. This was achieved through strong, flat lighting against contrasting backgrounds, which imparted an impressive presence to the frankly presented subjects. Duveneck's *Francis Boott* (fig. 3) confronts the viewer with such a commanding presence, one that transcends the simple monumentality of its pose. Although the tenebrist manner of the Munich students did not survive the 1880s in this country, their later activity as portraitists and their aspirations for the form must certainly have been influenced by the serious expectations for portraiture acquired during their early artistic maturity.

The Americans who studied in Paris in steadily increasing numbers from the early 1870s received a course of instruction that prepared them for painting the figure in ambitious

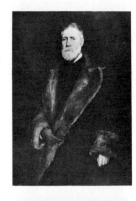

3
Frank Duveneck
1848–1919

*Portrait of Francis Boott*
1881

47⅛ x 31⅝ in.

The Cincinnati Art Museum, The Edwin and Virginia Irwin Memorial

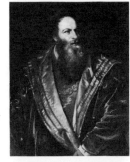

4
Titian
(Tiziano Vecelli)
1477–1576

*Portrait of Pietro Aretino*
1545

42½ x 30 in.

Pelazzo Pitti, Florence, Alinari/Editorial Photocolor Archives

5
Léon-Joseph-Florentin Bonnat
1833/34–1922

*Portrait of Adolphe Thiers*
1876

49⅝ x 37⅜ in.

Musée du Louvre, Paris, Department of Painting

narrative compositions. There the traditional hierarchy of genres still reigned, and most masters sought to prepare students for the figure pieces that would win praise in the salons, assuring a successful career. The nude figure, rather than the head, was the cornerstone of the curriculum, and the best students were given every encouragement of precept and example to devote their talents to supposedly higher forms than portraiture.

An exception to this kind of art instruction in Paris was the atelier of Charles Auguste Emile Durand, known as Carolus-Duran. When opened in 1872 by the young and independently minded master, the studio was unique in Paris in being identified primarily with portraiture and unusual in its emphasis on painting technique in the early stages of instruction. Skipping the customarily lengthy introductory phase of drawing from casts and from the nude, the students of Carolus-Duran began from the outset to think of form in terms of color and the painter's materials. The training in painting technique they received was similar in spirit to that taught in Munich— direct and rapid. Both groups of students learned to paint *au premier coup*, building forms rapidly without later retouching, preserving the movement of the brush and choice of modulating colors and values, visible in the finished work, as an element of additional interest. As in Munich, students were taught to paint realistic portraits with a dramatic "presence." Carolus-Duran's paintings, however, have a more elegant fluency, avoiding the harshness inseparable from the relentless earnestness of Munich tenebrism. The model revered by Carolus-Duran and his students was the Spanish Baroque painter Diego Velázquez, whose realism, achieved through close control of values, represented the basis of their approach. They concentrated primarily upon the middle values, adding the deepest tones and highlights last, as accents. Their flesh tones are shot through with Velázquez' lambent silvery quality. Carolus-Duran never taught more than a few students at one time, yet his small atelier produced such leading American portraitists as John

Singer Sargent, Carroll Beckwith, and Irving Wiles.

If Paris did not encourage its students to pursue portraiture, it nevertheless provided the successful styles that influenced portraiture internationally. The example of the French was particularly strong in fashionable circles in America, where dealers arranged tours for top Parisian portraitists. During the 1870s and 1880s the market for American art withered as leading collectors bid record prices to bring to this country works by the leading French painters. Not surprisingly, Mrs. Catherine Lorillard Wolf, a celebrated collector of French art, commissioned a portrait by Alexander Cabanal, and Mrs. William Astor sat for one by Carolus-Duran. These artists were the established portraitists of women who could be depended upon to paint quickly an image of predictable chic.[4]

The preferred portraitist for men was the Frenchman Léon Bonnat, who emerged as a specialist in that genre around 1875 and quickly became the most successful and influential portraitist of the Third Republic (fig. 5). His active role as teacher also contributed to his considerable influence upon American portraiture. Bonnat's approach to portraiture was similar to the dramatic manner developing in Munich during the 1870s, and logically so, since both derived their inspiration from Spanish artists of the Baroque period. Interest in Spanish art had been a slowly developing trend in Paris since at least the 1850s. It was brought to Munich chiefly through the French-trained Royal Academy professor Karl von Piloty at the same time that it was taken in several different directions by his French contemporaries. Bonnat, who spent much of his youth in Madrid, first achieved success in 1860 with his *Adam and Eve Finding the Body of Abel* (Musée des Beaux-Arts, Lille) and similar religious and historical paintings inspired by the Caravaggist lighting and textural realism of Ribera. He continued this tendency in his successful portraits, similar in appearance and spirit to fully developed Munich portraits such as Duveneck's *Francis Boott* (fig. 3). His subjects were usually illuminated by powerful, flat lighting that seemed unsparingly frank. Standing close to the picture plane

and filling much of the surface, their forms stood out dramatically from the indefinitely shadowed background as they confronted the viewer with their direct gaze. His portraits have a photographic feeling, both in their textural realism and in their apparent objectivity; and Bonnat did use photographs in his work. At the same time, his portraits carry forward the convention of male portraiture of the Neoclassical period, the image of a straightforward, no-nonsense man of affairs, who without hesitation looks his fellow man in the eye. His portrayals, however, go one significant step beyond such Neoclassical portraits as Rembrandt Peale's *Jacob Gerard Koch* (cat. no. 32) by eliminating the colorful setting in which Koch seems so comfortable. Often with no familiar object nearby, even to suggest scale, Bonnat's men stand independently, isolated against a metaphysical darkness. They are determinedly independent and self-reliant. Search as it will, the prying, all-revealing light finds no softness, no emotion in them. Another manifestation of their tough point of view is their self-control, their flawless decorum. The great American industrialists, heroes of laissez-faire Social Darwinism, look out from Bonnat's portraits with grim self-confidence.[5]

Bonnat's example shaped portraiture in Boston and Philadelphia, this country's two most Francophile Eastern cities, through their leading portraitists, Bonnat's pupils Frederic Vinton and Thomas Eakins. Vinton had sharpened this tough realism with Duveneck in Munich, after acquiring from Bonnat a certain compositional finesse, as well as a reverence for the French master's model, Velázquez. He quickly became Boston's foremost portraitist, and like Bonnat, was particularly identified with male portraiture. His subjects confront the viewer very much as Bonnat's do, standing out against an indefinite dark background in simple dignity and monumentality. His masterpiece may be the slightly more elaborate portrait of *John Codman Ropes* (cat. no. 64), with its shadowed table, the whole elegantly shimmering with the fluid silvery quality

of Velázquez. The inspiration of the Spanish master can be seen in Vinton's work at least as early as 1882, when he traveled to Spain with William M. Chase to copy Velázquez, and on his return painted the full-length portrait of *William Warren* (fig. 6) with its emphatic silhouette, so like the royal portraits of Velázquez.

As the leading portraitist in Boston, Vinton may have provided a sufficiently strong example to have shaped expectations and fostered what might be called a Boston manner, at least in male portraiture. One encounters the same dark background, strongly directed lighting, and abrupt realism in the portraits of the 1880s by Dennis Bunker and Edmund Tarbell. The fact that Sargent used Vinton's large Boston studio when he visited there in 1890 may be of certain symbolic significance. Sargent's Boston portraits are by far his sternest works—simple, frank, and dramatically lighted. The confrontational impact of a portrait such as that of *Mrs. Edward L. Davis and Her Son, Livingston Davis* (cat. no. 53), while exceptional among the poised works of Sargent, easily fits into the context of Boston portraiture of the period.

The debt of Thomas Eakins to his Parisian masters and the influence of Bonnat upon Eakins' portraiture have been noted.[6] Indeed, although Eakins studied with Bonnat only briefly, his influence would appear to have been greater than that of Gérôme. From Gérôme, Eakins learned precision and exhaustive technical control, essential elements in his lucid boating subjects of the early 1870s. The dark palette of most of Eakins' work, however, and his tough, almost harsh realism are far closer to the example of Bonnat. Since Gérôme generally did not paint portraits, whereas Bonnat was a portrait specialist, it should not be surprising that Bonnat had a formative influence on Eakins' portraiture.

The majority of Eakins' portraits are late works, of the 1890s and after the turn of the century. Those painted soon after his return from study in Europe are distinct in approach and spirit because they reflect more completely the influences absorbed there.

6

Frederic Porter Vinton
1846–1911

*William Warren*
1882

88¼ x 52¼ in.

Courtesy Museum of Fine Arts, Boston, Gift of a Committee of Citizens

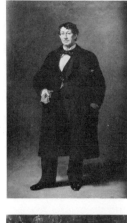

7

Thomas Eakins
1844–1916

*The Gross Clinic*
1875

96 x 78 in.

Thomas Jefferson University, Philadelphia

8

John Singer Sargent
1856–1925

*The Four Doctors*
1906

129 x 109 in.

The Johns Hopkins University, Baltimore

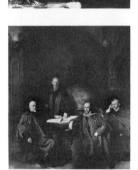

These early portraits, mostly of acquaintances—especially physicians and scientists—combine with the detailed, researched settings of Gérôme the unmitigated force of Bonnat's dramatic Caravaggism. This is true of none more than of Eakins' greatest portrait, his greatest painting, and perhaps the greatest of American paintings, his *Portrait of Professor Gross,* generally known as *The Gross Clinic* (fig. 7). In its basic conception and composition the portrait utilizes Old Master traditions, both thematic and stylistic, with the self-consciousness of Eakins' period. The most familiar precedent for the format was, of course, the anatomy lesson portraits of Rembrandt. This form for a group portrait of a medical professor and his students had been revived, in fact, in France in recent years. At the same time, the general composition, with its lighted foreground figures in a large, shadowed interior containing onlookers, may well have been inspired by Velázquez' *Las Meninas,*[7] which held a fascination for other artists of the period (fig. 8). The quality of realism in *The Gross Clinic,* however, has a clarity totally different from the hushed sfumato of Rembrandt, and a harsh rawness unlike the more reserved honesty of the mature Velázquez. It is the brutal Caravaggism of Ribera, as transmitted through the religious subjects of Bonnat, Théodule Ribot, and other French realists of the 1860s. Their historical and religious subjects often featured the nude body in torment, as in Bonnat's *Job* or Ribot's scenes of excruciating martyrdom. The combination of surrounding darkness and bloody suffering found in *The Gross Clinic* is much in their spirit and manner. Their tragic realism is summed up in the modeling of the head of Professor Gross. An excessively strong light casts much of the face in deep shadow and rakes across the transitions from light to dark, exaggerating the textures.

It is hard to conceive of Eakins painting *The Gross Clinic* without having absorbed from his young master in Paris the expectation of this emotional intensity and the means to achieve it. On the other hand, there is also much in the painting that would have been quite foreign to Bonnat's approach to portraiture. The technical detail of the surgery, the prominent foreground details

of the instruments, and the active role of the principal subject—features closer to the example of Gérôme—while appropriate to the specific form of the anatomy lesson, are utterly unlike the severe simplicity and rigid stasis of Bonnat's portraiture. Even more importantly, although the startling realism that Bonnat had first developed in his religious paintings prepared him for his approach to portraiture by providing him with the technical control of strong lighting, the French artist always maintained a clear distinction between the character, or quality of impact, offered by the two genres. The realism of the portraits was direct and persuasive, yet always characterized by a cool, matter-of-fact objectivity. The portraits never attempt the theatricality or heightened emotional appeal appropriate to the religious paintings. Against this background, *The Gross Clinic* represented a definite departure for Eakins, a gesture of baroque audacity that produced an unexampled masterpiece that even Eakins could not repeat. It startled and shocked his contemporaries by violating all conventions and expectations for portraiture, as it continues to do today. It was too much a tour de force to have had any identifiable effect on American portraiture of the time; it did not inspire imitations. Perhaps a better way to look at it is as the culmination of a strong current of the 1870s and 1880s, when realist trends in Paris and Munich captured the imagination of numerous American students and had a profound impact on portrait painting.

As opposed to the painting's extreme emotional appeal, the approach to characterization employed in *The Gross Clinic*—the portrayal of a professional man at work in his customary vocational ambience—was employed by Eakins in several ambitious portraits of the 1880s. His *Portrait of Professor William D. Marks* of 1886 (cat. no. 55) provides a glimpse into the professional life of the distinguished mathematician and inventor. He sits at his desk in his study, surrounded by books and equipment, absorbed in his theoretical work, apparently oblivious to the intruding viewers. Near the front of his desk is the machine for ruling fine lines that he had developed. Other subjects,

such as *Professor Henry Rowland* (Addison Gallery of American Art, Phillips Academy, Andover, Massachusetts), look up from their work as though interrupted by a visitor. These portraits serve to present both the man and the profession. A distinctly different effect is generated when this essential unity is not present. In the portrait of *Mrs. William D. Frishmuth* (see opposite cat. no. 72), for instance, the collector is shown surrounded by her curious treasures, rather than in the act of collecting. She sits quietly, looking toward the viewer, and cannot avoid the self-conscious formality of the large conventional portrait.

The type of portrayal to which Eakins' portraits of scientists and physicians belong is known as the *portrait d'apparat*. While rare in this country, the form enjoyed a great vogue in Europe in the late 1880s and early 1890s. It was particularly widespread in Germany, where it coincided with a trend toward a crystalline, detailed naturalism. The *Portrait of the Artist's Father* (fig. 9), painted in 1891 in Munich by the expatriate American artist Carl Marr, exemplifies this type, with its prominent window and its interest in reflections and other effects of daylight filtering through the crowded still life of the engraver's studio.

Portraits of individuals at work or surrounded by an extensive still life had been developed in the eighteenth century as an extension of the informal portrait. Throughout Europe, subjects were shown in their studies, at hobbies, or amid collections. The extension of the *portrait d'apparat* into the world of the scientist during the late nineteenth century no doubt resulted both from the increasing prestige of science and from the identification of Eakins and other artists with scientists. In German portraits of this type, such as that by Carl Marr, the careful recording of detail reveals a curiosity and precision not unlike the attitude of a scientist. As much as portraits, these paintings are demonstrations of the action of daylight as it is diffused through the cloth-hung window and filters through the crowded still life, reflected from the shapes of polished metal and refracted through lenses and containers of liquid. The scientist is depicted with the same pellucid objectivity and clarity that characterize his

9

Carl Marr
1858–1936

*Portrait of the Artist's Father*
1891

50 x 50 in.

West Bend Gallery
of Fine Arts,
Wisconsin

world. Compared to such contemporary European portraits, Eakins' portraits of scientists were decidedly old-fashioned in method and spirit. While their detail was no doubt carefully researched, their dark obscurity suggests a world of mystery rather than system; their baroque lighting seems contrived and romantic. Bonnat's dark backgrounds and strong lighting, when combined with an extreme simplicity, could generate effects of startling immediacy. When partially illuminating a detailed environment, however, as in Eakins' portraits, this kind of lighting suggests a world of encroaching uncertainty, of very unscientific mood.

The later portraits of Eakins from about the turn of the century continued in general format the realism prevalent in this country during the 1880s. Turning from the *portrait d'apparat*, Eakins returned to the single figure isolated against an indefinite background. His portraits likewise retained the rumpled clothes and other realistic detailing of Bonnat and the 1880s. On the other hand, his realism becomes less stern and less histrionic as backgrounds become lighter and lighting effects less dramatic. Eakins during this later period also felt the attraction of fellow artists of the 1890s to the full-length portrait. The change toward a generally cooler style is seen in the comparison of *The Gross Clinic* (fig. 7) with Eakins' second attempt at the theme, *The Agnew Clinic* of 1889 (fig. 10). With its lighter background and even lighting, *The Agnew Clinic* lacks the drama and impact of the masterpiece of Eakins' youth.

After the turn of the century, Eakins occasionally returned to the dark backgrounds and strong lighting of earlier periods, and these portraits are generally his most impressive. A particularly fine example is the portrait of *Sebastiano Cardinal Martinelli* (cat. no. 57). It forms part of a series of portraits of high-ranking Catholic clergymen that Eakins undertook between 1900 and 1905, a total of a dozen, more than half of them full-length. The fact that most of this closely clustered series were portraits solicited by the artist strongly suggests that Eakins was absorbed in the

form itself, in the compositional and psychological possibilities of the episcopal portrait. As has been noted recently,[8] Eakins' fascination with this problem may reflect the inspiration of the great portrait of *Pope Innocent X* by Velázquez (Galleria Doria Pamphili, Rome). Equally, it may reflect the fact that one of Bonnat's finest and most impressive portraits, possibly his masterpiece, was the full-length seated portrait of *Cardinal Lavigerie* of 1888 (fig. 11). A fundamental and characteristic difference, from either the Velázquez or the Bonnat prototype, however, is that Eakins' prelates do not, as a rule, look out of their portraits at the viewer. Through most of his portrait career, Eakins appears to have had trouble with the direct gaze of the sitter and the powerful presence that his realistic technique could evoke. The essence of most French and American realist portraiture was the almost confrontational immediacy of a strongly lighted face. Eakins consistently avoided this emotional pitch; his subjects look away, or are absorbed in thought or in some slight activity. When combined with the empty backgrounds and stern objectivity of the realist school, these portrayals of self-absorbed subjects strongly suggest a quality of personal isolation that can constitute a more basic psychological and philosophical realism. Of all the episcopal portraits, Cardinal Martinelli is most idiosyncratically turned into a nearly profile position. His chair is placed in the center of the room, so that he is surrounded by empty space, isolated in the manner of Bonnat's portraits. He sits in a large chair, its extremely high back thrusting up above his head and shoulders. The assertive lines of the chair are the most forceful design element in the portrait. The cardinal sits erect, contained within the chair, his arms following the structure of its arms. The highbacked chair seems to dominate the form of the prelate, its position turning him away from the viewer. In what may be a too elaborately allegorical interpretation of the portrait, the episcopal throne of his high office directs the cardinal away from the solace of human companionship, as it also turns him from the world; the internal order of the Church is sufficient. The portrait's image of isolation is so evocative that it seems to invite such metaphysical speculation.

10

Thomas Eakins
1844–1916

*The Agnew Clinic*
1889

130½ x 70½ in.

University of Pennsylvania, Archives, Philadelphia

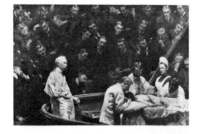

11

Léon-Joseph-Florentin Bonnat
1833/34–1922

*Cardinal Lavigerie*
1888

94⅛ x 64⅝ in.

Musée National du Château de Versailles

12

James Abbott McNeill Whistler
1834–1903

*Harmony in Grey and Green: Miss Cicely Alexander*
1872–73

74⅞ x 35½ in.

The Tate Gallery, London

Eakins thus takes the emotional resources of the grand manner tradition in directions as personal as they are profound.

There were few young portraitists in the 1880s who did not fall under realism's spell. Sargent's portraits of the 1880s are often audaciously realistic, his startling effects usually achieved through imaginative play with formal qualities. The virtually unmodulated whites of the flesh of *Madame X* of 1884 (Metropolitan Museum of Art, New York), set against the stark black of her gown, and the bold shapes of her contours and gown, were a fresh and daring departure that at the time seemed perfectly outrageous. Critics strenuously objected to Sargent's unconventional point of view in many of the early portraits, and the unusual, often awkward poses he chose for his female subjects. His aim was immediacy and impact. When he reined in his youthful unconventionality to paint a straightforward society portrait, as in his stately likeness of *Mrs. Henry White* (cat. no. 52), he followed Bonnat's approach to female portraiture, the full-length figure in evening clothes isolated in a large space, her train trailing out of the picture to one side. (The same convention was employed by Thomas Eakins in *The Concert Singer* [cat. no. 56].) Even the silvery middle tones, shimmering hypnotically through the crisply differentiated play of planes, cannot mitigate the stern authority of the image.

Drawing on Munich, Paris, and even contemporary sources from Spain, the best American artists emerging during the 1880s sought to achieve a forceful realistic style in their portraits. The patrons, for the most part, were delighted with the evident technical mastery and commanding presence of these works. The realistic portraits of the 1880s succeeded with their subjects because they were believable images in a very rational age. They were also no-nonsense portrayals that achieved strength through simplicity. For the artists, the technical challenge of realism was engrossing, and the abruptness and strong lighting of the paintings provided scope for a certain discreet dramatization in the manner of Baroque art, which also fascinated them.

Yet, already during the 1880s —the heyday of Bonnat-inspired portraiture in this country—a completely opposite trend began to find expression here that over the next decade would go a great way toward supplanting realistic portraiture. This was what has been called the Aesthetic movement, basically an English direction that toward the end of the century extended its influence throughout Europe; for a brief period, from about 1900 to 1910, it became a significant force in American art. It began as a trend allied to the Pre-Raphaelite movement, which mined the art of the early Renaissance for stylistic insights. With the rise of Gothic architecture in England, the decorative arts of earlier periods began to be studied, and an appreciation arose for the effects and vocabulary of surface patterning. In the 1860s and 1870s new aesthetic theories championed surface design as the superior approach to the decorative arts. By the late 1870s, theorists such as Walter Crane extended the application of this sensibility into the realm of book illustration and the fine arts. The first to fully develop an approach to painting that primarily expressed a consciousness of the decorated surface was James Whistler, the American artist living in England. Taking an approach not fundamentally different from that of many twentieth-century artists, Whistler painted landscapes and small figure pieces that mainly made sense as design on the painted surface, sacrificing elements of conventional realism as necessary. His paintings were usually built around tonal variations of a single color or a range of delicately modulated grays. In his *Harmony in Grey and Green: Miss Cicely Alexander* (fig. 12), for instance, the figure of the young girl is beautifully drawn, but care is taken that she does not seem to be a solid form standing in space. Insistent banding elements and patterning in the nominal background pull to the surface of the canvas, as does the large, distinct, decorative brushwork in the figure itself. With her crisp skirt, the subject presents an elegant silhouette that is carefully placed in relation to the four edges of the canvas, so that the surrounding negative spaces also form taut shapes that read as surface pattern.

Whistler's example may have had a disproportionate influence upon the development of formal portraiture because of the exceptional interest he took in the possibilities of the full-length portrait. Indeed, many of his chief works are in this form. His portraits responded to the steady English market for portraiture, but a further impetus toward the full-length portrait may have come from the work of Velázquez, various aspects of whose style struck responsive chords with the artists of Whistler's period. Certainly, Whistler would have been attracted to the decorative qualities of Velázquez' court portraits, with their delicate balance between three-dimensional illusion and surface design, achieved principally through a strong silhouette, placement of the figure within the frame, and careful control over intervals between shapes and over the relation of those shapes to the frame. This feeling for surface design, that seems so natural to the twentieth-century viewer, was explored by only a few American artists of the nineteenth century. It is no doubt part of what also attracted Edouard Manet to Velázquez, inspiring his similar full-length Spanish figures set against plain light backgrounds. As mediated through Manet, this aspect of Velázquez would also influence American portraitists of Robert Henri's circle.

Whistler's full-length portraits are of two basic types. In one, the figure stands before a decorated light background, as does Cicely Alexander. In the other type, which is larger, the figure emerges from enveloping darkness. Whistler's portrait of *George W. Vanderbilt* (cat. no. 65) is a fine example of the second type, which may ultimately have had greater influence upon American artists, such as Wilton Lockwood, toward the turn of the century. Vanderbilt, heir to a great fortune, was a collector and a man of learning and refinement, like most of Whistler's American sitters. The elongation that has often lent a sense of elegance to portraits in the grand manner is, in the Vanderbilt portrait, taken to an extreme of attenuation. The unusual thinness of the figure and the stylish cane make Vanderbilt the very image of the aesthete, poised and nonchalant. The dark background is relieved on one side by a light-colored dado, which suggests a deep interior and space behind the figure. It is drawn so high in

the picture, however, and at such an angle, as to also imply that the floor has been tipped upward, counteracting the suggestion of depth in the painting. The placement of the figure high in the canvas, his head nearly touching the top, also serves to bring him decoratively to the surface of the picture. These three qualities—repose, elegance, and decorative effect—are the constants of Whistler's portraiture and art. Together they produce portrait images of great sophistication and a certain iconic power.

Although Whistler worked in London and could only have achieved his innovative style within the hothouse of English aestheticism, he was an American by birth and citizenship, a fact that contributed greatly to his effect on American art. His first significant contact with American artists was in Venice during 1879 and 1880, when a small colony of his countrymen there absorbed his love of the media of pastel and etching. Through the influence of his fellow expatriate Anna Lea Merritt, Whistler's great portrait of his mother was shown in Philadelphia and other cities in 1881. The painting was noticed by critics and younger artists such as Cecilia Beaux, whose first major work, *Les Derniers Jours d'Enfance* (see with Addendum, cat. no. 74), painted between 1883 and 1885, was directly inspired by Whistler's great portrait, as to a lesser extent were several other portraits in profile and in a dominant color, such as Dennis Bunker's haunting *Portrait of Anne Page*. Whistler's influence can be seen in the work of several other important American artists active during the 1880s, such as in Thomas Dewing's extraordinary *Portrait of DeLancey Iselin Kane as a Boy* of 1887 (cat. no. 59). Young Kane is posed in a white middy before a white curtain, on a polished floor that reflects the curtain. A pile of pale roses and the crisp navy blue accents in his costume are all that relieve the most Whistler-like monochrome. A pattern of fleur-de-lis in the curtain and the lettering across the top further enhance the consciousness of the flat painted surface. Dewing painted this audacious portrait shortly after his return from a period of study in France, when he was full of new ideas but not yet set in terms of either style or subject matter. He painted only

one other large portrait known to us today before developing a specialty in small-scale figure pieces. Through these paintings, pastels, and drawings he became the most conspicuous American exponent of the Aesthetic movement toward the end of the century.

A name almost as closely identified with this movement was that of John W. Alexander, one of the most successful portraitists of the early years of the twentieth century in New York. Alexander's style of the early 1880s reflects his training at the Royal Academy in Munich and the influences of J. Frank Currier and Frank Duveneck in Munich and Venice. In her portrait of about 1880, *Mrs. Samuel Tilton* (fig. 13) stands out against an indefinite dark background, her face lighted by a strong, flat light that establishes the physical reality of the features with an unflinching directness, a treatment that suggests a similarly penetrating and unrelenting personality. During the 1880s Alexander's work began shifting subtly toward the highly individual style he established in the following decade. The effect of strong light, which had been an instrument of forceful realism in the portrait of Mrs. Tilton, instead creates fantastic distortions and a sense of the unreal when it becomes a footlight effect in his portrayal of *Joseph Jefferson* of the late 1880s (Collection of The Players, New York). A strong sensitivity to linear rhythms also emerges in his portraits of this decade, as in the expressive portrait of *Mrs. Henry W. Draper* of 1888 (cat. no. 60), in which the full-length figure is turned in profile and the lean lines of the greyhounds create elegant patterns on the surface. After moving to Paris in 1890, Alexander began exhibiting figure pieces and portraits in a striking new style developed from the elements just discussed, reinforced by the example of Whistler and the newer currents in Paris. The portrait of his wife, *Mrs. John White Alexander* (cat. no. 61), painted about 1894, is a particularly dramatic example of this new decorative style. A Whistlerian unity of color is achieved by limiting colors to variations of muted rose and moss green. The surface is emphasized both through the long, flowing lines and through the coarse texture of the canvas, stained by the paint, rather than vigorously brushed. A footlight effect is used once more to provide a foundation of

realism, which results, however, in a disquieting distortion close to the spirit of Symbolism. Finally, the tone is set by the high-style accessories, the balustrade, picture hat, and park, recalling Lawrence and late Georgian portraiture. Alexander's portraits combine the most graceful aspects of the Aesthetic current with a stylish portraiture that won for the artist a flourishing practice and the presidency of the National Academy after his return to this country in 1901.[9]

Another leading artist who came under the strong influence of Whistler during the 1880s was William M. Chase, who shortly before had been one of the most forceful of the realists. While studying at the Royal Academy in Munich during the 1870s, Chase worked in as dramatic and earthy a realist style as any of the Americans or Germans, winning immediate recognition in this country through such startling images as *The Jester*, of 1875 (Pennsylvania Academy of the Fine Arts, Philadelphia). During the early 1880s he was attracted to the aggressive realism of the Spanish-Italian school, repeating in his *Portrait of Miss Dora Wheeler* of 1883 (fig. 14) the uniform strong lighting, abrupt contrasts, and brilliant turquoise and yellow coloring developed by Madrazo. In 1885, however, already having developed an interest in Whistler's work, Chase met the expatriate in London, spent time and traveled with him, and painted a portrait of Whistler so much in his own style that Whistler and several commentators judged it to be a lampoon, rather than the tribute that it was. During the following several years he painted a group of portraits very much under Whistler's influence, paintings that are "arrangements" of a dominant color, as is Dewing's *DeLancey Iselin Kane*, primarily decorative works in which a balance is maintained between the form and personality of the sitter and the requirements of surface design and aesthetic unity. As its title suggests, his *Portrait of a Lady in Pink* of about 1888–89 (cat. no. 63) is a particularly complete example of the Whistlerian influence on Chase's portraiture. Except for the subject's dark hair, every shade in the painting is a permutation of the color red, although with sufficient admixtures of other tones to

4
John Smibert

*Mrs. Nathaniel Cunningham*
1730

Oil on canvas

49⅞ x 40¼ in.
(126.8 x 120 cm.)

Lent by The Toledo Museum of Art, Ohio, Gift of Florence Scott Libbey

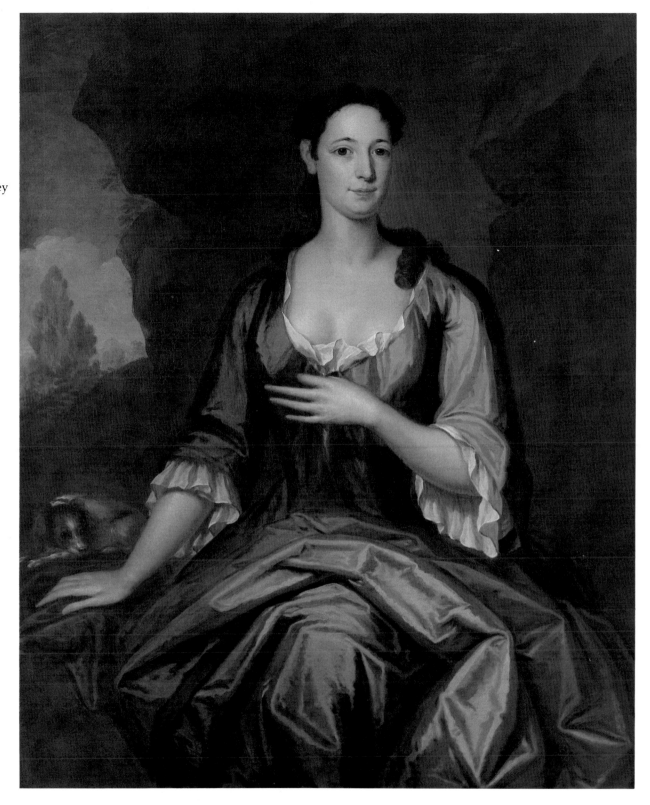

5
John Smibert

*Sir Peter Warren*
1746

Oil on canvas

92 x 58 in.
(233.7 x 147.3 cm.)

Portsmouth
Athenaeum,
Portsmouth, New
Hampshire, Gift of
John Fisher

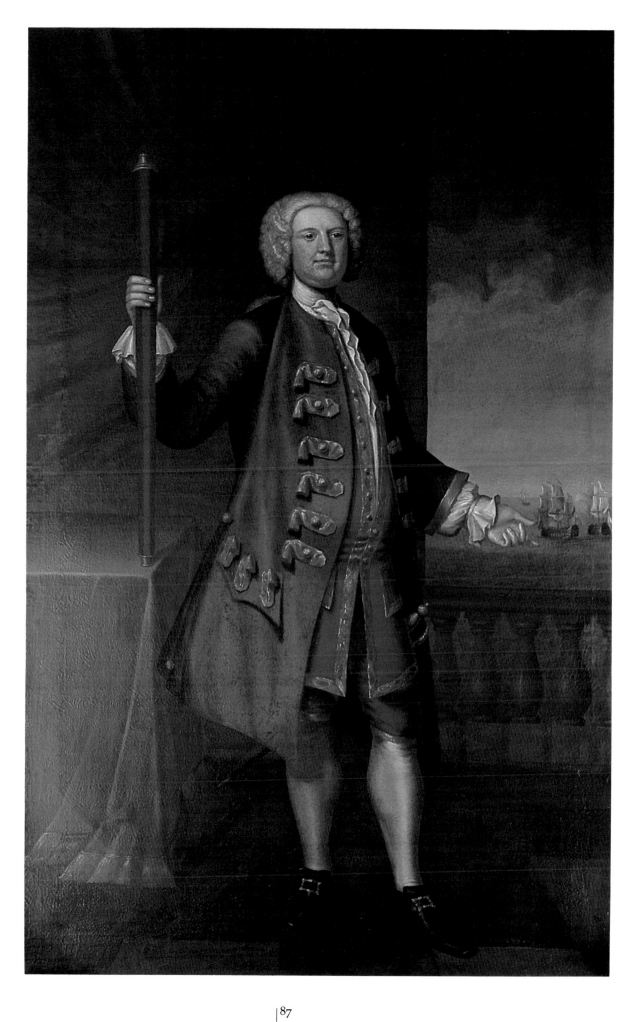

Although Robert Feke occupies a prominent place in the history of American art as the greatest painter between Smibert and Copley, little is known with certainty about his biography, aside from the evidence provided by his signed and dated paintings. It is likely that he was the Robert Feke, Jr., who was born in 1707 in Oyster Bay, New York, and lived there until about 1731. He may next have lived in New York City but was identified as a resident of Newport, Rhode Island, when he was married there on September 23, 1742. A diary entry records his presence there as an established portraitist on July 16, 1744. He was also known as a mariner, as the records of his daughter's marriage on October 15, 1767, state. A descendant in 1859 held that because of failing health, Feke went to Bermuda about 1750; new evidence seems to indicate that he died in 1752. Like many of his associates, Feke traveled frequently in quest of commissions. He was in Boston in 1741, Philadelphia in 1746, Boston again in 1748–49, and once more in Philadelphia in the spring of 1750.

Although some family portraits may be dated earlier, little is known about Feke's work before he appears on the scene in Boston with his handsome group portrait of the *Isaac Royall Family*, dated on the back September 15, 1741. The body of his mature work stretches over just ten years and consists of fewer than one hundred paintings. The quality of the Royall family portrait is high enough to indicate that several years of professional portrait painting preceded it. Yet, certain elements of style that persist in his later work support the tradition that he was self-taught. He is certainly the greatest American-born talent before Copley, his style representing a fusion between the linear, decorative qualities of American primitive painting and the solidity and presence of the European tradition.

Even over the brief course of his known career, Feke's powers developed steadily, reaching a peak of excellence during his third period of work in Boston in 1748–49. His portrait of *Judge Richard Saltonstall* shows all the strengths of this final style, particularly in the slight idealization of the face, while the textures of the linen, velvet, and gold braid are fully developed. Most importantly, the pose is so arranged that the lines of the costume sweep in strong rhythms toward the head, contributing additional monumentality to the austerely simple forms.

Richard Saltonstall was born in 1703 at Haverhill, Massachusetts, son of Richard and Mehitabel (Wainwright) Saltonstall, of a family active for generations in the affairs of the colony. He graduated from Harvard College in 1722, and was commissioned colonel in 1726. Beginning in 1728, he was a representative from Haverhill. In 1736 he became a judge of the Supreme Court, a position he held until his death in 1756.

6
Robert Feke

*Judge Richard Saltonstall*
c. 1748

Oil on canvas

49 x 38⅞ in.
(124.5 x 98.7 cm.)

Peabody Museum of
Salem, Massachusetts

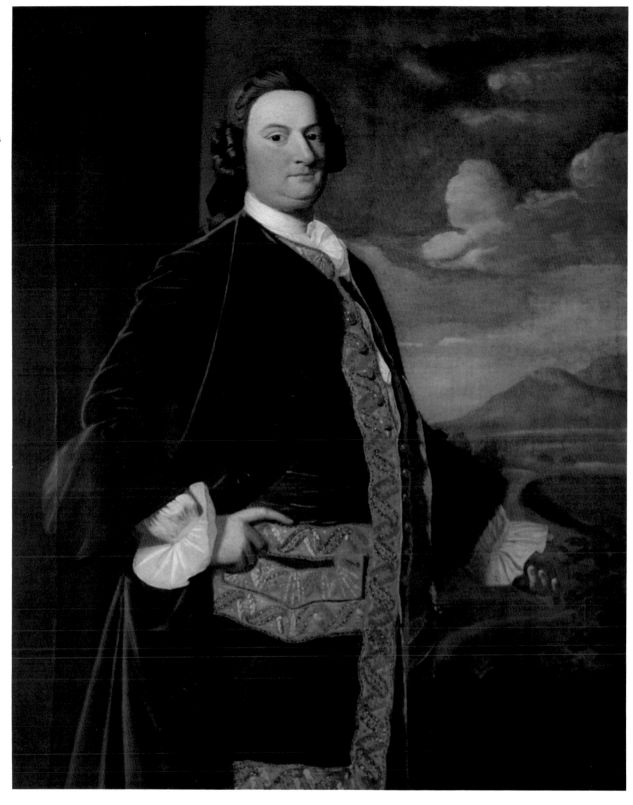

Joseph Blackburn
c. 1700–1780

Uncertainty still characterizes such basic questions about Joseph Blackburn as where and when he was born, where he received his artistic training, and when he died. His earliest signed and dated paintings place him in Bermuda in 1752 and 1753 with a fully developed English Rococo style, yet with a somewhat brighter palette. In 1754 he was probably in Newport, Rhode Island, and in 1755 in Boston, where he remained through part of 1760, although he did not establish a permanent connection with the city by buying property or associating with a church. From 1760 through early 1763 he was in Portsmouth, New Hampshire, and again in Boston, before he returned to London that year. His last dated portrait was painted in England in 1778.

Upon his arrival in Boston, Blackburn met with instant success; his only competitors were Badger and the youthful Copley. He certainly must have captivated his patrons with the lively Rococo style that he introduced to the colonies. It was the most important impulse to the development of American painting since the arrival of Smibert more than thirty years earlier. The style is epitomized in the portrait of *Mrs. James Pitts*, with its asymmetrical arrangement, strong contrasts, broken line, flickering surfaces, and mastery of shimmering textures. It is a portrait characterized by lightness, movement, and nonchalant elegance. The subject is Elizabeth, daughter of James and Hannah (Portage) Bowdoin of Boston, born there on April 27, 1717. On October 26, 1732, she married James Pitts of Boston, a prominent merchant and a member of the King's Council. She had one daughter and died on October 20, 1771.

The portrait of *Benning Wentworth* is less typical of Blackburn's work, as it is one of only two full-length

John Smith
1652?–1742

Mezzotint of
*The Celebrated
Mrs. Sally Salisbury*
c. 1723

after a painting by
Sir Godfrey Kneller

13⁷⁄₁₆ x 9³⁄₄ in.

Henry E. Huntington
Library and Art Gallery,
San Marino, California

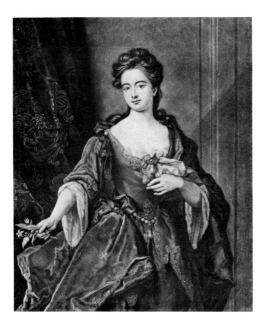

7
Joseph Blackburn

*Mrs. James Pitts*
1757

Oil on canvas

50⅛ x 40 in.
(127.3 x 101.6 cm.)

Courtesy of The Detroit Institute of Arts, Founders Society Purchase, Gibbs-Williams Fund

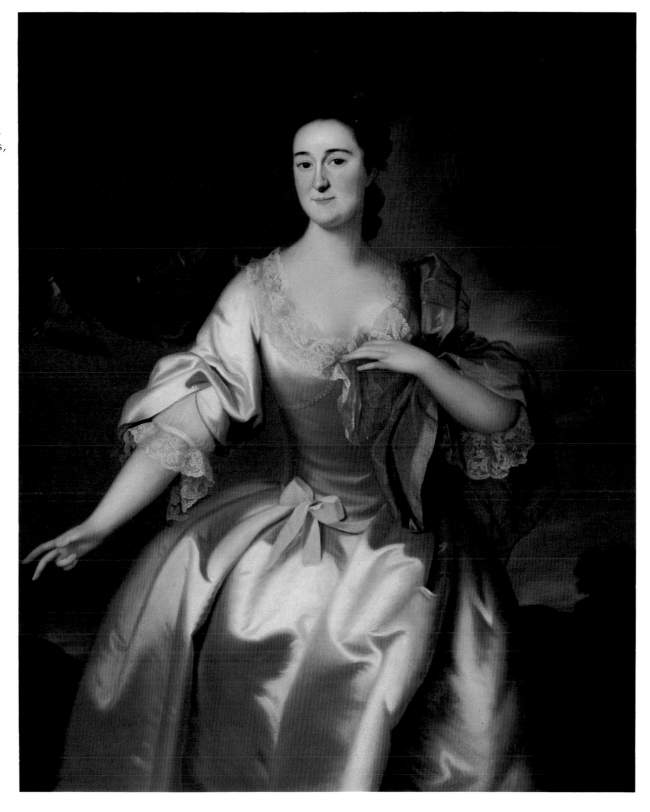

portraits by him known. It was painted, together with a similar painting of Benning Wentworth's deceased father, Lieutenant Governor John Wentworth (1671–1730), to hang as a pair of state portraits in the principal room of the Wentworth mansion in Portsmouth, the seat of government of the colony. The pair is by far the most formal of Blackburn's portraits, which generally avoid the columns and draperies of the Baroque period. Another unusual feature is the isolation of the figures in space, with an indication of perspective in the floor. In almost all of Blackburn's portraits the figures are cut by the edge of the canvas, so that they come to the surface of the picture in an ambiguous spatial relationship. In the portrait of Mrs. Pitts, for instance, the figure fills most of the canvas, her dress cut by the bottom edge and her trailing scarf by the left edge. The space behind her is a soft, ambiguous distance that tends to read on the surface. All of this makes her a relatively flat, insubstantial form. Benning Wentworth, in contrast, appears as a quite solid form in a definite relationship to the canvas and his surroundings. The contours of the figures are broken, as are the interior lines, but the faintly flickering reflections on his suit fail to break up the definite volumes. It is possible to explain this departure in Blackburn's style as evidence of the influence of the young

Copley's greater sculptural feeling and realist solidity. It may also represent a return by Blackburn to the Baroque style still strongly associated with state portraiture in the colonies.

Benning Wentworth was born on July 24, 1696, in Portsmouth, New Hampshire, of a prominent family. He was the eldest son of Lieutenant Governor John and Sarah (Hunking) Wentworth. Graduated from Harvard College in 1715, he then associated with his uncle Samuel, a prominent Boston merchant. In 1719 he married Abigail Ruck, of a leading merchant family. After serving as a member of the New Hampshire Assembly, he became a member of the council in 1734. He took a leading role in the effort to make New Hampshire independent of Massachusetts and became the province's first royal governor, a position he held for twenty-five years, a period of considerable growth for the province. He was a prominent supporter of the expeditions against the French, including the campaign against Louisbourg in 1745. Following the conclusion of the French and Indian War, he gave soldiers numerous grants in the area west of the Connecticut River, which was also claimed by New York and eventually became the state of Vermont. Bennington, Vermont, is named for him. He married his second wife, Martha Hillen, in 1760. Eventually he encountered strong resistance to his vigorous defense of royal prerogatives. He resigned the governorship in 1767 and was succeeded by his nephew, John Wentworth. He was known for his aristocratic bearing, and his home at Little Harbor was one of the most gracious country houses of colonial America. He died on October 14, 1770, his widow the only heir to his sizable fortune.

8
Joseph Blackburn

*Benning Wentworth*
1760

Oil on canvas

93½ x 58 in.
(237.5 x 147.3 cm.)

Lent by the New
Hampshire Historical
Society, Concord,
Gift of Anne Went-
worth Morss, Margaret
Wentworth Whiting,
and Constance
Wentworth Dodge

*Photographed prior to conservation.*

Joseph Badger was born on March 14, 1708, of an old but poor family in Charleston, Massachusetts, where he grew up. He married in Cambridge in 1731 and spent the first two years of his married life there before moving to Boston, where he died during the summer of 1765. He appears to have made a very modest living primarily as a painter and glazier as well as a limner after about 1740, working entirely within the Boston area.

Living near Smibert, and no doubt purchasing some of the prints and artists' supplies that Smibert sold to supplement his income from portraiture, Badger must have known the leading painter in Boston and perhaps learned from him. Indeed, his early portraits of seated men come close to the general feeling of Smibert's work. Basically, however, he was a self-trained artist with an incomplete mastery of the skills of the portraitist. It is primarily the naive charm of the primitive that gives his paintings interest today. Notwithstanding his obvious limitations, some of the richest and most important Bostonians sat for Badger because, from the decline of Smibert in the early 1740s to the rise of Copley in the late 1750s, Badger was at times the only portraitist in Boston or New England.

Badger's portrait of *Captain John Larrabee* is the painter's most important work, in terms of both size and quality. Challenged by his most ambitious commission, Badger surpassed himself, imparting to the figure a monumentality and presence quite unlike the spectral appearance of most of his portraits. Many of the elements of the portrait are familiar in Badger's work. The posture with one hand on the hip, two fingers spread, holding back the skirts of the long coat—a pose he may have taken from Feke—is one of his stock poses for men. Although he did not paint other full-length adult portraits, he was familiar with the compositional considerations from the many full-length

portraits of children he painted. The vague, feathery background with ships is also familiar. The cannon and assertive vertical of the telescope are distinctly new elements, and yet they are not sufficient to account for the unmistakable force of personality. The portrait has been dated about 1760, and an explanation of its exceptional strengths may be found in the example of the young Copley—earlier influenced by Badger—who progressed rapidly to the point of shaping the portraiture around him.

John Larrabee was born at Lynn, Massachusetts, in 1686. He married Elizabeth Jordan in Lynn in 1710 and then settled in Boston; there he married his second wife, Mary Jenkins, in 1737. He was captain-lieutenant, or commanding officer of Castle William (afterwards Fort Independence) in Boston Harbor for more than forty years before his death on February 11, 1762.

Obituaries indicate that Larrabee was generally admired as a soldier and as a man. Yet, there is no single act of valor in his career as we know it to suggest the justification for a public commission of a portrait that would honor him and allow him to join the gallery of worthies in Faneuil Hall. It also would have been unlikely that a private individual of Larrabee's station in life would himself commission a monumental portrait. The only possibility that suggests itself is that Larrabee commissioned the painting to hang as a state portrait at Castle William, as royal governors hang their portraits in the seat of government, but there is no precedent at the level of the military commander.

9
Joseph Badger

*Captain John Larrabee*
c. 1760

Oil on canvas

83⁹/₁₆ x 51¹/₈ in.
(212.2 x 129.9 cm.)

Worcester Art
Museum,
Massachusetts

The son of the Swedish-born and -trained artist Gustavus Hesselius, John Hesselius was born in 1728 in Philadelphia, where he was raised. His professional career appears to have begun in 1750, when he began his travels through Delaware, Virginia, and Maryland; he is primarily identified with Maryland. Feke seems to have been the strongest influence upon the work of the young Hesselius, who moved in the direction of the style of John Wollaston after about 1758. One senses a steady development of Hesselius' skills through about 1764, although he continued to paint until at least 1777. In January of 1763 Hesselius married a rich widow, Mary Woudward, of Primrose Hill, near Annapolis, and responsibilities of the estate appear to have distracted his primary attention from his art. The contents of his house following his death on April 9, 1778, including musical instruments, books, and scientific instruments, suggest a man of gentlemanly accomplishments.

The portrait of *Charles Calvert and His Servant* is by far Hesselius' most elaborate and impressive work, unlike the quiet bust or half-length portraits typical of him. Its pastel coloring, asymmetry, and rich costumes are characteristic of the Rococo lightness of his best period; but the complicated composition, firm sculptural feeling, and drama surpass his usually solid and rich, although unambitious level of accomplishment.

In 1761 Hesselius received the most prestigious commission of his career, to paint the portraits of the four children of Benedict Calvert, born Benedict Swingate, the illegitimate son of Charles Calvert, Fifth Lord Baltimore, by an unknown mother. Benedict was sent to Maryland as a child and was later appointed a member of the Governor's Council; in 1761 he was made collector of customs for Patuxent. The three sisters were painted attractively, but simply, in thirty-by-twenty-five-inch canvases in three-quarter-length poses. As great things were expected for his son, Charles, he was painted in an elevated manner that would accord with his future rank and achievements. Unfortunately, he died at the age of seventeen, while at Eton.

10
John Hesselius

*Charles Calvert
and His Servant*
1761

Oil on canvas

50¼ x 40¼ in.
(127.6 x 102.2 cm.)

The Baltimore
Museum of Art, Gift
of Alfred R. and
Henry G. Riggs in
Memory of General
Lawrason Riggs

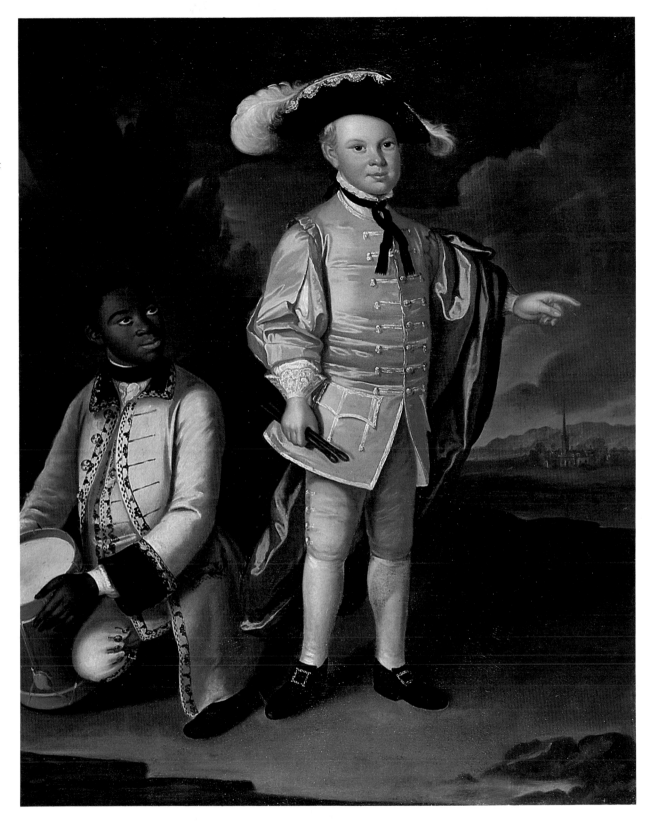

William Johnston was born in Boston, the son of Thomas Johnston and his first wife, Rachel Thwing. The artist John Johnston was his half-brother. Thomas Johnston was a limner, as well as a japanner, map-maker, and organ builder, and the boys would have grown up within his circle of artists and craftsmen. The Boston and New Hampshire portrait painter John Greenwood was at one time apprenticed to Thomas Johnston and William was, in turn, later apprenticed to Greenwood. In the early 1760s William spent some time in Portsmouth. Like his father, a man of many accomplishments, William Johnston served as organist of Christ Church (Old North Church) from 1750 to 1753 and at a church in Barbados in the early 1770s. He died suddenly in Bridgetown, Barbados, in August of 1772. The largest group of his paintings that have been identified date from a period of considerable activity as a portrait painter in New London, New Haven, and Hartford, Connecticut, from 1762 to 1764. The presence of his sister, Sarah Hobby, in Middletown, Connecticut, may have led to his becoming apparently the first portraitist to work in that state. William Johnston stands out as one of the ablest of the New England provincial portraitists of his period. The strongest influence upon his style does not appear to have been Greenwood but Joseph Blackburn, whose work was widely ad-mired both in Boston and Portsmouth dur-ing the time Johnston was developing his style. A further influence would have been his acquaintance in Boston, the young Copley, himself just then beginning to transmute the strong influence of Blackburn. In the *Portrait of Mrs. Thomas Mumford VI* one recognizes numerous elements of Blackburn's style—the low viewpoint, the landscape background, the intense muted colors, the attention to shimmering fabrics, the asymmetry, and the crisp accents. The provincial artist's strong sense of line, however, renders the volumes much firmer and clearer. His sense of patterning brings the figure to the surface as a flat design. Johnston's work provides a Rococo analogy to the similar blend of high style and primitive decora-tiveness in the portraits of the next significant Connecticut portraitist, Ralph Earl.

Catherine Havens (1735–1778), daughter of Jonathan Havens and Catherine Nicoll, was born on Shelter Island on Long Island Sound. She was mar-ried there on December 7, 1752, to Thomas Mumford VI (1728–1799) of Groton, Con-necticut. Upon his father's death in 1768 Mumford took over management of Groton Bank, the family homestead near Groton. In September 1780, after Mrs. Mumford's death, the house was burned by British troops under Arnold. After that, Mumford lived in Norwich. He later mar-ried Anne Saltonstall. Thomas Mumford came from an old, established family in Connecticut, and he in turn accepted the public responsibilities of the head of a prominent family. He was a thriving mer-chant who lived in handsome style, but he was remembered as a gentleman and a patriot. In 1764 he was commissioned as an ensign and was appointed by a legisla-tive committee, with Gurdon Saltonstall and Nathaniel Shaw, to collect reasons and arguments to be sent to the agents of the colony in England against revival of the Stamp Act. In 1774 he was one of seven men who organized the expedition that took Ticonderoga. Mumford was particu-larly active in public affairs during the Revolution and owned four privateers. He served in numerous appointed posts and was the elected representative for Groton in 1774, 1775, 1778, 1779, and 1781.

11
William Johnston

*Portrait of
Mrs. Thomas
Mumford* VI
1763

Oil on canvas

49½ x 39 in.
(125.7 x 99.1 cm.)

The Brooklyn
Museum, Dick S.
Ramsay Fund

John Singleton Copley was a phenomenal talent who took portraiture far beyond anything ever achieved in the American colonies and created some of the most profound and enduring images of the American tradition of portraiture.

Although he rose by his abilities to be a substantial citizen, a property owner on Beacon Hill, Copley was of humble origins. He was born in Boston in 1738, the son of recent emigrants from Ireland, his father a tobacconist. After her husband's death, Mrs. Copley married the Boston painter and engraver, Peter Pelham, in 1748. Although Copley's stepfather died only three-and-a-half years later, the boy grew up in artistic circles and with a studio full of engravings. Already in 1753, at the age of fourteen or fifteen, he was contributing to the family income with a mezzotint after a portrait by Badger and also with his first portraits. With Badger and Nathaniel Smibert (nephew of John Smibert) his only competitors in Boston, Copley was able to work as a portraitist, young as he was. He taught himself rapidly during this period, picking up hints from Feke, Smibert, Greenwood, and Badger, as well as from engravings in his stepfather's collection. In 1755 Blackburn arrived, dazzling Boston with his skillful mastery of costume painting and his animated Rococo style. Copley quickly assimilated the elements of Blackburn's style, and by 1757 or 1758 he was painting portraits that might be confused with those of the older artist. He continued to perfect his skills, and when he painted his handsome portrait of *Mrs. Daniel Sargent* in 1763 he was master of an opulent illusionism, firm sculptural form, rich color, and a range of courtly conventions. As undisputed master, he received a flood of commissions from all the best families during the next years, with opportunities for increasingly elaborate portrayals. His portraits of Mr. and Mrs. Jeremiah Lee of 1769 represent the apex of his early efforts toward impressive portraits with grand settings.

In 1769 Copley married the socially prominent Susanna Farnham Clarke and began to accumulate property on Beacon Hill for his estate, known as Mount Pleasant. He had risen to the social and financial level of his sitters. Despite his successes, during the 1770s his style became simpler and more somber, with dark backgrounds and stronger contrasts; it was a dramatic style of great psychological, as well as physical realism, in which Copley created some of his greatest masterpieces.

Although his wife's family was solidly loyalist, Copley managed to avoid allying himself with either party. Yet, as tensions grew and business fell off, Copley felt again the attraction of a period of study in Italy and London, a course in which he had received the encouragement of his contemporary, Benjamin West, since 1765. On June 10, 1774, Copley sailed for London; his wife and family set off the following May. After a period of travel and study on the Continent and especially in Italy, Copley joined his family in London in October 1775. They were never to return to America. Thus, the larger part of Copley's career was spent in England.

Always able and eager to seize upon hints that would develop his style, Copley progressed rapidly in Europe, soon acquiring the looser, more fluent painting technique of the leading English painters. He also began to paint the highly regarded history paintings. His portraits of this period are dramatically presented, combining enough of the high style of history painting to become a more animated form, truly portraiture in the Grand Manner. His portrait of Major *Hugh Montgomerie* (fig. 22, p. 19), for instance, incorporates not only the dramatic sky and scene of battle, but also the pose of the *Apollo Belvedere*, the most admired classical sculpture during that period. Copley was elected to the Royal Academy in 1779 and achieved honor, success, and even a royal commission. He died in London on September 9, 1815. His son, John Singleton Copley, Jr., rose to become Baron Lyndhurst, thrice Lord Chancellor under Queen Victoria.

The portrait of *Mrs. Daniel Sargent*, of 1763, is characteristic of the opulent and showy portraits of socially prominent ladies for which Copley was sought out in the 1760s. Mary Turner of Salem married the son of a

Gloucester shipowner, Daniel Sargent, in 1763. Thus Copley's portrayal would be of the nature of a bridal portrait, although the elaborate dress with its silver braid may have been a fashionable gown Copley owned to clothe his sitters, since it appears elsewhere. The fountain would have been an allusion to her virginal purity, and it still adds a note of sparkling freshness, contrasted to the rusticated wall from which it issues. Much later, Mrs. Sargent's son, the Boston artist Henry Sargent, asked his mother about the portrait, and learned of the time and effort its delicate effects of modeling and luminosity required of both the artist and his sitter. Mrs. Sargent reported having sat for the artist fifteen or sixteen times, six hours at a time. After several sittings she peeked at the portrait to discover that the head had been rubbed out. Copley was apparently a conscientious craftsman who struggled for both accuracy and subtle artistic effects.

Mary Sherburne (1735–1799) was the daughter and sole heir of Joseph Sherburne of Boston, from whom she received a substantial fortune as dowry and by bequest. In 1763 she married Jerathmael Bowers, a wealthy Quaker who built for his bride an elaborate mansion at Somerset, Massachusetts. At the outbreak of the Revolution he was imprisoned as a loyalist.

Copley's use of the mezzotint by James McArdell after Sir Joshua Reynolds' portrait of *Lady Caroline Russell* (fig. 11, p. 15) is the most complete of the numerous cases of his borrowing from English print sources.

Jeremiah Lee was born on April 16, 1721, in Manchester, Massachusetts. There his father, Samuel Lee, was a prominent shipowner, merchant, and builder, and his great-great-grandfather Henry Lee had settled there in 1650. The family had moved to Marblehead by 1745. Jeremiah learned the shipping and mercantile business in partnership with his father. He took over the business after his father's death, using the profitable triangular trade between New England, the West Indies, and Europe to build one of the greatest

fortunes in the colonies. Jeremiah Lee married Martha Swett in 1745, and she bore him nine children. In Marblehead his brother Samuel built Jeremiah one of the largest and finest mansions in the colonies, which was filled with rich furnishings of the highest quality. The house was completed in 1768, and the following year Copley painted his monumental portraits for the staircase landing. Mrs. Lee, on the left side of the landing, led the way up the second flight. Full-length portraits of a man and his wife were highly unusual in the colonies. These may have been suggested to Lee by the full-length portraits of Mr. and Mrs. William Browne that Smibert had painted for nearby Browne Hall, a country seat that would have been the marvel of the countryside about the time that the Lees moved to Marblehead. Or Lee may have conceived his mansion on the scale of those he had seen on his trips to England. A pair of grand portraits was entirely in keeping with the ostentatious setting and the display of rich materials; carpet and pier table—borrowed from an engraving of a royal portrait—suggest opulence and splendor. The fruit Mrs. Lee holds in her skirt is a symbol of fecundity. Although his portrait suggests a landed aristocrat, Lee was a patriot and a member of the Committee of Safety and Supply for Massachusetts, once forced to flee to a cornfield in his nightshirt to avoid a British search party. His sudden death in 1775 caused the collapse of his business, and the family were barely able to save the house, land, and portraits. Mrs. Lee died in 1779.

William Pepperrell Sparhawk (1746–1816) was the son of Nathaniel Sparhawk and his wife, Elizabeth Pepperrell, the only surviving child of Sir William Pepperrell, a man of extensive landholdings and great wealth. Sir William had led the successful expedition against the French fortress of Louisbourg in Nova Scotia in 1745 and was created a baronet the same year. When he died in 1759, the bulk of his estate passed to his grandson, on the condition that he change his name to William Pepperrell. The grandson did so, and in 1774 was created baronet as a courtesy to the memory of his grandfather. In 1767 he had married Elizabeth Royall, who

died in October 1775. The following May, Pepperrell and his four children sailed for England with a large group of loyalists. This large portrait must have been commissioned very soon after their arrival in London and soon after Copley's arrival there from Italy. It was exhibited at the Royal Academy in 1778 and shows how quickly Copley mastered the color, modeling, animated treatment, and fluent technique of the most fashionable English portraiture. The extensive landscape, imparting a strong suggestion of an outdoor setting, is a stylish element that does not appear in Copley's first sketches for the portrait.

Copley had painted Lady Pepperrell when she was a girl, but it is not clear which memory or portrait he based his likeness on in the family portrait. For the sake of consistency, he apparently painted each of the children two years younger, in effect recreating a scene from the time when their mother was still living. In her lap stands little William Royall Pepperrell, embraced by his eldest sister. His youngest sister (later Lady Palmer) sits as a baby on the table, playing with the third sister. The central group of the heir standing in his mother's lap, embraced by another child and reaching outward to a standing figure, recalls the traditional composition of the Holy Family with John the Baptist. Such a quotation from earlier art was central to the original eighteenth-century conception of portraiture in the Grand Manner.

12
John Singleton Copley

*Mrs. Daniel Sargent*
1763

Oil on canvas

50 x 40 in.
(127x 101.6 cm.)

The Fine Arts
Museums of San
Francisco, Gift of Mr.
and Mrs. John D.
Rockefeller, 3rd

13
John Singleton Copley

*Mrs. Jerathmael Bowers*
1761–65

Oil on canvas

49⅞ x 39¾ in.
(126.7 x 101 cm.)

The Metropolitan
Museum of Art,
New York,
Rogers Fund, 1915

14
John Singleton Copley

*Portrait of*
*Jeremiah Lee*
1769

Oil on canvas

95 x 59 in.
(241.3 x 149.9 cm.)

Wadsworth
Atheneum, Hartford,
Connecticut, The Ella
Gallup Sumner and
Mary Catlin Sumner
Collection

15
John Singleton Copley

*Portrait of
Mrs. Jeremiah Lee*
1769

Oil on canvas

95 x 59 in.
(241.3 x 149.9 cm.)

Wadsworth
Atheneum, Hartford,
Connecticut, The Ella
Gallup Sumner and
Mary Catlin Sumner
Collection

16
John Singleton Copley

*Sir William Pepperrell
and His Family*
1778

Oil on canvas

90 x 108 in.
(228.6 x 274.3 cm.)

North Carolina
Museum of Art,
Raleigh, Purchase
from Original State
Appropriation

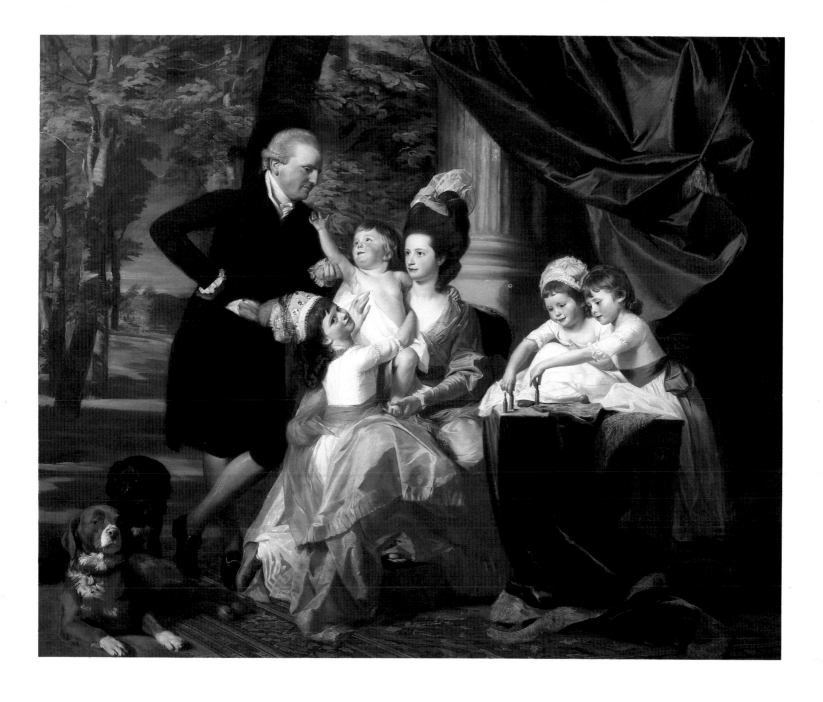

Benjamin West, a handsome man of genial nature and easygoing manners, showed artistic ability as early as the age of six. His first professional encouragement came from a minor artist, William Williams. To this he added assiduous independent study, and eventually, through the financial aid of friends, study in Italy. Arriving in 1760 he may have been the first American to study there. By the time he arrived in England three years later his style had been developed. There his pleasant manners and influential acquaintances helped him rise to the position of "Historical Painter" to King George III, a position he held for almost forty years (1772–1811), and to president of the Royal Academy (1792–1820, with the exception of one year). His considerable art historical importance consists of both his contributions to the development of the Neoclassical style and his early use of the romantic style beginning about 1787. West's success in the homeland drew the most ambitious of the younger colonial artists to study with him, including such portraitists in this exhibition as Charles Willson Peale, Joseph Wright, Ralph Earl, Gilbert Stuart, John Trumbull, Rembrandt Peale, Thomas Sully, and Samuel F. B. Morse. His patient, sympathetic interest set young artists securely in their professions as portraitists (almost the only subject matter then affording a living for painters) and for a few, elevated their ambitions to historical painting. For aspiring young American artists he stood as a symbol of success.

James Hamilton, a Philadelphia lawyer, man of considerable fortune, proprietor of Bush Hill estate, lieutenant governor for two terms in the colony of Pennsylvania, and acting governor twice, had known and aided West while the young artist had worked in Philadelphia. He was probably among the influential Philadelphia royalist friends who supplied West with the letters of introduction that were so important to the young artist in London. About 1766, having only recently completed his second term as lieutenant governor, Hamilton traveled to London. There, reacquainting himself with West who had only recently arrived from Italy, he had his portrait painted. West has posed Hamilton in one of the oldest conventions of state portraiture: he stands with one hand resting on a table, with the traditional column and drapery behind him. Hamilton's rich clothing and gentleman's sword further suggest his social position. The wide stance of the large man and way in which his right fist clutches his gloves add a definite note of personal energy and official authority.

West stood painting the portrait at the moment Charles Willson Peale arrived at his London door with a letter introducing him as a prospective pupil. Needing someone to pose for Hamilton's hand, West invited Peale in, initiating a long pupil-colleague association. Hamilton never married, and after his death the portrait descended through the female line to a Henry Beckett (d. 1871), whose executor eventually made a gift of it to the city of Philadelphia. In the early 1890s Charles Henry Hart, an early American art historian, rediscovered the picture in a lecture room of Horticultural Hall. Through his efforts the work was cleaned and hung in the Old State House (now Independence Hall), which had served as Capitol of the Province at the time Hamilton was its lieutenant governor. During restoration, conservators discovered that at one time the head and bust had been cut out of the canvas. (Perhaps the portrait was a victim of the revolutionary destruction of royal portraits?) Cleaning also revealed the signature "B. West 1767 London," deciding the authorship which for many years had been attributed to Matthew Pratt, West's pupil.

17
Benjamin West

*Governor
James Hamilton*
1767

Oil on canvas

95 x 61 in.
(241.2 x 155 cm.)

Independence
National Historical
Park Collection,
Philadelphia

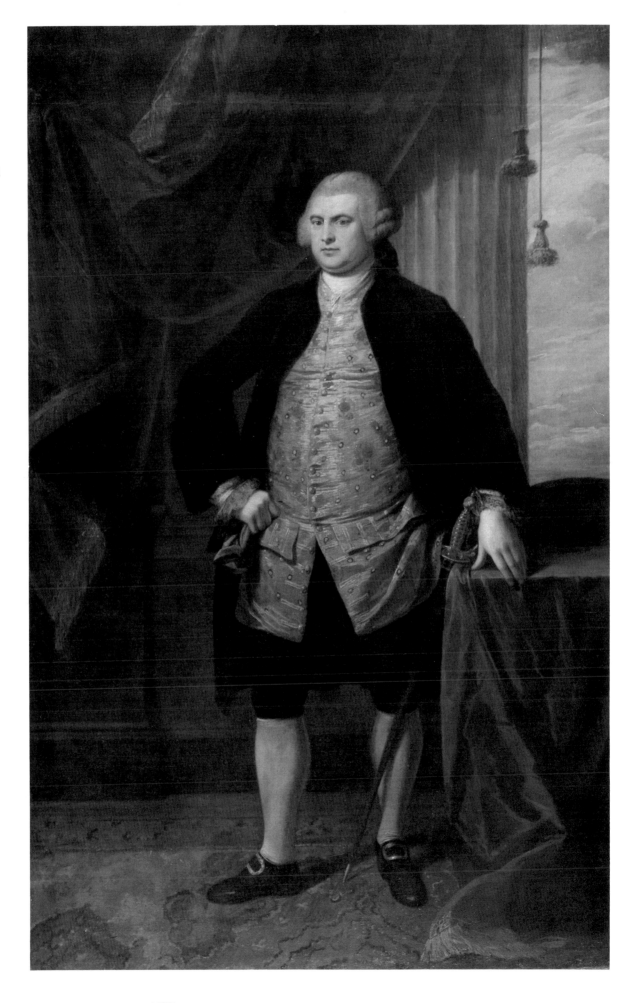

18
Charles Willson Peale

*William Pitt*
1768

Oil on canvas

95¼ x 61¼ in.
(241.9 x 155.6 cm.)

Westmoreland
County Museum,
Montross, Virginia

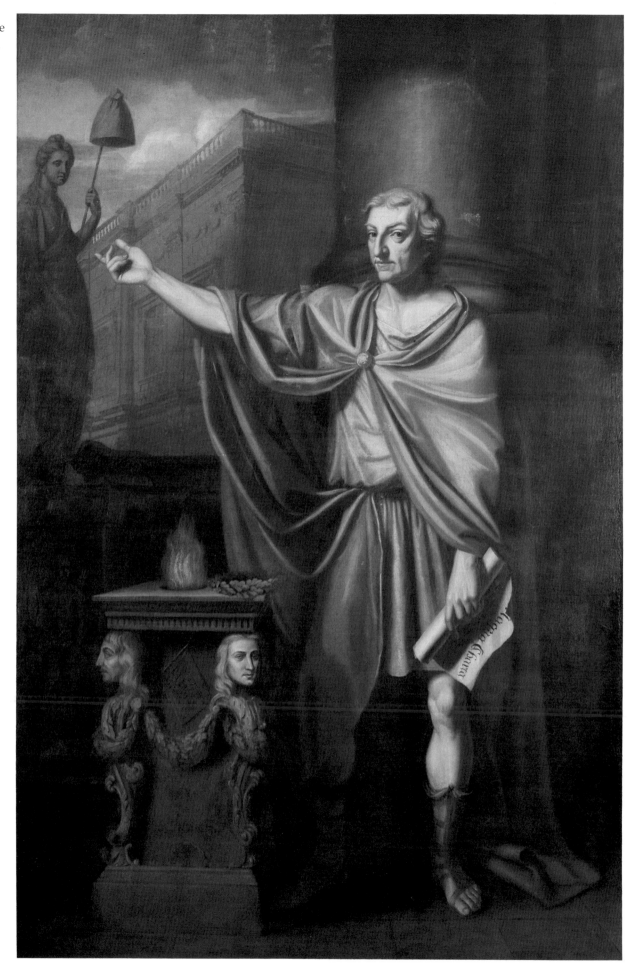

19
Charles Willson Peale

*Conrad Alexandre Gérard*
1779

Oil on canvas

95 x 59⅛ inches
(241.3 x 150.2 cm.)

Independence
National Historical
Park Collection,
Philadelphia

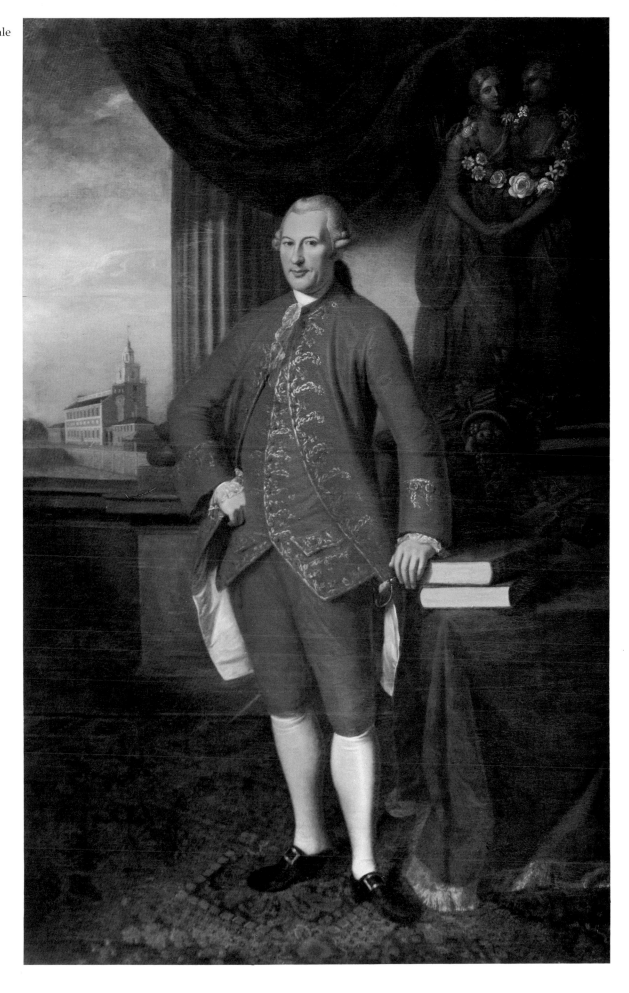

20
Charles Willson Peale

*George Washington
after the
Battle of Princeton*
1779

Oil on canvas

95¼ x 63¾ in.
(241.9 x 156.8 cm.)

Lent by Princeton
University, Bequest of
Charles A. Munn

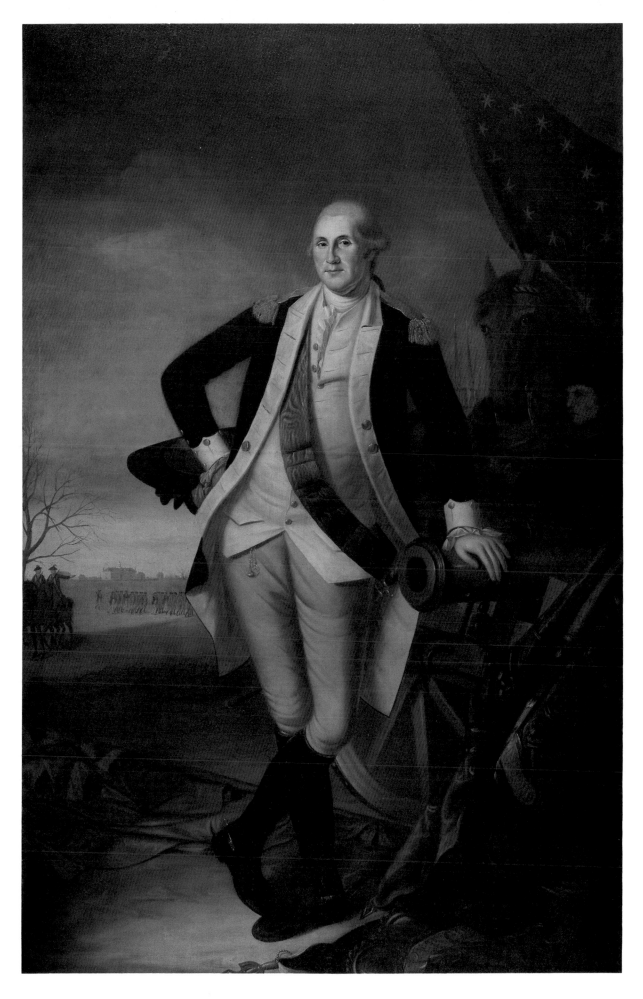

Son of a Scottish-born artisan, Gilbert Stuart was born in Rhode Island during 1755. After taking some painting lessons from an itinerant Scottish artist, Cosmo Alexander, Stuart accompanied the artist as apprentice through the South and then to Edinburgh in 1771. Returning to Newport, he worked in a conscientious style based upon little training but a clear vision, achieving a primitive realism. In September 1775, soon after the outbreak of the Revolution, he left for London, where the inadequacies of his technique brought him to impoverishment. In his need he wrote in 1777 to his fellow American Benjamin West, then just recently appointed history painter to the king. Stuart spent the next five years in West's large home, where he mastered the most fluent technique and the most current style, learning both from West and the works of other leading artists, such as Reynolds, Gainsborough, and Romney. In the Royal Academy exhibition of 1782 he exhibited *The Skater,* and on the strength of that great success set up his own studio. He soon became one of the most fashionable portraitists in London. In 1786 he married Charlotte Coates, a physician's daughter who bore him a large family. During this period he lived so extravagantly that he was obliged to move to Ireland in the late summer of 1787 to escape his debts. In Dublin, too, he became a highly successful portraitist, but by the end of five years he was again heavily in debt and so left in early 1793 for America. He worked first in New York, moved to Philadelphia in late 1794, to Washington in 1803, and in 1805 to Boston, where he died in 1828. He was by far the best and most admired portraitist of his period in this country and exerted considerable influence on the development of portraiture in America. The

painting known as *The Skater* is a portrait of William Grant, a gentleman from Congalton, East Lothian, near Edinburgh. Little else is known about him. It appeared in the Royal Academy exhibition of 1782

under the title *Portrait of a Gentleman Skating* and was such a success that it established Stuart as one of the leading portraitists of the day. More than just proving Stuart's competence with the full-length figure, however, *The Skater* demonstrated his complete mastery of portraiture "in the Grand Manner" as established and defined by Reynolds. The striding figure that turns itself recalls the *Apollo Belvedere* that Copley had also referred to in his portrait of *Hugh Montgomerie* (fig. 22, p. 19). Although only participating in a fashionable sport, the active, alert subject is dramatized to the point of the heroic. Most importantly, the painting is attractive and interesting enough to succeed as a picture, even aside from the question of resemblance. Portraiture thus enters the highest reaches of creativity and ideality. It is indeed a beautiful piece of picture-making, with its background of other skaters and distant view of Westminster, precariously balanced main figure, bold silhouette, and elegant range of silvery greys. It is a painting that meets the highest standards of eighteenth-century portraiture.

Since deciding to return to America in 1793, the idea had never been far from Stuart's mind that he should paint the definitive portrait of Washington and enjoy the large income from replicas and engravings of the beloved leader. Stuart was able to obtain a sitting from Washington in late 1795, producing a bust portrait known as the Vaughan type. His second attempt was prompted by a commission from the Marquis of Lansdowne, an admirer of Washington who had supported recognition of the United States. The wife of the wealthy Philadelphia politician William Bingham insisted on presenting the portrait to Lord Lansdowne as a gift and persuaded the much-painted Washington to submit to further sittings. Lord Lansdowne acknowledged receipt of the portrait on March 5, 1797. It was greatly admired in London and in this country, and three full-size replicas were commissioned from Stuart. The related life study became the basis for a great many bust-length and half-length portraits that supplied a steady income to Stuart for the rest of his life. The pose and background of the portrait are based upon an engraving by Pierre Drévet of Rigaud's portrait of Bishop Bossuet. It is conceived as a portrait

of Washington the statesman, rather than the general, showing him at a table with papers of state. The scale and baroque movement of the print source balance the remote idealization of the head, the very quality of distant nobility that made this interpretation of Washington the icon and standard image of the first American president.

William Smith (1727–1803) was born near Aberdeen and graduated from the University of Aberdeen in 1747. He came to New York in 1751 as a private tutor. In 1753 he was invited to head the newly founded College Academy and Charitable School of Philadelphia but first returned to England to take holy orders. He became first provost of the school after his return in 1754. In 1758 he married Rebecca Moore. His growing differences with the Quakers caused him to return in 1759 for a visit to England, where his defense of the Church of England won him degrees of doctor of divinity from the universities of Oxford and Aberdeen and from Trinity College, Dublin. Charges of Toryism against him and the trustees led to the revocation of the academy's charter in 1779. The same year he moved to Chestertown, Maryland, where he served as rector of the parish and founded Washington College in 1782, becoming its first president. When his former academy in Philadelphia was rechartered as the University of the State of Pennsylvania in 1789, Smith became its provost, retiring after two years. His vigorous leadership had made the University a prominent educational institution.

His portrait of about 1800 is an exceptionally large and elaborate one for Stuart, containing references to Smith's numerous accomplishments. He is presented in the robes of a doctor of divinity of Oxford, seated in a large, somewhat Gothic chair that may refer to his academic offices. The books on his writing table represent his many publications in the fields of politics, history, literature, and theology. The theodolite recalls his participation in a notable observation of the transit of Venus in 1769. The landscape, unusual for Stuart, shows the Falls of the Schuylkill, where the wealthy Smith had an estate and extensive landholdings.

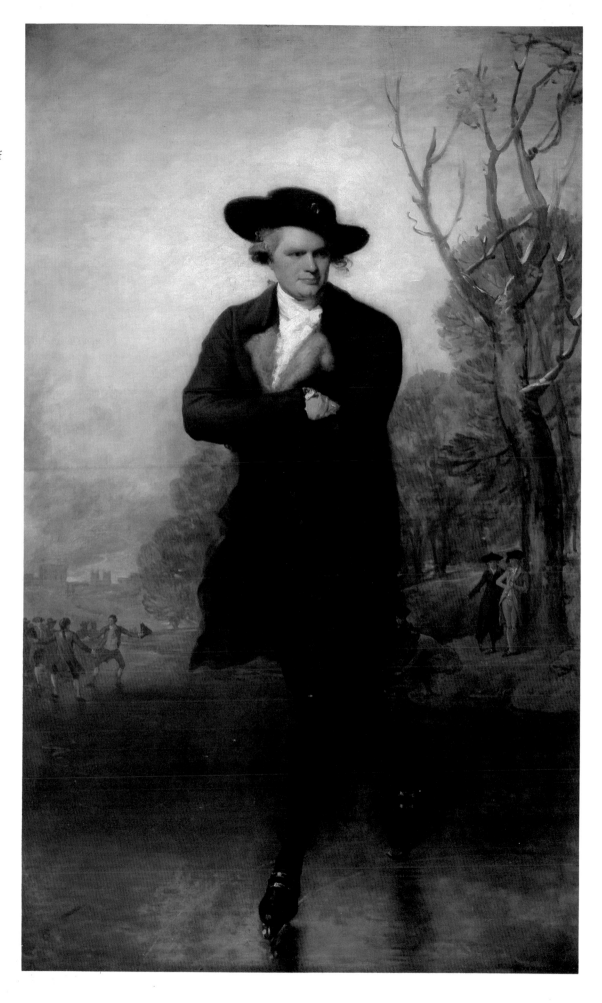

22
Gilbert Stuart

*George Washington* ("Lansdowne" portrait)
1796

Oil on canvas

96 x 60½ in.
(243.8 x 153.7 cm.)

Lord Rosebery, on loan to National Portrait Gallery, Washington, D.C.

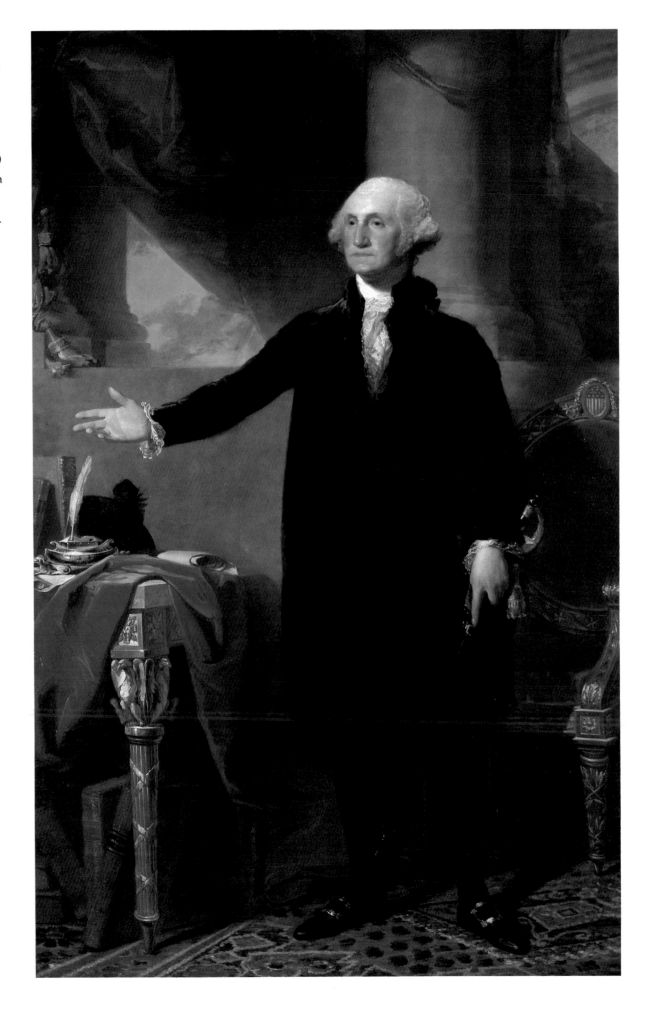

23
Gilbert Stuart

*Dr. William Smith*
c. 1800

Oil on canvas

37 x 60 in.
(94 x 152.4 cm.)

Lent by University of
Pennsylvania by
Courtesy of John
Brinton

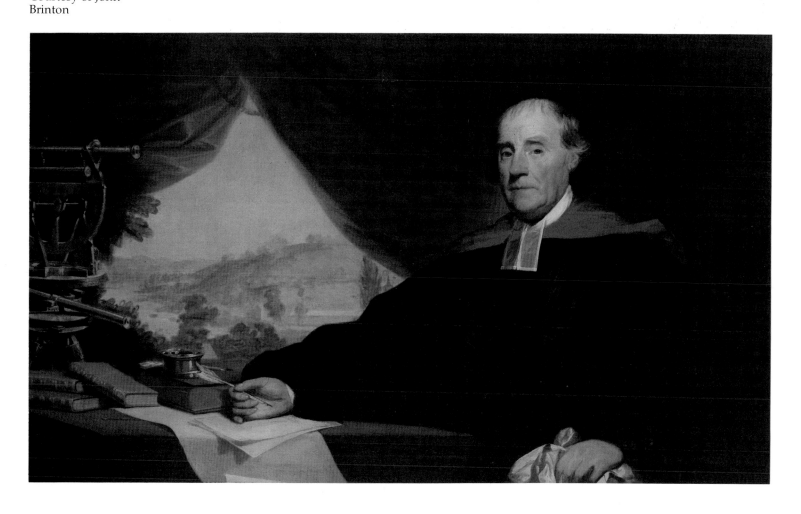

Joseph Wright
1756–1793

Joseph Wright was born in Bordentown, New Jersey, in 1756, son of Joseph and Patience Lovell Wright. She was the very successful modeler in wax and a secret American spy in London during the Revolution. After her husband's death she settled in London, in 1772, where her family followed her in 1773. She taught modeling to her son and introduced him into artistic circles that led to his admittance, as the first American, to the Royal Academy schools in 1775. He learned painting through his association with John Trumbull, Benjamin West, and his brother-in-law, John Hoppner. In December 1781 he went to Paris, where he painted numerous portraits under the patronage of his mother's friend Benjamin Franklin. Later that year he sailed for America, a shipwreck delaying his arrival. Armed with letters from Franklin to influential persons and to Washington, he obtained sittings from the general and Mrs. Washington in October 1783. He first settled in Philadelphia but by 1787 was in New York, where he married a Miss Vandervoort. In 1790 he followed Congress to Philadelphia, where he and his wife died during the yellow fever epidemic of 1793. He painted portraits of many of the leading political figures and modeled some of the government's first medals and coins. His pupil Benjamin Rush became the first American sculptor of note.

John Coats Browne was born October 23, 1774, son of Peter Browne and Mary Coats Browne and named for his maternal grandfather. Peter Browne left the Society of Friends when he bore arms in the Revolution. John Coats Browne was educated at the Episcopal Academy and graduated from the University of Pennsylvania in 1793. He joined his father's ironmongering business, became the first president of the Kensington Bank, and held the various civic posts generally signifying wealth and standing in the community. In April of 1800 he married Hannah Lloyd. He died on August 8, 1832.

Browne's portrait by Joseph Wright was probably painted about 1785. Its pose and plumed hat are that of

Thomas Gainsborough
1727–1788

*Jonathan Buttall:*
*The Blue Boy*
c. 1770

70 x 48 in.

Henry E. Huntington Library and Art Gallery,
San Marino, California

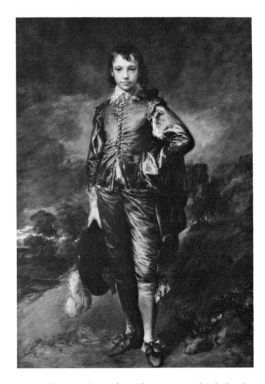

Gainsborough's *The Blue Boy*, which had not yet been engraved but which Wright would have known while in England. In place of Gainsborough's background of landscape and storming sky, Wright has introduced a grand manner column and drapery, more in keeping with his somewhat Neoclassical style, no doubt influenced by his experiences in Paris.

24
Joseph Wright

*John Coats Browne,*
*1st, as a Young Man*
1785

Oil on canvas

61¾ x 43¼ in.
(156.8 x 109.8 cm.)

Permission of The
Fine Arts Museums of
San Francisco, Gift of
Mr. and Mrs. John D.
Rockefeller, 3rd

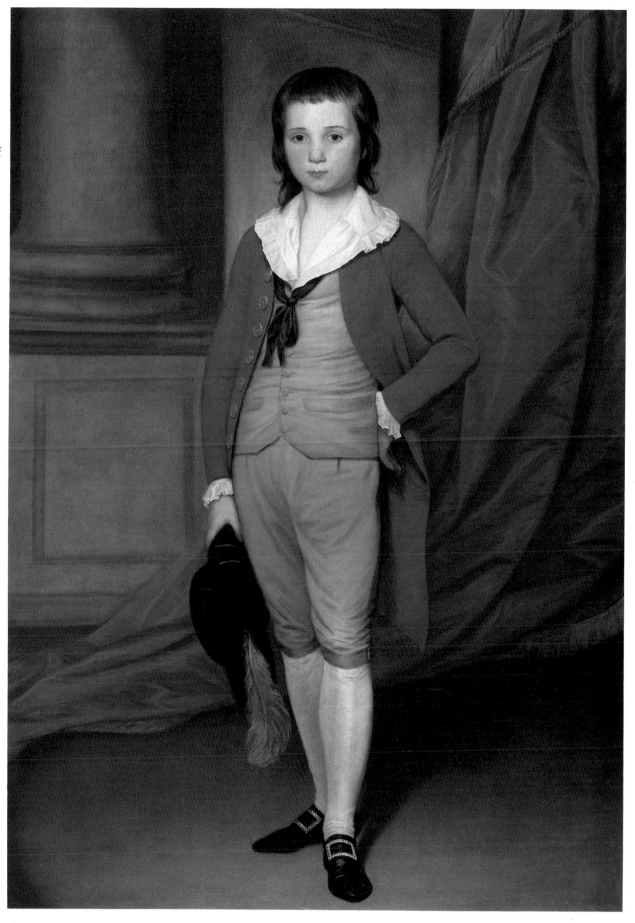

Born in Philadelphia in 1743, Henry Benbridge was raised in the home of his Scottish-born stepfather, Thomas Gordon, a leading merchant. He studied at the College Academy and Charitable School (which later became the University of the State of Pennsylvania) from 1751 to 1758, leaving in mid-term. While in Philadelphia briefly in 1758, John Wollaston painted his stepfather and also gave some instruction to Benbridge, who soon emerged as an artist. Achieving his majority in 1764, Benbridge inherited from his father some property which enabled him to study in Rome. There he took instruction from Pompeo Battoni and Anton Raphael Mengs, studied Old Masters, and learned what he could from the large colony of English and Scottish painters in Rome. In Corsica during the summer of 1768, Benbridge painted the large full-length portrait of the Corsican leader Pascal Paoli. When shipped to London, it was promoted by Paoli's discoverer, James Boswell, who also had commissioned the portrait. In December 1769 Benbridge arrived in London, where he was closely associated with Benjamin West. At the Royal Academy exhibition of 1770 he showed two recent portraits, including one of Benjamin Franklin. Later that year he returned to Philadelphia, where he married Esther Sage. In 1772 he moved to Charleston, South Carolina, the principal city of the South, with which he is chiefly identified as an artist. As a known patriot, he was imprisoned and exiled to St. Augustine, Florida, by the British who occupied Charleston during the Revolution. After about 1790 he painted very little, either because of ill health or because of the fortune he had inherited from his father's estate upon the death of his mother in 1778. Benbridge died in Philadelphia in 1812.

In Charleston, Benbridge found generous patronage for his stately portraits in the Neoclassical style. Of all Americans, Benbridge comes closest to the manner of Benjamin West in the early 1770s, with his firm volumes, jewel-like colors, classical settings, and sometimes classical costumes. He had taken an interest in the group portrait, or conversation piece, even before his studies in Europe, and found the opportunity in Charleston to paint many, both in full-scale and in small-scale. At their best they can achieve a strong mood of spiritual communion amid a nostalgic stillness.

None of the four women in the portrait titled *The Hartley Family* bore that name at the time the portrait was painted, about 1787. The older woman on the left, born Margaret Miles in 1722, married James Hartley, and after his death married Robert Williams, who also predeceased her in 1776. To her left is her daughter Sarah Hartley, who had married William Somersall in 1774. Standing to her mother's left is Mary Somersall. The younger girl is Margaret Phelp Campbell, great granddaughter of Margaret Miles Hartley Williams and great niece of Sarah Hartley Crosthwaite Somersall.

25
Henry Benbridge

*The Hartley Family*
1787

Oil on canvas

76 x 60¼ in.
(193.1 x 150 cm.)

Maitland A. Edey, on
loan to The Art
Museum, Princeton
University

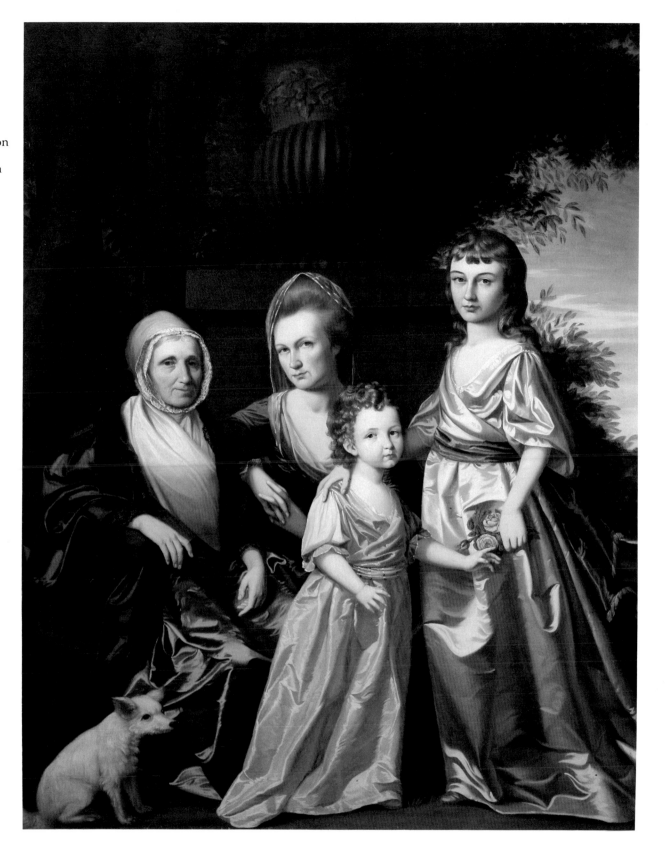

Ralph Earl was born in Worcester County, Massachusetts, the eldest son of Ralph and Phoebe Whittlemore Earl, in an established family of farmers and craftsmen. The family moved to Leicester, where Ralph and his brother, James, also to be a portraitist, grew up. It is not clear from whom Ralph received his artistic training, but in 1774 he established his own studio in New Haven, Connecticut. His first paintings are in a primitive style of undeniable charm. The same year he married his cousin Sarah Gates, who later divorced him. Because of his loyalist sympathies he was forced to leave Connecticut in 1777, and reached London in April 1778. Like other Americans, he was welcomed into the studio of Benjamin West and slowly began to acquire the polish of the English school. He painted at first in the country but later exhibited at the Royal Academy. About 1784 he married Ann Whiteside, who bore a daughter and a son, Ralph Eleazer Whiteside Earl, who later married the niece of Mrs. Andrew Jackson and painted many likenesses of the seventh president. Earl and his wife arrived in Boston in May 1785. By November he was in New York City, where his drinking and extravagance brought him to debtor's prison. During his second American period he traveled a great deal, painting principally in Connecticut but also as far as Bennington, Vermont and Worcester, Massachusetts. His style reverted somewhat to the primitive quality characteristic of his first American period, achieving a delightful balance of competence and naive charm. About 1800 the quality of his work dropped off sharply, and he died in Bolton, Massachusetts, on August 16, 1801, the cause of death listed as "intemperance."

Mary Floyd (1763–1805), daughter of a signer of the Constitution, in 1784 married Colonel Benjamin Tallmadge (1754–1855), a Yale graduate and hero of the Revolution, in which he rose to become chief of the intelligence service. The year of his marriage he settled in Litchfield, Connecticut, where he became wealthy as a merchant and bank president. He was a member of Congress from 1801 to 1817 and also served as president of the Society of the Cincinnati. The portrait of Mrs. Tallmadge and two of her five children is one of Earl's dressiest, showing the subjects elaborately costumed in what was the height of fashion in Connecticut. In the matching portrait, Colonel Tallmadge is shown with his eldest son, seated at a table with a bookshelf behind. The luxurious Axminster carpet unites the pair. The portrait of Mrs. Tallmadge shows the clarity of organization and slight geometricization of forms that have made Earl's portraits so appealing to modern eyes. Even though Litchfield was a prosperous town, it is still remarkable that so many large and stately portraits should have been commissioned there and in similar towns in Connecticut.

*Mrs. Benjamin Tallmadge with Her Son Henry Floyd and Daughter Maria Jones*
1790

Oil on canvas

79½ x 55½ in.
(201.9 x 141 cm.)

Litchfield Historical Society, Connecticut

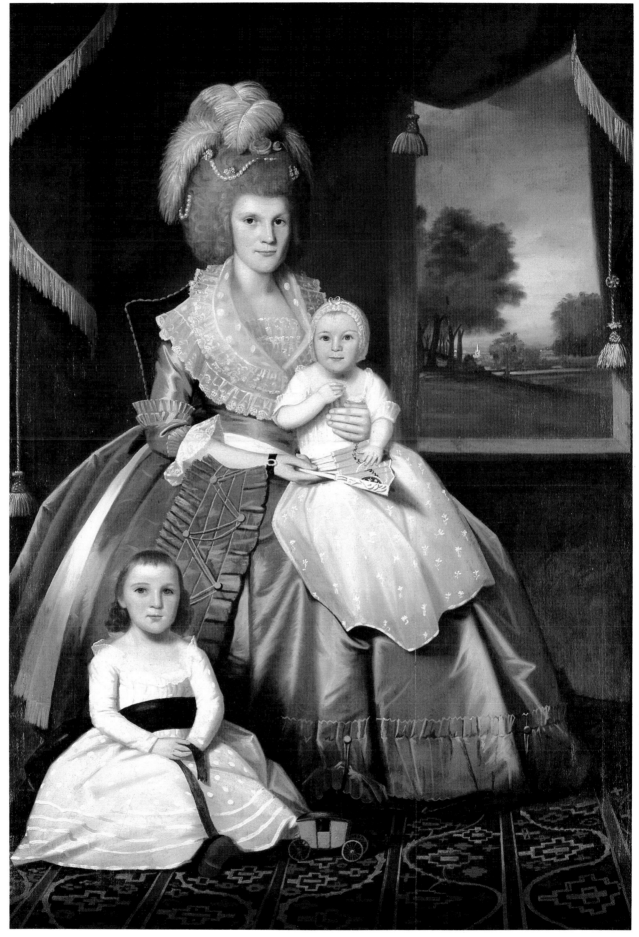

John Trumbull came from a wealthy and prominent Connecticut family. He was discouraged in his artistic aspirations by his father, who required him to attend Harvard in order to enter business or law. By 1783, however, Trumbull had won the debate and begun to study art with his fellow countryman Benjamin West in London. It was in West's studio that he spent his most productive and rewarding period. Trumbull began his career as a history painter, the first to celebrate the great events of the founding of the new nation. While in London he began his best-known work, *The Declaration of Independence* (Yale University Art Gallery); it was one of a series of paintings of the Revolution, and he planned to market engravings of the work. Over the next eight years he painted numerous small, life portraits of patriot leaders in preparation for the series of paintings. During his visits to this country he was frequently given the major commissions for large portraits, notably those for New York City Hall. Through his father's influence, Trumbull had early been involved with American patriots; he briefly served as second aide-de-camp to General Washington and speculated in stores and provisions for American troops. Sporadic secretaryships and minor diplomatic assignments and positions carried him through the middle years of his life, while he continued to make portrait studies for his paintings of the American Revolution. After 1815, however, he returned to the United States, where he painted portraits and worked for seven years on a major commission, four large historical pictures for the rotunda of the Capitol. In his declining years the criticism these received, as well as his financial disappointment, the failure of the American Academy of Fine Arts under his presidency, and the death of his wife made the proud aristocrat bitter. Nevertheless, he completed his substantial *Autobiography* and, through the influence of his relative Benjamin Silliman (cat. no. 36), had the honor of seeing his name on the first art museum connected with an educational institution in the United States, the Trumbull Gallery at Yale.

In 1790, only a few brief years after the conclusion of the Revolutionary War, William Loughton Smith, United States senator from South Carolina, was struck by the celebrated portrait of George Washington he had seen Trumbull painting for New York City Hall. With patriotic fervor he questioned why the city hall in Charleston should not have a similar portrait. Nine months later, during the president's stay in Charleston on a Southern tour, the city council resolved to request such a portrait "to commemorate his arrival in the metropolis of this State and to hand down to posterity the remembrance of the man to whom they are so much indebted for the blessings of peace, liberty and independence."

Trumbull obtained sittings from the president in Philadelphia, where the United States government was then meeting. His personal acquaintance with Washington as a military commander and his own predilection for dramatic historic scenes inspired the artist to portray Washington before the Battle of Trenton. The rearing horse in the background, the tempestuous sky, and Washington's attention on the distance helped to make the spirited portrait one of the classic images of Washington (Yale University Art Gallery). Charleston, however, wanted a "more matter-of-fact likeness"—as they had recently seen him—"calm, tranquil, peaceful," and asked Trumbull to paint them another. Washington agreed to further sittings. In this new interpretation, though Washington still wears his uniform as commander-in-chief, no sense of militancy remains. Instead we see Washington as president, a man at peace, standing on the shore near Haddrill's Point on the day of his arrival in Charleston in 1791. The city is seen in the background where the Cooper River appears, covered with boats and adorned with flags. The president's horse is standing near him, and at his feet grow several palmettos, the laurel of South Carolina.

27
John Trumbull

*George Washington*
1792

Oil on canvas

90½ x 63 in.
(229.9 x 160 cm.)

City Council of the
City of Charleston,
South Carolina

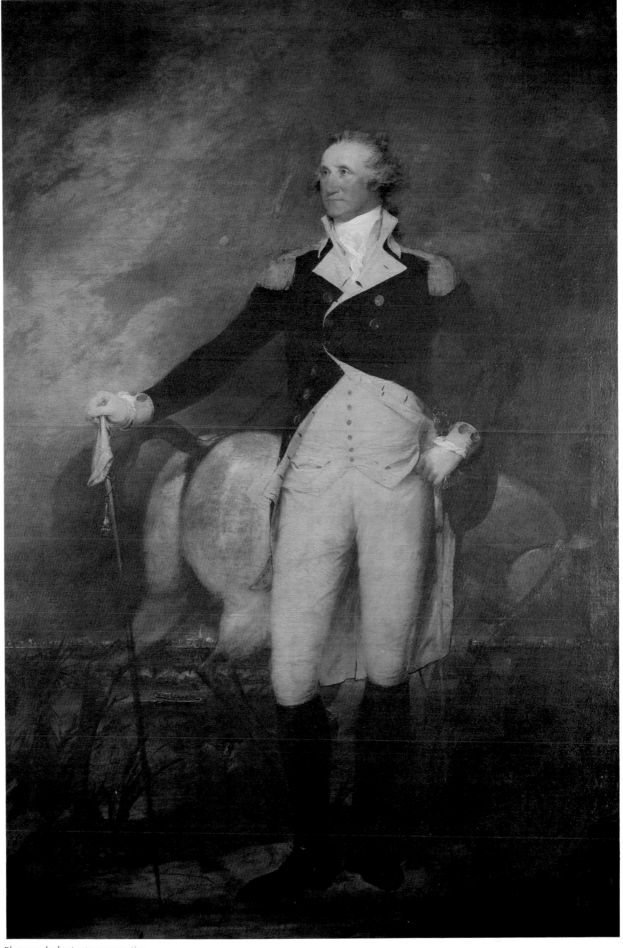

*Photographed prior to conservation.*

Thomas Sully was born at Horncastle, Lincolnshire, England, in 1783 and came to this country at the age of nine when his actor parents settled the family in Charleston, South Carolina. Showing an early interest in art, he studied under his brother-in-law, Jean Belzons, and under his elder brother, Lawrence Sully, a miniature painter. The brothers were associated in Richmond and Norfolk, Virginia, until Lawrence's death in 1803. In 1805 Thomas Sully married his widowed sister-in-law. In 1806 he moved to New York, where he received patronage from acquaintances in the theater. Briefly in 1807 he received some instruction from Gilbert Stuart in Boston. The following year he moved to Philadelphia, henceforth his permanent home, where he soon established his preeminence as the leading portraitist. By 1809 he had saved enough money to spend nine months in London, where Benjamin West referred him to Lawrence. He absorbed enough of the foremost English portraitist's style to become known as the "American Lawrence." He went to England again in 1837 to fulfill a commission for a portrait of Queen Victoria, one of his great successes. He dominated Philadelphia portraiture until about 1850 and continued to paint more modest portraits almost until his death in Philadelphia in 1872.

George Frederick Cooke was born in London in 1756. He made his theatrical debut there in 1778, before establishing himself as one of the principal players in Dublin. In 1800 he returned to London, where he achieved immense success, particularly in the roles of Shakespearean villains, such as Iago and Richard III. He ranked with Kemble as the leading actor of his day. In 1810 he came to New York, the first British actor of such high standing to grace the American stage, and was received with great enthusiasm. He came to Philadelphia in 1811, and there Sully painted him on a commission from a group of the actor's admirers who purchased the portrait for the Pennsylvania Academy. Sully finished the portrait in January of 1812, after Cooke's sudden death in New York the previous September. It was placed on the stage of the Chestnut Street Theatre during a memorial service there. Sully's tour de force received additional attention during the period of grief for the actor, and made Sully's reputation.

The portrait long known as *The Lady with a Harp* is a portrayal of Miss Elizabeth Ridgely. Elizabeth Eichelberger Ridgely, known as Eliza, was born in 1803, the daughter of Nicholas Greenberry Ridgely, a prominent merchant of Baltimore. She was already noted for her beauty at the age of sixteen when Sully painted her portrait between May 1 and May 27, 1818. Her father entertained Lafayette during his visit to Baltimore in 1825, and the great man exchanged several letters with Eliza after his return, apparently charmed by her. On January 8, 1828, she married her widower cousin, John Ridgely of Hampton, son of Governor Charles Ridgely. A daughter, Eliza, was born the following October. The family traveled in Italy and France in 1834. She died in 1867.

Thomas Handasyd Perkins was born in Boston in 1764 of an old but humble family. His father was a vintner. He attended school in Boston and Hingham but went into business rather than attend a university. After working in a counting house and engaging in trade with South Carolina and the West Indies, he sailed to China and embarked upon the oriental trade. He made a substantial fortune in this and other ventures until about 1838. A prominent member of the Federalist party, he held legislative offices in Massachusetts between 1805 and 1824 and served as a presidential elector in 1816 and 1832. A longtime member of the Massachusetts militia, he was generally known as "colonel." As active and important as his financial and political activities were, he was best known for his generous philanthropies, especially to the Massachusetts General Hospital, the Boston Athenaeum, the Bunker Hill and National Monument associations, and the New England Asylum for the Blind, which since 1839 has borne his name. He was also Boston's leading art collector. Perkins died in Boston in 1854.

28
Thomas Sully

*George Frederick Cooke as Richard III*
1811

Oil on canvas

95 x 60½ in.
(241.3 x 153.7 cm.)

Courtesy of the Pennsylvania Academy of the Fine Arts, Philadelphia

29
Thomas Sully

*Lady with a Harp:
Eliza Ridgely*
1818

Oil on canvas

84⅜ x 56⅛ in.
(214.3 x 142.5 cm.)

National Gallery of
Art, Washington,
D.C., Gift of Maude
Monell Vetlesen

30
Thomas Sully

*Colonel Thomas Handasyd Perkins*
1831–32

Oil on canvas

94 x 58 in.
(238.8 x 147.3 cm.)

Boston Athenaeum, 1831, Commissioned by the Trustees of the Boston Athenaeum

John Wesley Jarvis
1780–1840

John Jarvis was born in England in 1780 to an American father of the same name and his English wife, Ann Lambert, who was related to the Methodist John Wesley, a name John Jarvis later added to his own. About 1785 the family followed their father to Philadelphia, where the children were raised. About 1793 the young John was apprenticed to Edward Savage, the engraver, who moved to New York in 1800, taking Jarvis along. In 1801 Jarvis set up as an engraver and painter in New York. By 1803 he was in partnership with the miniaturist Joseph Wood. Jarvis' first recorded portrait was painted in 1803, and during the following five years he steadily developed his skills, emerging as an established portraitist. With the departure of Trumbull for England in 1808, Jarvis faced little competition in New York, and his practice grew. About 1809 he married Betsy Burtis. In the fall of 1810 he set out upon the first of his trips to seek portrait commissions in the cities of the South. In 1814 he received from the city of New York the first of several commissions for full-length portraits of heroes of the War of 1812. The great success of these portraits made his reputation and established Jarvis as the foremost portraitist in New York, until he was eclipsed by his pupil Henry Inman, about 1825. During the winter of 1833 he apparently suffered a stroke and was prevented from further painting by the resulting partial paralysis. He died in New York in 1840.

Samuel Chester Reid was born in 1783 in Norwich, Connecticut, the son of Lieutenant John Reid, a former British naval officer who had joined the American cause during the Revolution. Samuel went to sea at the age of eleven, and by the time he was twenty he was master of the brig *Merchant* of New York. Commanding the privateer *General Armstrong* during the War of 1812, he resisted capture by two British warships while in the harbor of Fayal in the Azores in late September of 1814. Although he finally scuttled his ship, the week or ten days' delay for the British ships on their way to New Orleans greatly aided Andrew Jackson's defense of that city. Reid was accorded a hero's honors upon his return to New York, including a silver service presented by New York merchants and a sword awarded by the New York legislature. It is presumably that sword which he holds in Jarvis' portrait. His left hand, resting upon a cannon, holds a mariner's speaking trumpet. Although the portrait was a private commission, Jarvis has portrayed Reid in the thick of battle, in the kind of heroic presentation that won him such acclaim for his official portraits of heroes of the War of 1812 commissioned for New York City Hall. Reid was for many years harbor master of New York, was pensioned in 1843, and died in New York in 1861. Among his lasting contributions was a proposal for the design of the United States flag, which had not yet been standardized when his portrait was painted. In 1817 he asked Jarvis to paint a pasteboard model of the design, which was adopted by Congress the following year.

31
John Wesley Jarvis

*Portrait of*
*Samuel Chester Reid*
1815

Oil on canvas

50½ x 36⅝ in.
(128.2 x 93 cm.)

The Minneapolis
Institute of Arts,
Minnesota

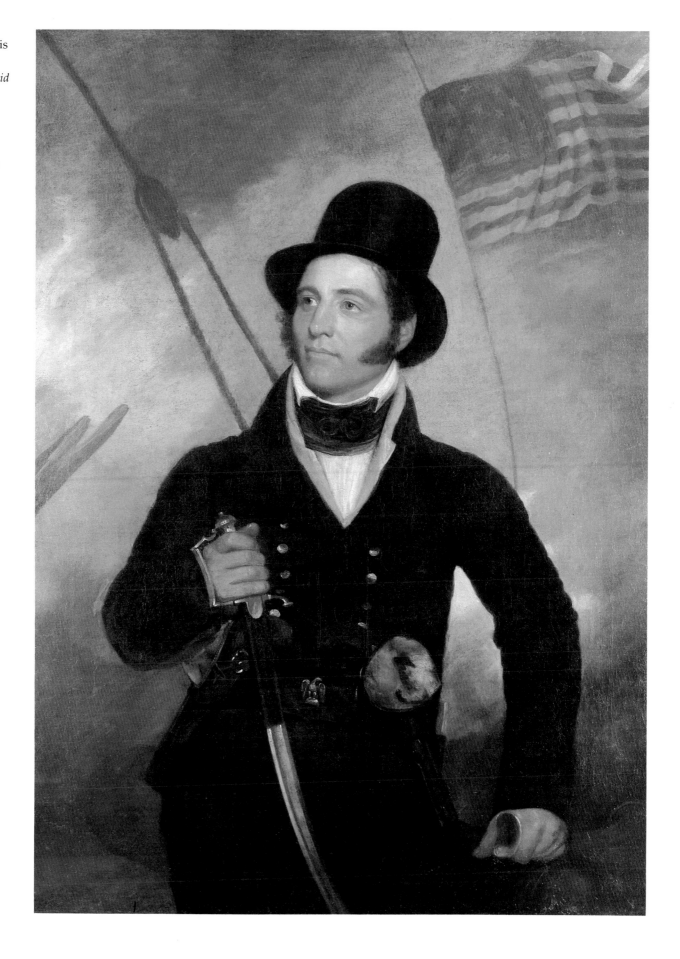

Rembrandt Peale
1778–1860

Rembrandt Peale was born in 1778 in Bucks County, Pennsylvania, the son of Charles Willson Peale. He followed the example of his father by entering diverse fields of endeavor that included natural history and museum management. Receiving early instruction from his father, he exhibited his first portraits in 1795. In September of that year he sketched Washington during a sitting given for Rembrandt's father. During the following years he painted in Charleston, Baltimore, and again in Philadelphia. In 1798 he married Eleanora Mary Short. He assisted his father in the exhumation and reconstruction of the mastodon skeleton and in 1802 accompanied it to London. There he studied with Benjamin West and exhibited at the Royal Academy in 1803. During the following years he was employed by his father to paint portraits for his collection; for this purpose he traveled in this country and then to Paris in 1808 and again in 1809. About this time his mature style began to coalesce, influenced to some extent by the French school. After his return to Philadelphia in late 1810, he began several paintings of idealized themes, including his very large *The Court of Death*, the centerpiece of the museum of paintings and natural history he established in Baltimore in 1814, and which his brother Rubens directed from 1822 to 1830. After a period in New York, he returned in 1823 to Philadelphia, where he labored to perfect his portrait of Washington, the often-replicated "porthole" likeness. Again in New York in 1825, he succeeded John Trumbull as president of the American Academy of the Fine Arts. He next resided in Boston, where he was among the first American artists to take up lithography. In 1828 he traveled in Europe, chiefly in Italy, copying old masters. He returned to New York in 1830 and published *Notes on Italy* in 1831. In 1832 he was in Europe for the fifth time, painting portraits in London. In 1834 he published a manual for artists and in 1839 his *Portfolio of an Artist*. He lectured widely on his portrait of Washington and published articles on art as well as his reminiscences. He died in Philadelphia in 1860, survived by his second wife, Harriet Carey.

Jacob Gerard Koch was born in Holland in 1761 and emigrated to America before 1778, settling in Philadelphia and later becoming a citizen. In 1778 he married Elizabeth Degerin. His business as importer and merchant of German linens made him a very wealthy man. In 1801 in Philadelphia he married his second wife, Jane Griffith, who had emigrated from Ireland, where she was born about 1772. At about the time of the wedding, Jacob purchased a country seat, Fountain Green, at the Falls of the Schuylkill. During the War of 1812, Koch, a conspicuous patriot, contributed $5,000 toward the building of a frigate. His contemporaries remarked upon his exceptional corpulence. About 1819 the Kochs gave Fountain Green to Jane's brother, William Griffith, turned over the managements of their American investments to her brother-in-law, Matthew Huizings Messchert, and moved to Paris where they enjoyed retirement. Jacob Koch died intestate in Paris in 1830, and it was not until 1834 or 1835 that his widow received his immense estate of over a million dollars. She declined the proposal of a Lieutenant Levy of the U.S. Navy and in 1836 broke with and disinherited her nephew, William R. Griffith, whom she had supported and educated and who had served as her secretary in the early 1830s. She continued to enjoy driving in the Bois de Boulogne and entertaining friends and acquaintances. At the age of seventy she kept no servants and did all her own housework, to keep herself strong. She died in 1848 at the age of seventy-six and was buried with her husband in the Père Lachaise cemetery.

The style of the artist and of the clothing in the pair of portraits does not correspond to the date of the couple's wedding but rather to the period around 1815, when Koch may have been enjoying his greatest prosperity. In 1834 Mrs. Koch commissioned Sully to paint copies, now unlocated.

John Oliver was born in Ireland about 1763, the son of Robert Oliver of Lisburn, Ireland, and Margaret Waterwood. By 1794 he sailed to Santo Domingo for the firm of his brother Robert, who had settled in Baltimore soon after the Revolution. In 1796 he entered into partnership with his brothers Robert and Thomas; when the latter died in 1803 John and Robert continued as partners. John was in Europe on the firm's business from 1796 to about 1803. The firm grew to be one of the leading merchant-importers in the city. John did not marry, but he provided for two illegitimate sons. He was a president of the Hibernian Society of Baltimore, to which he bequeathed $20,000 for the establishment of a free school, which opened in 1827 as the Oliver Hibernian Free School and continued in existence until 1904. Oliver died in 1823. The society commissioned Rembrandt Peale to paint a memorial portrait in 1824, basing the likeness upon a portrait by Gilbert Stuart. The enframing stonework is a convention of posthumous portraits, elsewhere used extensively by Peale.

34
Rembrandt Peale

*John Oliver*
1824

Oil on canvas

54½ x 50⁷⁄₁₆ in.
(138.4 x 102.7 cm.)

The Maryland Historical Society, Gift of the Hibernian Society of Baltimore

32
Rembrandt Peale

*Jacob Gerard Koch*
c. 1815

Oil on canvas

34 x 29 in.
(86.4 x 73.6 cm.)

Los Angeles County
Museum of Art,
Museum Purchase
with Funds from
Mr. and Mrs. William
Preston Harrison,
Mary D. Keeler
Bequest, and
Dr. Dorothea Moore

33
Rembrandt Peale

*Mrs. Jane Griffith Koch*
c. 1815

Oil on canvas

34 x 29 in.
(86.4 x 73.6 cm.)

Los Angeles County Museum of Art, Museum Purchase with Funds from Mr. and Mrs. William Preston Harrison, Mary D. Keeler Bequest, and Dr. Dorothea Moore

John Vanderlyn, who could trace his artistic lines back to his grandfather, the New York limner Pieter Vander Lyn, attended the academy of Kingston, New York, until he was sixteen. As a child, the young Vanderlyn had demonstrated artistic talent by sketching, and, unlike most children of the time who aspired to the impractical profession of painter, he was allowed to pursue its study. Archibald Robertson of the Columbian Academy of Painting in New York and Gilbert Stuart in Philadelphia gave him basic instruction. Aaron Burr's financial help enabled Vanderlyn to obtain European training. A five-year Parisian residence was the first of several lengthy sojourns extending to 1815. During these years Vanderlyn enjoyed the stimulating environment of Europe, supported by the profitable public exhibition in the United States of his two paintings *Ariadne* and *Marius Amid the Ruins of Carthage*. After Vanderlyn's return to America in 1815, however, his career declined. Further attempts to support himself by public exhibition of his work ended in financial failure. Vanderlyn, who aspired to paint historical and other "higher" subject matter, was forced to resort to portraiture for a livelihood. Imagined wrongs accumulated until his death, leaving this proud man bitter at the end of his life.

Vanderlyn's artistic career was not atypical for his time. Other artists, such as Washington Allston, Samuel F. B. Morse, and John Trumbull, who also held elevated aspirations brought about by European study and residence, found upon return to the United States that "Jacksonian" society held little respect for European aesthetic tastes, yet it was consumed by a "rage for portraits."

In January of 1824 the Charleston City Council wrote Andrew Jackson asking him to sit for his portrait to John Vanderlyn. Since 1790 the council had been commissioning portraits of and by men who had historical associations with the city. Andrew Jackson, hero of the Battle of New Orleans and born in South Carolina, had double significance to the Southern city. Though Jackson achieved his greatest fame while president as a man who preferred action to politics or words, he was proudest of his military campaigns. As early as the age of twelve or thirteen he had taken part in the battle of Hanging Rock during the Revolutionary War. After practicing law in frontier towns such as Jonesboro and Nashville and acquiring his plantation, The Hermitage, where he lived the life of a cotton planter, his true aspiration was not for the governorship of Tennessee toward which his friends encouraged him but for the major generalship of the militia of the state, which he eventually obtained. Jackson's greatest military accomplishment was the successful defense of New Orleans against the British troops under the experienced Wellington in 1815.

Vanderlyn proved an appropriate choice as Jackson's portraitist. At the time of the commission he was at the height of his powers, and just four years before had completed another very successful portrait of Jackson for New York City Hall. Jackson is seen at full length. As in traditional military portraiture, he bears an unsheathed sword, suggestive of preparedness, and wears the full-dress uniform of major general in the United States Army, the highest military position to which he rose (not counting commander-in-chief when he became president). Compared to Vanderlyn's earlier portrait for New York City Hall in which Jackson twists with action, the Charleston work seems contained. Earlier, Charleston city fathers had asked Trumbull to repaint his George Washington for them because the first had been too military. Perhaps in view of this, Vanderlyn decided on a less warlike visage for his sitter. To secure Jackson's likeness Vanderlyn traveled to Washington, where Jackson was then serving as senator from Tennessee. After numerous sittings to complete the head, the artist John James Audubon, whose gaunt, almost emaciated frame matched that of Jackson, posed for the body. The result is a formal work of relatively peaceful mein; the cannon, seen dimly in the background, suggests the sitter's former military triumphs but does not dominate the spirit of the work. The painting blends comfortably with the pacific Washington and hints at Jackson's less warlike new position, seventh president of the United States; he was elected to the presidency in 1824 and again in 1828. His last years were spent at his plantation, The Hermitage.

35
John Vanderlyn

*Andrew Jackson*
1824

Oil on canvas

98 x 62½ in.
(248.9 x 158.8 cm.)

City Council of the
City of Charleston,
South Carolina

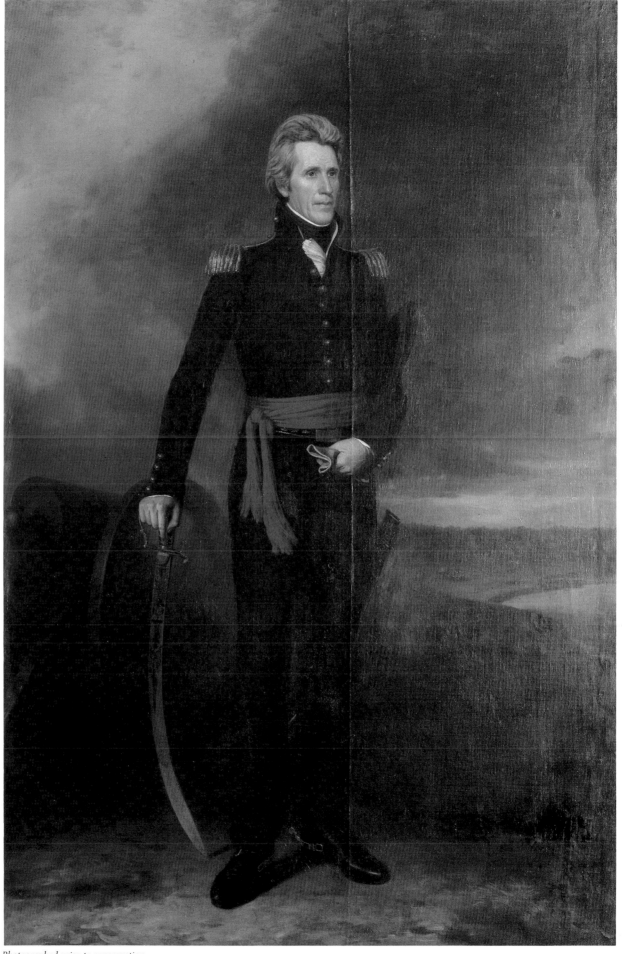

*Photographed prior to conservation.*

Samuel F. B. Morse, best known as the inventor of the telegraph and the Morse Code, would have preferred to be an artist. From an early age he exhibited artistic abilities and while a student at Yale amazed his classmates with his miniature portraits on ivory. When two of his pictures gained him approval by Washington Allston and Gilbert Stuart, his father finally allowed him to study art. For four years, beginning in 1811, Morse studied painting with Allston in London, where he produced history pictures of distinction. Like other artists of his time, when he returned to the United States full of ambition "to be among those who shall revive the splendor of the fifteenth century," he found he had to paint portraits to survive. Until the mid-1830s, Morse pursued portraiture, with studios at different times in Boston; Concord, New Hampshire; Charleston, South Carolina; and finally New York City. After that time, financially discouraged, he focused on his scientific interests.

Though most of Morse's portraits were modest, bust-sized pieces, he did have several opportunities to paint masterful, large portraits in the grand manner style. One of the finest, painted at the height of his powers in New York, is that of *Benjamin Silliman* (1779–1864). From 1802 to 1853 Silliman was professor of chemistry and natural history at Yale College; he was the most prominent and influential scientist in America during the first half of the nineteenth century. At a time when religion still dominated study in many fields, Silliman pursued personal observation and experimentation. Through his more than sixty articles, his several books, and the *American Journal of Science and Arts* of which he was the founder, proprietor, and first editor, as well as through his immensely popular college and public lectures, he introduced a doubting public to the excitement of scientific discovery. He was interested in art, too, and played an important role in obtaining the Trumbull Gallery for Yale.

The artist had known Benjamin Silliman since he studied under him at Yale and was introduced by him to electricity. Silliman later became his friend. When Morse invented his pump he showed the model to Silliman, who exhibited it in one of his classes. Later, when Samuel's father moved to New Haven, the Morses lived next door to Silliman, and Samuel accompanied Silliman on geology explorations in the Berkshires and Adirondacks and occasionally studied with him in the laboratory. Morse frequently discussed his telegraph with Silliman, who supported him both when Morse was waiting for Congress to vote the $30,000 to build a trial electric telegraph from Washington to Baltimore, and later in life, when Morse was continually besieged by lawsuits over the telegraph.

Morse painted his former teacher and friend in New York in 1825. The seemingly incongruous objects with which Morse has surrounded him all symbolize some part of his multifaceted personality. The rock specimens strewn on the desk and the quartz crystal held in his hand undoubtedly refer to his own position as professor, as well as to the Colonel George Gibbs mineral collection which Silliman used to illustrate his lectures and which he obtained for Yale in 1823. Behind him appears a view of New Haven as seen from the porch of Silliman's Georgian house situated on the northern edge of the campus. It features the geological formation West Rock, which Silliman described in a paper in 1806. Morse portrays Silliman in the act of lecturing, capturing his handsome appearance, his commanding presence, and his refined character. When the portrait was exhibited later at Yale, however, Silliman's colleagues on the faculty felt it did not capture the professor's features or the energy and enthusiasm that Silliman usually exhibited while lecturing. The general composition, resembling standard portraits of clergymen on the pulpit, is Morse's way of alluding to Silliman's deeply personal religious beliefs and, in conjunction with the minerals, sums up Silliman's particular blend of science and religion.

36
Samuel F. B. Morse

*Benjamin Silliman*
1825

Oil on canvas

55¼ x 44¼ in.
(140.2 x 112.4 cm.)

Yale University Art
Gallery, Gift of
Bartlett Arkell

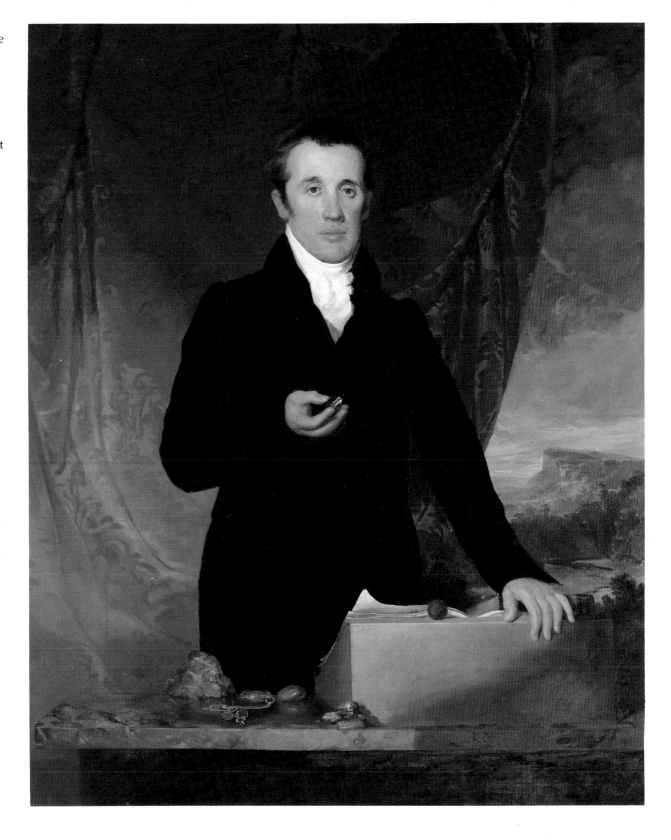

John Neagle was born in Boston in 1796, during a brief visit there of his Philadelphian parents. He was raised in Philadelphia by his mother and her second husband after his father died in 1801. He was apprenticed to Thomas Wilson, a coach and ornamental painter. Wilson later became a pupil of Bass Otis, from whom Neagle also received some instruction and later an introduction to Thomas Sully. In 1818 Neagle set up as an independent portraitist in Philadelphia and, after travels in the West in 1820, married Mary Sully, Thomas Sully's niece and stepdaughter. In 1825 he traveled to Boston in all humility to seek the counsel of Gilbert Stuart, who praised him, gave freely of his advice, and sat for a portrait by Neagle. The following year's portrait of *Pat Lyon at the Forge* (fig. 7, p. 37) made Neagle's reputation and launched his successful career as Philadelphia's number-two portraitist. About 1827 he visited New York to fulfill a commission for several portraits of leading actors, which developed into a specialty. He was a director of the Pennsylvania Academy of the Fine Arts in 1830–31 as well as a founder and for eight years (1835–43) president of the Artist's Fund Society. He died in Philadelphia in 1865.

Anna Gibbon Johnson (1809–1895), daughter of Colonel Robert G. Johnson of Guilford Hall Farm, Salem, New Jersey, married Ferdinand Wakeman Hubbell of Philadelphia in 1836. The high price her father paid for her portrait indicates that it was a special effort of the artist. The landscape background was perhaps inspired by the early primeval landscapes of Thomas Cole, who was in Philadelphia at the time, exhibiting his work. It may also accord with the personality of the sitter, whose notebook, filled with transcriptions of romantic poetry, has been preserved.

The name of Henry Clay (1777–1852), congressman, senator, and secretary of state, is among the best known of any American statesman. His great popularity is attested to by numerous portraits, of which Neagle's has been judged to be the best. It was commissioned in 1842, after Clay delivered a memorable farewell address announcing his retirement from the Senate and public life. Neagle sketched Clay that year on his estate in Kentucky and painted the large portrait the following year, while support was building for Clay's nomination for the presidency. The great orator gestures toward a flag-draped globe showing Latin America, where Clay's campaign for the recognition of its independence from Spain had made him a hero second only to Simón Bolívar. The anvil to his left may refer to Clay's role in raising high tariffs to protect American industry. The plow and cattle in the background may symbolize his own large farm and his consistent efforts in support of Western expansion.